Sailing Gold

Sailing Gold

Great Moments in Olympic Sailing History

MARK CHISNELL

ADLARD COLES NAUTICAL
LONDON

Published by Adlard Coles Nautical
an imprint of Bloomsbury Publishing Plc
49–51 Bedford Square, London WC1 3DP
www.adlardcoles.com

Text copyright © Mark Chisnell 2012

Photography copyright © Getty Images, PPL and
Steve Arkley/surf2turf.com

First edition published 2012

ISBN 978-1-4081-4647-7

A CIP catalogue record for this book is available from the British Library.

This book is produced using paper that is made from wood grown in managed, sustainable forests. It is natural, renewable and recyclable. The logging and manufacturing processes conform to the environmental regulations of the country of origin.

Typeset in ITC New Baskeville
Printed and bound in China by C&C Offset Printing Co

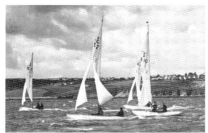

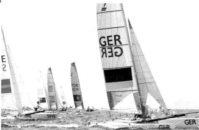

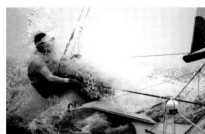

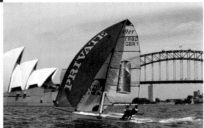

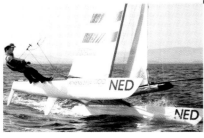

Introduction

THE OLYMPIC GAMES is the world's greatest sporting pageant and sailing has been a part of it since (almost) the beginning. Every four years the planet sweeps its gimlet gaze onto sports that, for much of the rest of the time, a celebrity-obsessed media ignores. And into that gaze step some very special men and women. The broiling heat of the Olympic cauldron requires remarkable qualities if the dream is not to become a nightmare. The people that fill these pages have found within themselves a bottomless well of determination and talent, and then added the ability to perform under the most remarkable pressure. They are unique heroes.

It was the turn of a new century and the second modern Olympics when sailing made its first appearance, in Paris in 1900. In the beginning, it was very much yacht racing rather than sailing, a mélange of keelboats and yachts competing against each other by the dispensation of a rating system of dubious quality. They were thrown together in a venue that would cause a shudder even amongst some of today's enthusiasts for 'stadium sailing' – short course racing, set close to the shore for spectators, but arguably to the detriment of a fair competition. Like so many other sports in the nascent Olympic movement, yacht racing was still bubbling up and forming in the wake of late nineteenth century peace and prosperity. International sailing events had only started a few decades earlier,

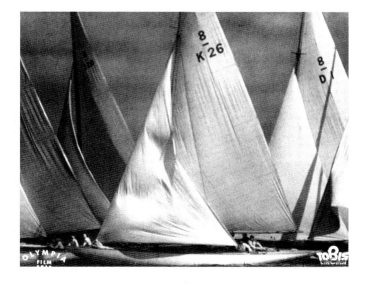

Left: The Berlin Olympics in 1936 were often called 'Hitler's Games' – these Eight Metre yachts were racing at the sailing venue in Kiel Firth.

Opposite

Top: The 1912 Olympics were held in Stockholm, and the chosen venue was Nynäshamn.

Bottom left: The first post-Second World War Olympics were held in London, with the sailing in the resort town of Torquay in south-west England. These Swallows were one of four keelboat classes, along with the Star, Dragon and Six Metre, and a single dinghy class, the Firefly.

Bottom centre: The Six Metre class racing at Torquay in 1948.

Bottom right: At the 1912 Olympics in Stockholm there were medals for four International Rule classes: the Six Metre, Eight Metre, Ten Metre and Twelve Metre; only 21 boats competed.

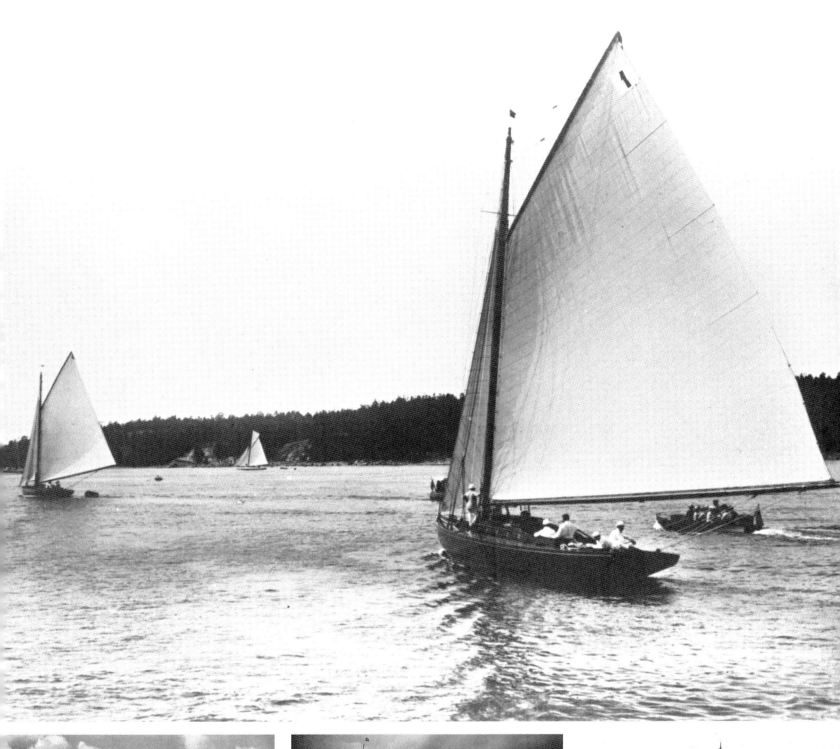

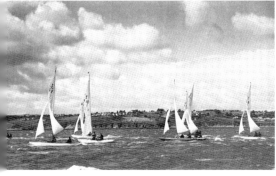
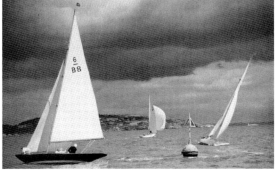
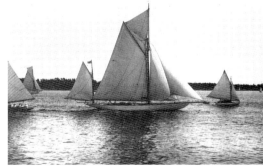

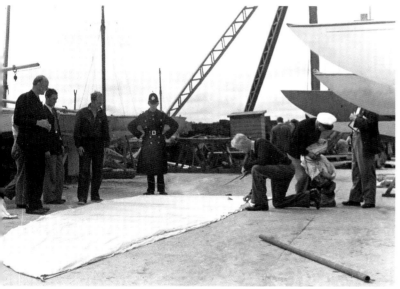

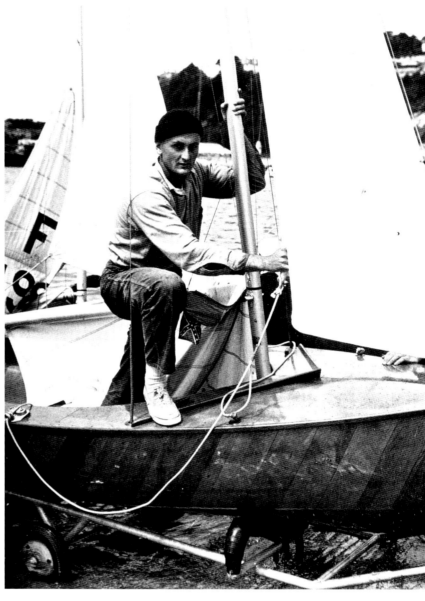

with the arrival in British waters of the yacht *America*. The subsequent race around the Isle of Wight for an ugly silver ewer became the legendary America's Cup, and the beginning of a new type of yacht racing.

The following images show us that those early Olympic events are unrecognisable as such to the modern spectator. Medals were handed out for single races in 1900, and eight years later a series still only constituted three races, compared with as many as 13 in the modern era. A single entry in the Seven Metre class in 1908 had to do just two races of one lap to go home with gold. The apocalypse of the First World War and then the Great Depression ensured that it was a while longer before things improved – the 1920

Top left: The Star class is craned into the water in Torquay in 1948.

Bottom left: A spinnaker is measured on the dock at Torquay in 1948 to check if it is within the rules – was the policeman a bystander or an official?

Above: Ralph Evans won silver for the USA in the Firefly class, second to the legendary Paul Elvstrøm.

Games were the strangest of the lot. There was just a single entry in seven of the 14 classes – those were not hard fought gold medals. In 1924, the silver medallist in the Eight Metre class took on two of his crew five minutes after the start. Delayed by a ferry cancellation and then a puncture, the race committee saw nothing wrong in letting them rejoin their yacht.

In 1932, in Depression-era Los Angeles, all of the competing Eight Metre and Six Metre yachts – two of the former and three of the latter – went home with a medal. But the first moves towards modern Olympic sailing were visible. The Star keelboat made its debut, sailing a seven race series. There was a single-hander, the una-rigged Snowbird, supplied by the organisers. As early as 1921 the International Olympic Committee (IOC) was anxious that 'the sporting instrument should count for nothing', believing that the athlete and not the equipment should be tested in the Olympic arena, and baby steps were being taken in that direction. By the time of 'Hitler's Games' in Germany in 1936, the Olympic Jolle had become the organiser-supplied dinghy class, and the boats were rotated amongst competitors.

Above: Finland's Dragon crew (left to right) Niilo Orama, Rainer Packalen and Aatos Hirvisalo, couldn't match the other Scandinavian teams, coming sixth behind the Norwegians (gold), Swedes (silver) and the Danes (bronze).

Below: The US team of (left to right) James Weekes, Michael Mooney, James Smith, Alfred Loomis and Herman Whiton won the gold medal in the Six Metre class in Torquay, 1948.

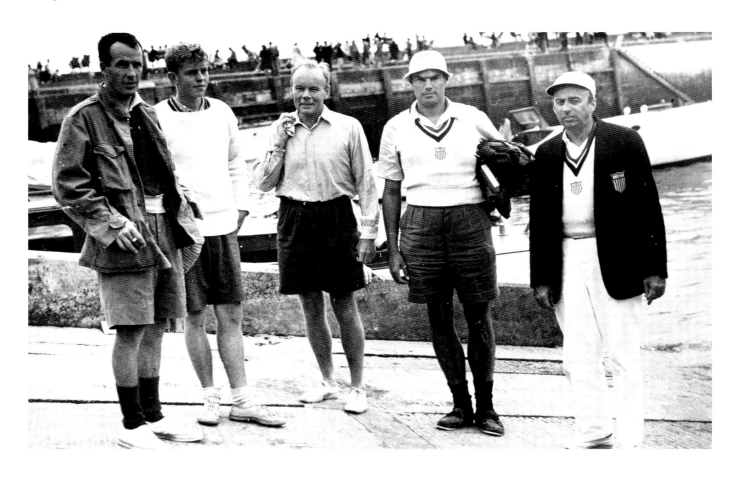

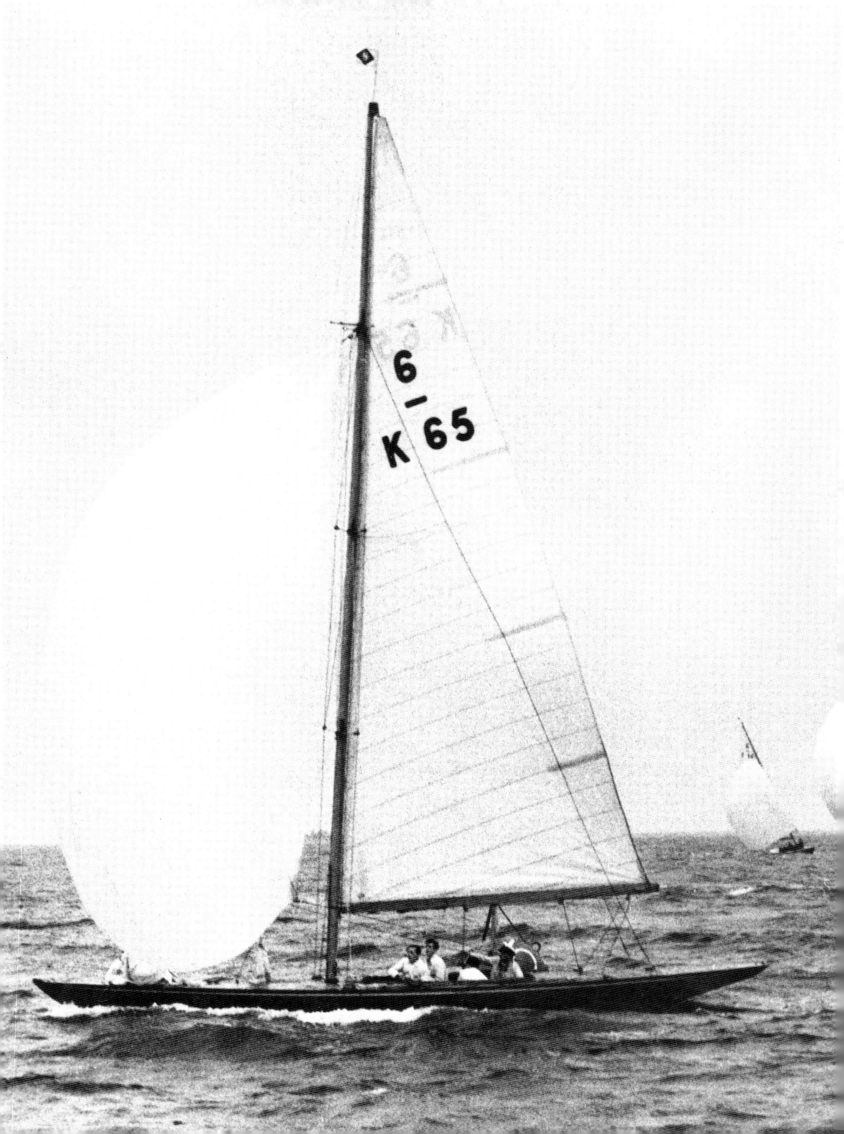

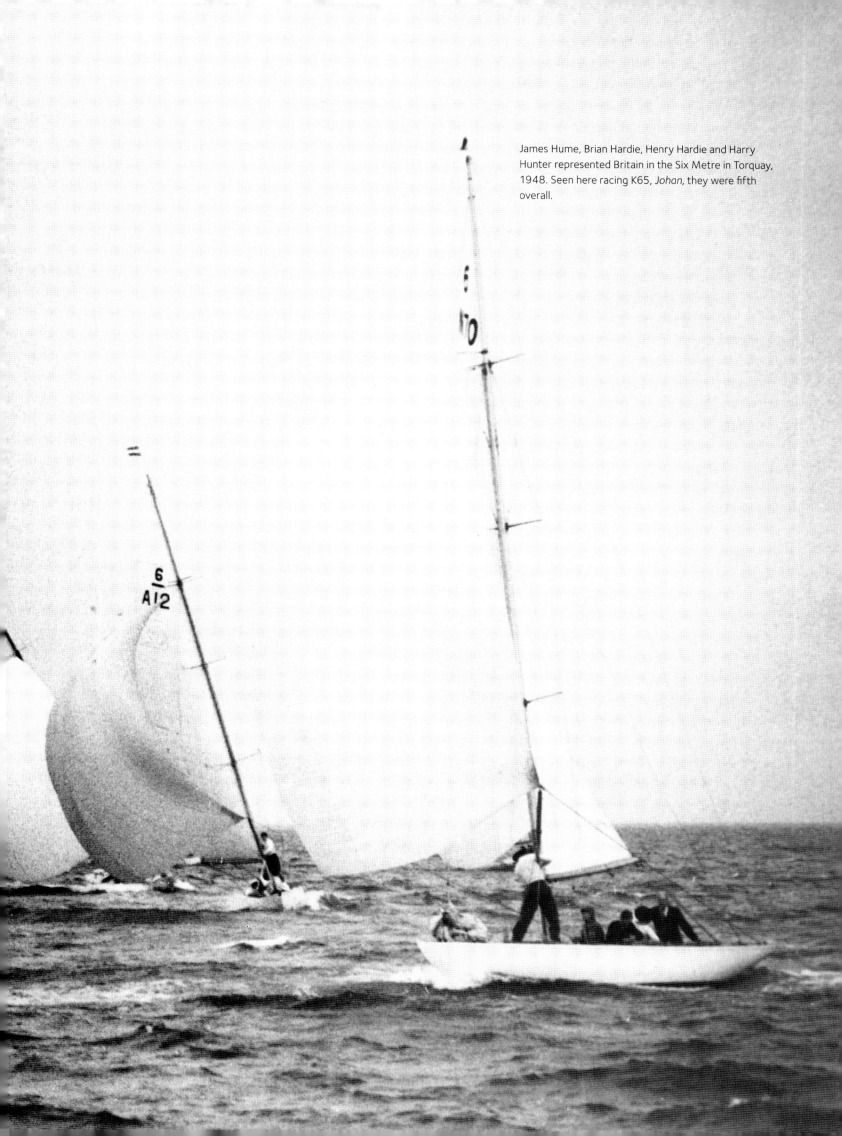

James Hume, Brian Hardie, Henry Hardie and Harry Hunter represented Britain in the Six Metre in Torquay, 1948. Seen here racing K65, *Johan*, they were fifth overall.

Above: Paul Elvstrøm stands in front of the scoreboard at the 1948 Olympics in Torquay – a scoreboard that he continues to dominate to this day, with an unmatched record of four consecutive gold medals.

It was 1948 before a bomb-scarred London hosted the next Olympics. The sailing was at the south-western seaside resort of Torquay, and the Six Metre was the last vestige of the pre-war supremacy of yacht racing. The new boats were much more accessible – the Firefly dinghy was sailed as a single-hander, and the Swallow and the Dragon joined the Star to complete the slate with small keelboats. All the classes sailed a seven race series, and for the first time the racing went upwind off the start line, sailing around what would soon become known as the Olympic triangle. It was a young Danish sailor who grabbed this new era by the throat and shook it till the gold medals dropped like apples off a tree – the time of Paul Elvstrøm had begun.

Elvstrøm won his first gold medal in 1948, after a shaky start followed by a steadily improving performance. It was four years later when he really turned the game on its head. The Firefly had been dropped in favour of a new design, the Finn, and Elvstrøm used the boat to redefine sailing. The legends have been told over and over – the hiking bench, the eight hours a day of training, the secret addition of boat-speed enhancing gear. Paul Elvstrøm brought an intensity and an innovativeness to the sport that no one

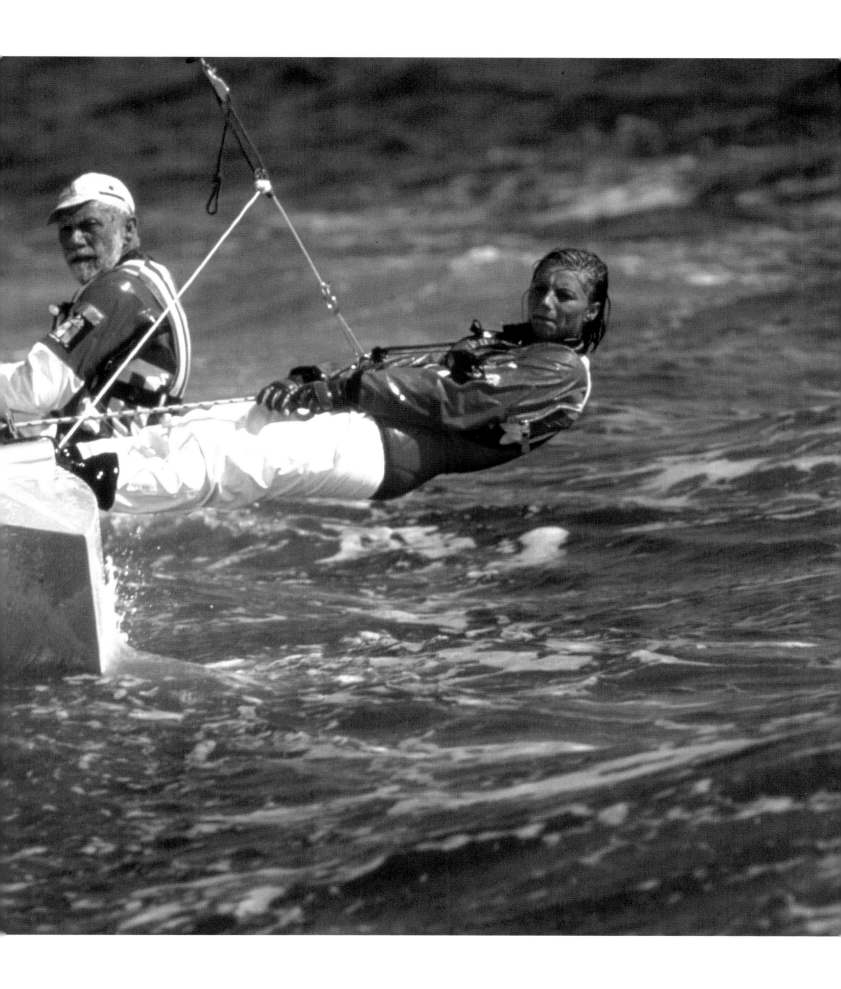

had seen before. He swept all before him for the next 12 years, the first Olympic athlete in any discipline to win four consecutive gold medals, and still one of only four men to achieve the feat in any sport.

The Dane's long shadow has been cast over every Olympic Games since he completed his run in 1960, not least because Elvstrøm himself was competing as late as 1988 at the age of 60. He just missed bronze twice in his last four appearances. The enormity of Elvstrøm's legacy has meant that it's taken over fifty years before anyone has got even close to matching or breaking his record. But the age of Elvstrøm is passing – we are into a new era, and a new hero now stands ready to take the mantle. Ben Ainslie already has a silver medal from Atlanta in 1996, and three consecutive gold medals from the Laser in Sydney 2000, and the Finn in Athens 2004 and Beijing 2008. If he wins again in Weymouth in 2012, he will surpass Elvstrøm and stamp his name even more definitively on this new Olympic epoch.

The most distinctive feature of the new era is that it's professional, and the sponsors' logos mark the transition very clearly in the images. But getting paid has always been a part of sailboat racing, even if it hasn't been a part of Olympic sailing for very long. Before the Second World War the sport was dominated by paid hands on boats from the Six Metre to the J Class yachts that contested the America's Cup, but the amateur ethos of the Olympics meant that those

paid hands could never compete for medals. The war broke that model – there was no money and little will to go back to the epic scale of J Class racing with huge professional crews. Sailing fell back to being a thoroughly amateur affair, even as it became more accessible – new building techniques began to lower the financial threshold for participation and cheaply built dinghies like the Firefly, the Optimist and the Mirror flooded onto the market.

Those two trends had to clash, and the result was as inevitable as it was in many other sports. Sailing had swept up hundreds of thousands of new enthusiastic participants in the post-war era, and the only way many of them could afford to compete at the highest level was if someone else paid for it. Amateurism was finally washed away in 1988, when the door to the Olympics was unlocked for professional sailors. Competition in the Games was no longer just an option for those who could afford it. Now the gold and the glory were there for anyone who was good enough to grab them, provided they could persuade a sponsor that it was worth it…

So, not quite open to the whole world, but other changes have subsequently helped; the introduction of new era boats like the one-design Laser, and women-only events. In retrospect, 1988 was a transitional moment for the sport. The 1987 America's Cup in Fremantle and the 1989–90 Whitbread Round the World Race had both ushered back in a new era of

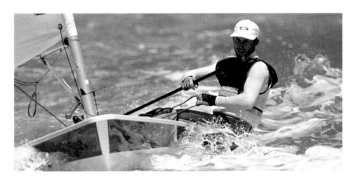

Top: Britain's Ben Ainslie sails to a silver medal in Atlanta in 1996, beaten to gold by Brazil's Robert Scheidt. Ainslie won gold in the next three Olympiads and is now challenging Paul Elvstrøm's record, trying for a fourth in Weymouth in 2012.

Right: Ben Ainslie and Brazil's Robert Scheidt battled for gold once again in Sydney in 2000, and this time Ainslie won. Otherwise, it would be Scheidt challenging for Elvstrøm's record in 2012.

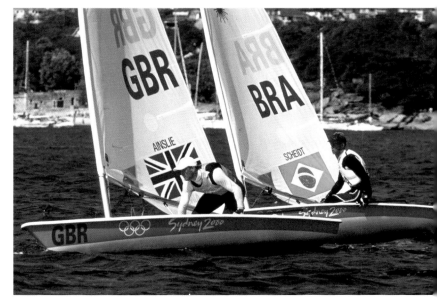

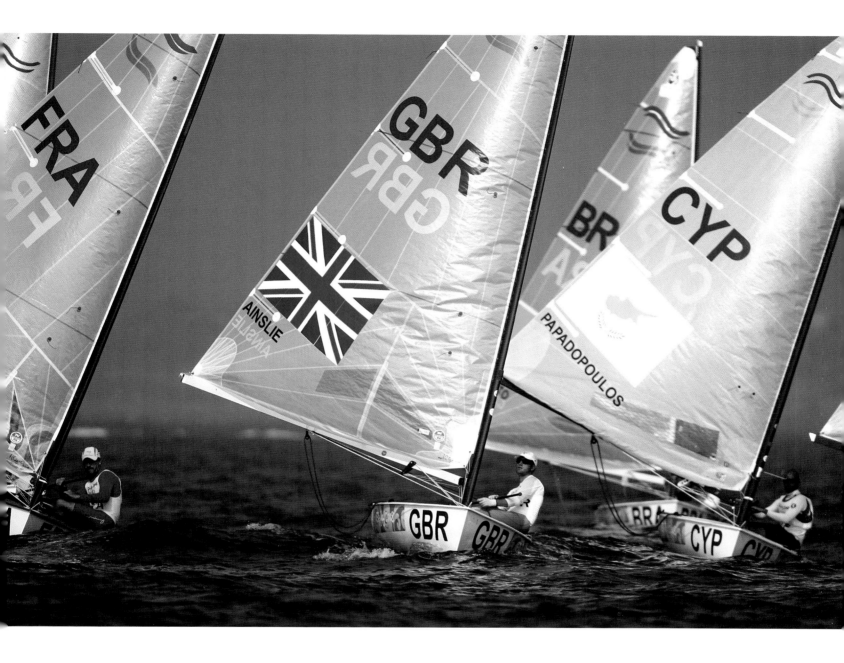

professionalism in big boat sailing. The change in the Olympic rules allowed those newly professional sailors access to the Games, and many of them prospered.

If Paul Elvstrøm was the ultimate amateur Olympian, funding his campaigns entirely from the proceeds of his house-building business, then Ben Ainslie is the consummate Olympic sailing professional. The sponsorship deals have helped to buy the Aston Martin and the beautiful home, but they've also paid for the long hours of training, and the endless search and research for a tiny edge in boat speed. Different eras, different sailors, but two great Olympians, both utterly dominant in the same boat, half a century apart. At the 2012 Games the sailing world will see if Ben Ainslie can grab the baton, seal his ownership of the new professional era, and write his own history as sailing's greatest ever Olympian.

Above: Ben Ainslie leads the Finn fleet to his third gold medal in Qingdao, 2008.

Overleaf: Ben Ainslie celebrates his second gold medal at Athens in 2004.

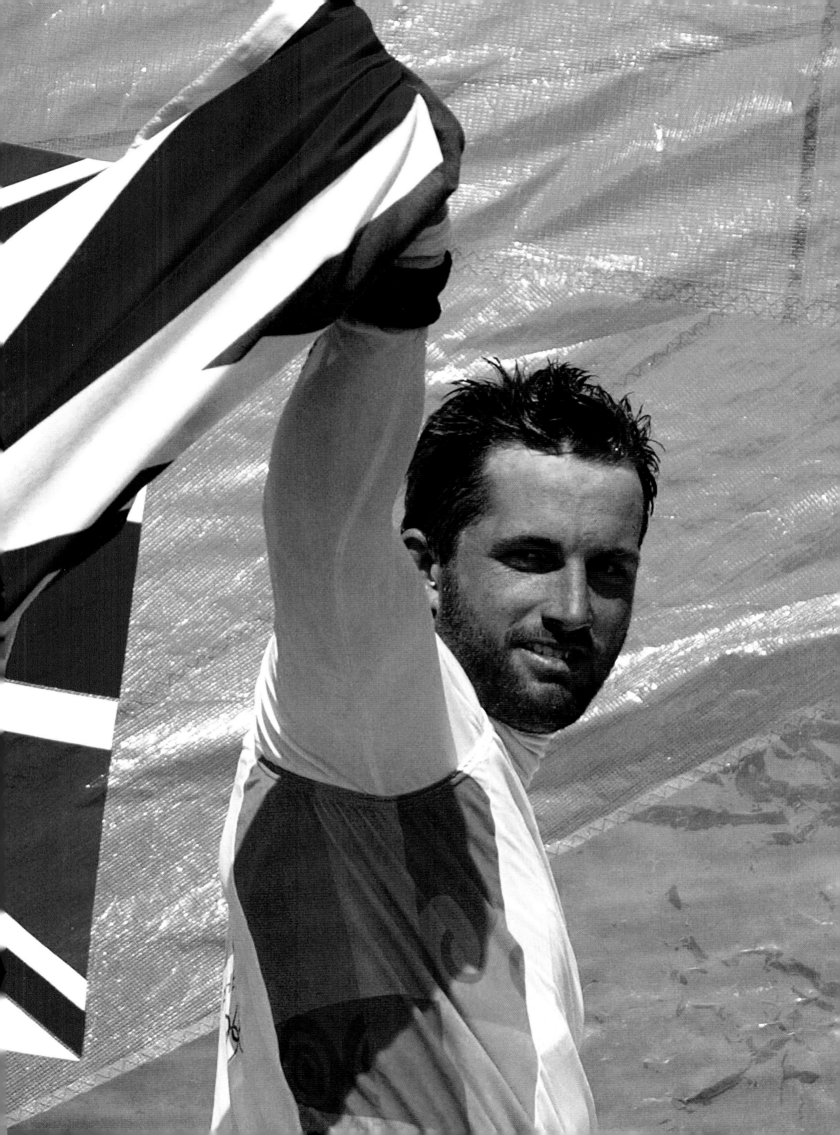

Origins

IT ALL BEGAN IN 1894, at a conference on international sport in Paris. One of the attendees, a French aristocrat by the name of Baron Pierre de Coubertin, had a bee in his bonnet about reviving the Olympic Games of Ancient Greece. There was widespread indifference, both at the conference and afterwards – even Athens initially wanted nothing to do with the idea, refusing to cooperate. But somehow the enthusiasm of de Coubertin and a handful of collaborators ensured that the Games returned to the land of their birth just two years later, in 1896.

By 2004, when Athens hosted the modern Games for a second time, sailing was a well established Olympic event. But things had not gone so smoothly for the sport the first time around. There's evidence in the records that a regatta was planned, but it never actually happened. So it was 1900 and Paris before yacht racing properly joined the quadrennial cycle of the Olympic movement and awarded some medals. The European elite – including a scion of the French banking empire, Édouard Alphonse James de Rothschild – took to the River Seine at two venues. The first was at the mouth, La Manche, near Le Havre, and it was used for the bigger yachts in two classes of 10–20 Ton and over 20 Tons – the rating being determined (unsurprisingly) by the French system. The second venue was for the smaller boats, in five classes, set more problematically at Meulan, about 30km downstream

The headquarters of the International Olympic Committee in Lausanne, Switzerland.

The first Olympic sailing medals were competed for on the River Seine at the 1900 Paris Olympics.

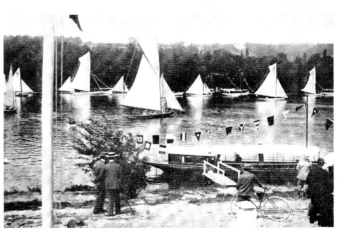

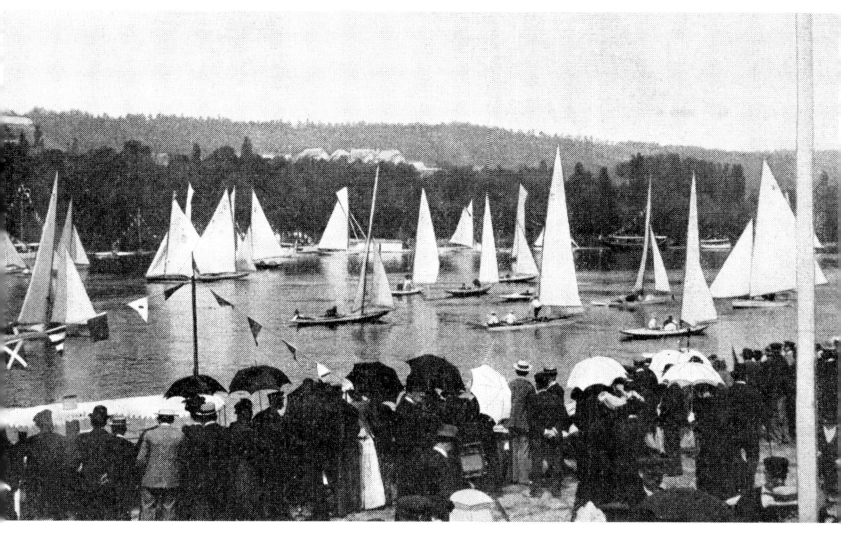

The sailing at the 1900 Paris Olympics drew a good crowd of spectators to the venue at Meulan, about 30km downstream from Paris on the River Seine.

Below: An official poster from the 1900 Olympics, now on display in the museum at the International Olympic Committee Headquarters in Lausanne.

from Paris. It's a modern preoccupation that Olympic racing is being brought too close to the shore, with too much emphasis being put on a single, final medal race, distorting the fairness and therefore the purity of the sport. These are not complaints that those pioneers would have recognised.

Ian Buchanan, first president of the International Society of Olympic Historians, trawled through the records to discover that more than 49 boats entered an open class race – or Concours d'Honneur – at Meulan. The absence of any wind left only seven finishers, and two of those were disqualified for the not unreasonable fact that they used an alternative means of propulsion to sailing. The yachts were split into

Above: Twelve Metre yachts like this one (*Copeja*) raced in the 1908, 1912 and 1920 Olympic Games – but the boats really became famous as the America's Cup class after the Second World War.

Right: The Six Metre yachts *Bissibi* (Sweden) and *Gallant* (US) race at the Los Angeles Olympics in 1932 – Sweden won gold, and the US won silver.

Overleaf: Paul Elvstrøm sailing to gold in the Firefly class at Torquay in 1948.

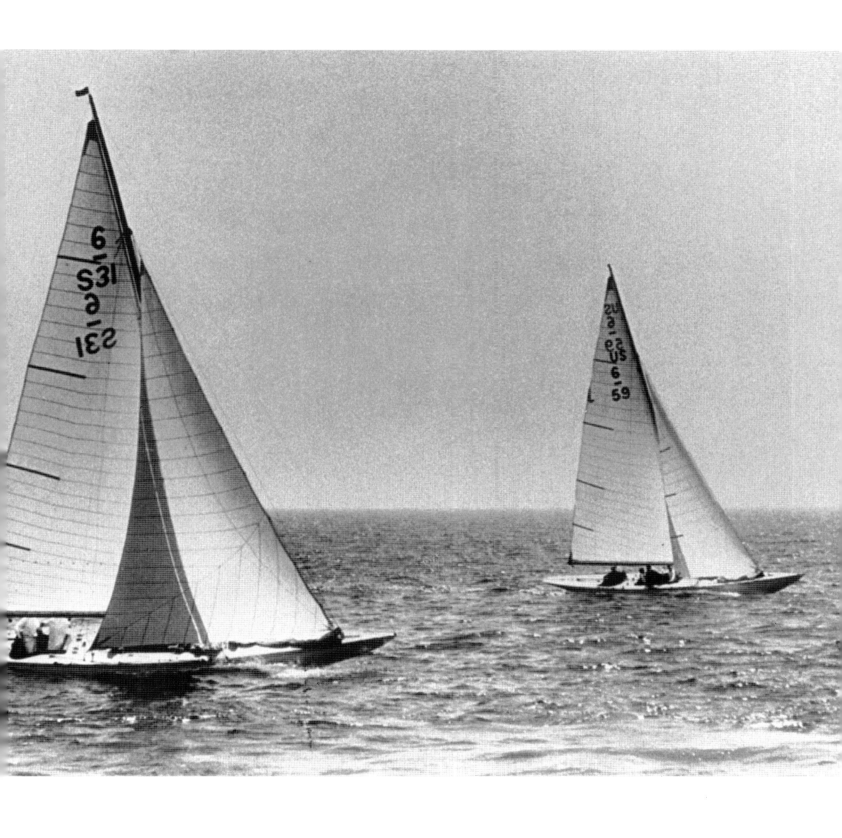

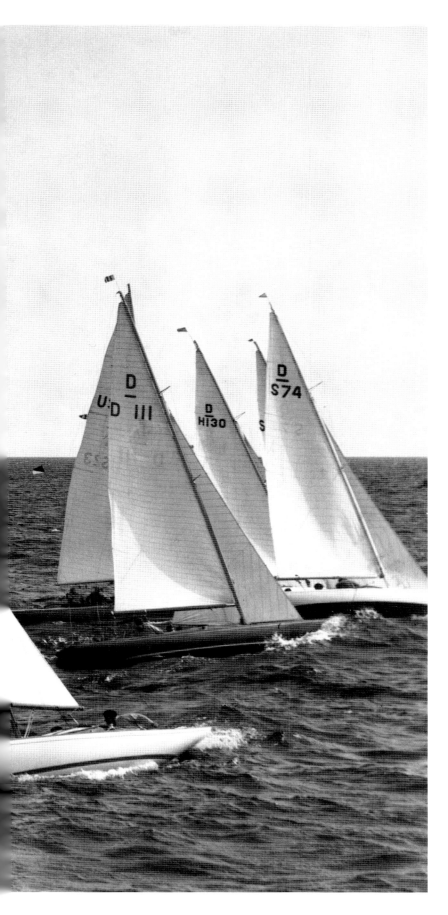

classes on subsequent days, but things didn't get a whole lot better, with a contemporary account from *Yachting World* recording, 'The river was absolutely blocked with vessels of all shapes, rigs and sizes, and it became exceedingly difficult to keep clear of each other… at the turning mark every boat was huddled up together.' The latter part might be a description of a mid-fleet mark-rounding at a modern ISAF Sailing World Cup.

If the first Olympic regatta on the Seine sounds a muddle, then it was, but this was before the International Yacht Racing Union (now the International Sailing Federation) was so much as a glimmer in anyone's eye. In 1900 there were no internationally recognised rules for the competition. Things did not improve in 1904, when the Games were held in St Louis. The Mississippi wasn't a good location for yacht racing, but the idea of holding the sailing competition distant to the main Games had not yet taken root, and so the sport was

Left: The Dragon class prepare for their start at the Helsinki Olympics in 1952.

Below: The Italian Star class team at Torquay in 1948: Agostino Straulino (left) and Nicolò Rode. They finished fifth, but went on to win gold in 1952 and silver in 1956.

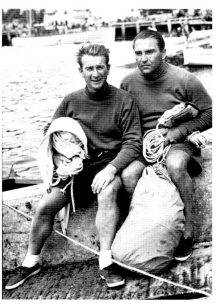

dropped from the event. It was 1908 when yacht racing reappeared and, inspired partly by the rather shambolic affair in 1900, a lot of work had been done in the interim to try and put the regatta on a more solid foundation.

The work started with Major Brooke Heckstall-Smith, secretary of the British organising authority, the Yacht Racing Association (or YRA), writing to the Yacht Club de France. Brooke Heckstall-Smith wanted to develop an international rule of yacht measurement, and to that end he organised two conferences in London in 1906. They led to the Metre Rule, which uses a mathematical formula to define a set of design parameters for yachts of different sizes, the idea being that the resulting boats should be reasonably equal in speed. The rule is still in use today, and its most famous application is probably the Twelve Metre class that raced for the America's Cup from the 1950s to 1987.

The good Major wasn't satisfied with that though, and everyone was roped up for a further meeting in Paris in October 1907, at which the International Yacht Racing Union was formed. The Union codified a set of rules for sailing races based on those of the YRA, and while it wasn't quite as international then as it is now, with a purely European membership, it was a start (the North Americans continued to do their own thing until an effective merger in 1929). The sailing events of the 1908 London Olympic Games were held at two venues: Ryde on the Isle of Wight and on the Firth of Clyde. But they had a recognisable rules structure, and a recognisable slate of boats, three of which are still raced today – the Six Metre, Eight Metre and Twelve Metre. The fate of the other two was rooted in that first Olympics – not a single Fifteen Metre and only one Seven Metre came to the start line. But the others went on, and became the first of many legendary Olympic classes. We had a beginning.

A rare aerial image of the Six Metre class racing off Torquay during the 1948 Olympics.

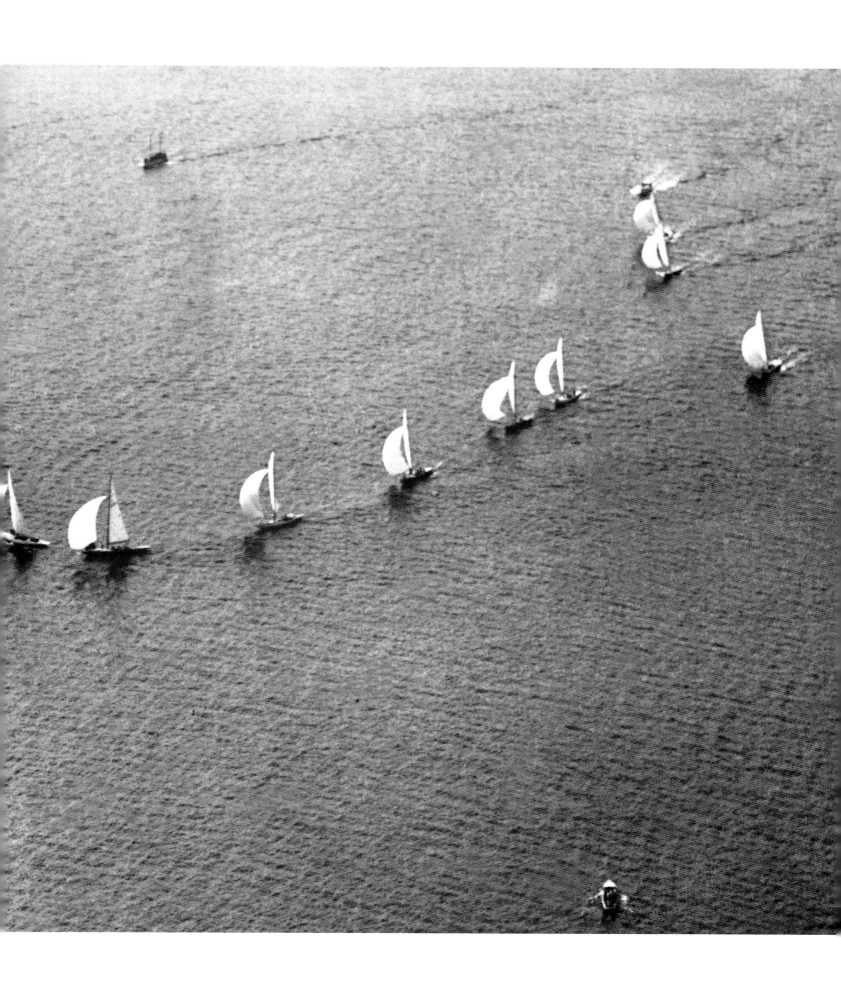

The Struggle

THE QUADRENNIAL CYCLE of the Olympic Games is the source of much of their mystique and drama. World Championships come around every year, but the Olympics only take place once every four years. The opportunity for victory is that much rarer and therefore the prize so much greater – and that's why the handful of men and women who win more than one Olympic gold are so special. But for many people, just getting to the Olympic Games was struggle enough, and some incredibly talented sailors never quite made it.

The reasons for missing out are all too numerous, with politics, injury and selection the most frequent. Looking at politics and the boycotts of 1980 and 1984, it's the first that dominates our thinking in the west.

In 1979 Soviet Russia invaded Afghanistan, and the US inspired an unevenly followed boycott of the 1980 Moscow Games. The idea was nothing new: 28 countries had missed the Montreal Games in 1976, after the IOC refused to ban New Zealand as punishment for the All Blacks' rugby tour of South Africa. Officially, 80 countries turned up in Moscow – a drop of a third from the 121 in Munich in 1972.

The US, Japan and West Germany were the main absent medal contenders, but the Australian, British, Canadian and French sailing federations also declined to send teams. It left a bitter generation of sailors stuck at home, many watching the celebrations as compatriots in other sports won gold. Perhaps the most notable casualties were Dave Ullman and Tom Lindskey of

Left: The British coach, Jim Saltonstall (second from right) holds the 1984 Yachtsman of the Year trophy, which he won with the Royal Yachting Association's Youth Team. But although the three young sailors with him (left to right) – Jason Belben, Andy Hemmings and Stuart Childerley – all won Youth World Championship titles, they struggled at Olympic level. Belben and Hemmings were fifteenth in the 470 in 1988, while Childerley was fourth in the Finn in both 1988 and 1992.

Opposite: Despite twice winning the World Championship in the Olympic Finn class, Cam Lewis missed out on the chance of an Olympic medal in the US's 1980 boycott of the Moscow Games. Lewis went on to great things elsewhere in the sport, sailing on Dennis Connor's victorious *Stars and Stripes* catamaran in the 1988 America's Cup, and then aboard *Commodore Explorer* in 1993, when she broke the mythical 80-day barrier for a circumnavigation of the planet.

Opposite: The Olympic classes have always raced at many other international regattas; in this case, it's a 49er at the French Olympic Sailing Week in Hyères. In recent years this has been formalised into a circuit called the ISAF Sailing World Cup.

Below: The 470 class has a long history of world champions that didn't make it to the Olympics. In 1984 Peter Evans and Sean Reeves (in the picture) beat the three-times and reigning world champions, David Barnes and Hamish Wilcox, for selection to the New Zealand team. Evans and Reeves came 14th in Los Angeles.

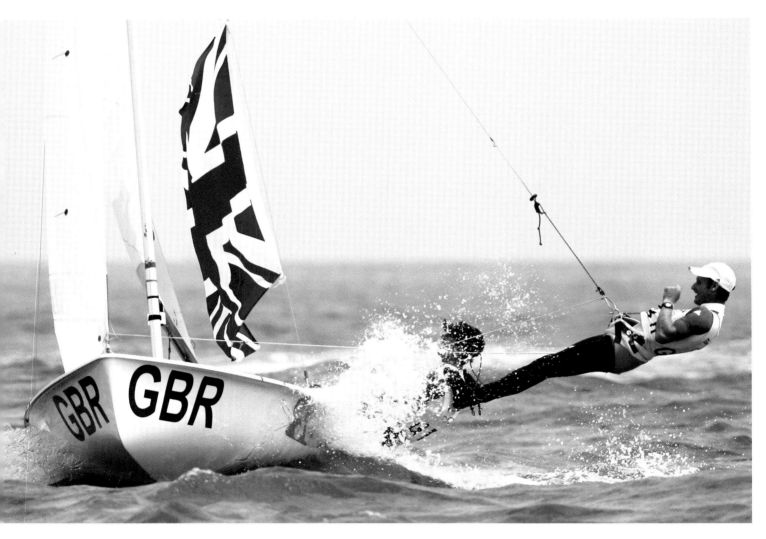

Above: Britain's Nick Rogers and Joe Glanfield were 470 sailors that did make it to the Games – keeping out British double world champions Nic Asher and Elliot Willis. Rogers and Glanfield scored a fourth in 2000, then won silver in 2004 and 2008.

Right: Sometimes it's a struggle just staying on the boat – the 49er sailors faced some epic conditions in Qingdao, 2008.

the US, who won the 470 World Championships in 1977, 1978 and 1980, and were then forced to miss the Games. They followed that up by losing out to Steve Benjamin and Chris Steinfeld for selection in 1984 (Benjamin and Steinfeld went on to win silver). The Soviets pulled a tit-for-tat boycott in 1984 and 14 countries withdrew, this time leaving many notable Eastern-bloc sailors high and dry.

The one spot available to each country for each Olympic discipline has probably led to more omission of talent from the Games than any other single cause. The 470 class is a leader in this field. If Dave Ullman and Tom Lindskey's experiences weren't bad enough, also sidelined from the 1984 Games were the Kiwi pair

of David Barnes and Hamish Wilcox, winners of three of the four World Championships between 1981 and 1984. Along with America's Cup legends Chris Dickson and Murray Jones, they were beaten for selection to the New Zealand Olympic team by Peter Evans and Sean Reeves, who eventually came 14th in Los Angeles. It must rank as one of the least successful selections of all time, given that at the 470 World Championships a few months before the 1984 Games, New Zealand's sailors had filled all three podium places.

Inevitably, the struggle doesn't stop when you reach the Games, and a simple injury can put paid to years of hard work. The Canadian sailboard competitor in 1992 was Murray McCaig, ranked second in the world

Alan Warren (left) and David Hunt came desperately close to gold in the Tempest class in Kiel in 1972, but had to settle for silver. They went to Montreal for the 1976 Games with unfinished business in mind, but damage to their boat (called *Gift Horse*) in transit left them slow, and they finished 14th. They decided to put the lame horse down and set fire to her after the end of the last race (above). Officials were not amused.

Opposite top: Kevin Curtis was one of the early stars of Paralympic sailing, winning the World Championships in Barcelona, held at the same time as the 1992 Paralympics.

Opposite below: Tony Downs, Andy Cassell and Kevin Curtis won gold in the Sonar class at the 1996 Paralympics. The demonstration event was the first time sailing had appeared at the Paralympic Games, and led to its full introduction in Sydney in 2000.

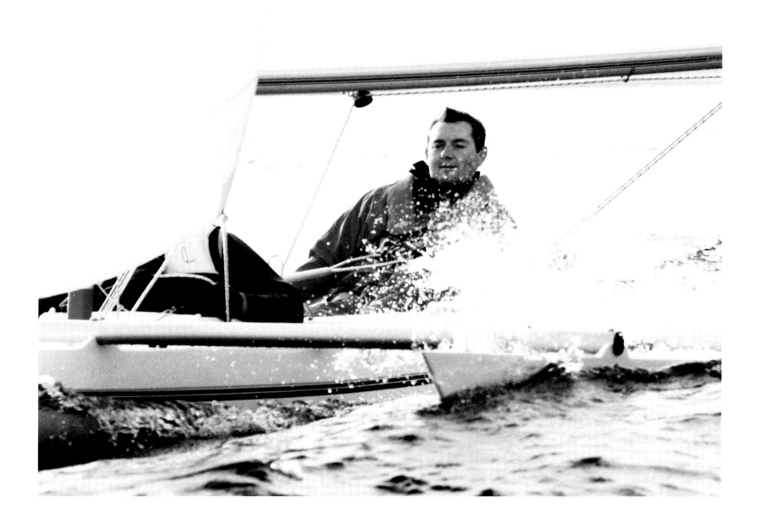

ahead of the event. Just a day before the regatta started, he collided with a police car while cycling through the Olympic Village, broke his leg and was out of the competition. McCaig wasn't finished and went on to win a gold medal at the 1994 Goodwill Games in Russia, and bronze at the 1995 Pan Am Games in Argentina. But he never made it back to the Olympics, missing out on qualifying after finishing second at Canada's Olympic Trials for 1996.

We shouldn't forget that even those who are successful have had to struggle. One of the planet's most famous sailors, four-times America's Cup winner Russell Coutts, sailed through the pain from salt-aggravated boils to win the Finn gold in 1984. He

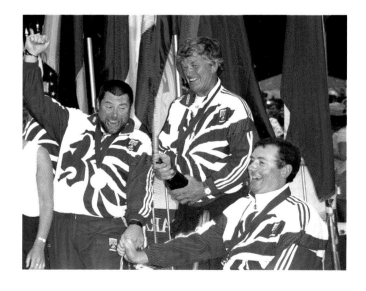

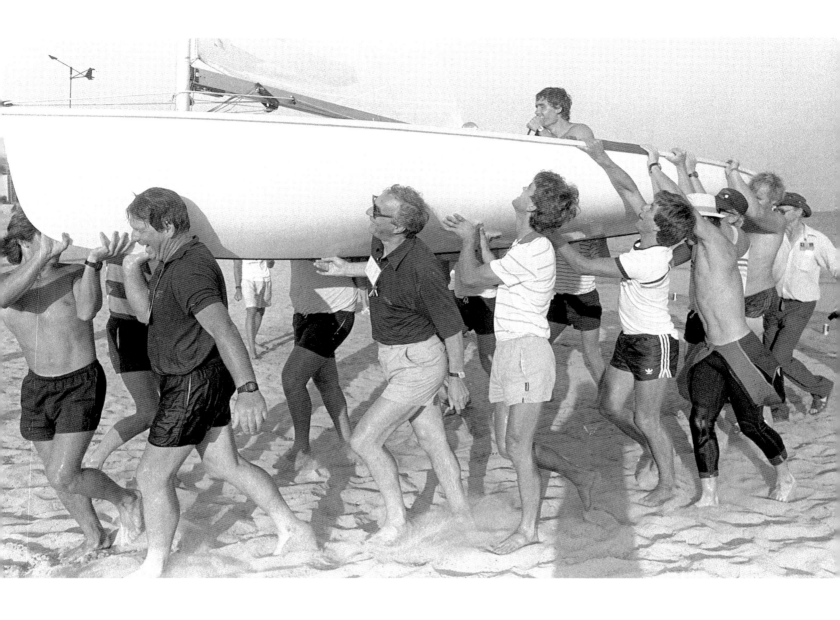

was less fortunate in 1992, when he represented New
Zealand in the Soling. The class started the regatta
with fleet racing, and when it was finished the top
ranked boats then settled the medals in a match racing
contest. Coutts had already begun his domination of
the world match race rankings, and was rightly feared
in the second stage of the competition. So the rest of
the fleet made sure he didn't even make it through to
the medal contest, and one of the greatest sailors of
the modern era went home from his second Olympics
empty-handed.

But if there is one story that epitomises all that
is best about the Olympic struggle, it belongs to
the extraordinary Nick Scandone and Maureen

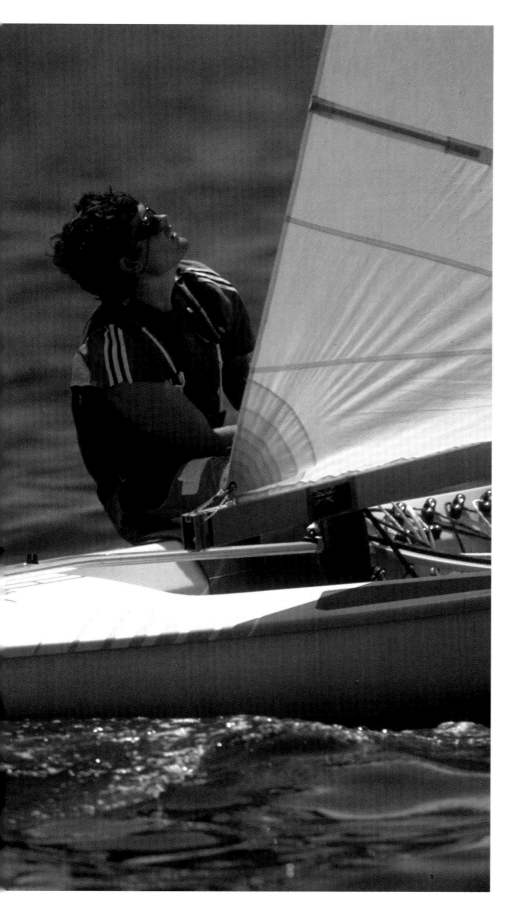

Opposite: New Zealand's Russell Coutts is lifted ashore still aboard his Finn. He overcame the pain and distraction of salt-aggravated boils to win gold in 1984.

Opposite bottom: Chris Law's Olympic career typifies the struggle – he won the Finn World Championships in 1976, and then didn't go because David Howlett was selected to the British team instead. He did qualify in 1980, but couldn't go because of the Royal Yachting Association's boycott. He finally qualified and attended in 1984, but came fourth in the Soling.

Left: Russell Coutts sails to Finn gold in 1984 – he faced a greater struggle in the Soling eight years later, not making it to the final match racing rounds that he was expected to dominate.

New Zealand's Aaron McIntosh reflects on every Olympic athlete's nightmare – fourth place. But four years later McIntosh went one better and picked up bronze in the windsurfing in Sydney.

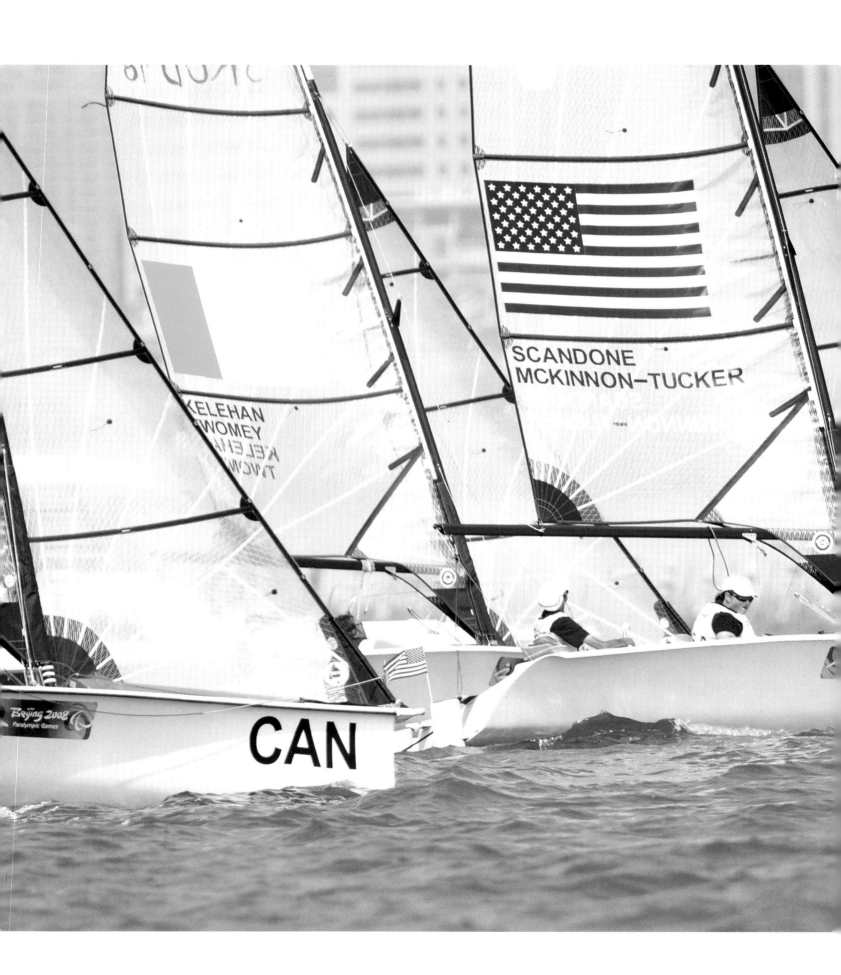

KELEHAN
SWOMEY

SCANDONE
MCKINNON–TUCKER

CAN

Beijing 2008
Paralympic Games

McKinnon-Tucker of the United States. Scandone was a top college and 470 sailor. He was North American champion in the boat in 1991, and narrowly missed selection to the US team for the 1992 Olympic Games. A decade later he was diagnosed with the degenerative disease ALS, with a prognosis for survival of just two to five years. Initially, Scandone sailed the 2.4mR, winning the open division at the World Championships in 2005, for which he was awarded the US Rolex Yachtsman of the Year. But by the time of the US trials for the 2008 Paralympics, the disease had tightened its grip to the point where he could no longer sail the 2.4mR alone.

Nick teamed up with Maureen McKinnon-Tucker, who had fallen off a sea wall and was paralysed from the waist down, and together they sailed the SKUD18. If illness itself were not enough to overcome, during the campaign Scandone lost his mother, and McKinnon-Tucker's two year old son was diagnosed and treated for a brain tumour. But Nick stayed alive long enough to light up not just the Paralympics with his courage, but all of sailing, all the way through to gold in Qingdao in 2008. Nick Scandone fought his disease just long enough to win his medal, and died early in 2009. A true Olympic hero.

Nick Scandone and Maureen McKinnon-Tucker won an incredibly courageous gold medal in the SKUD18 class in the 2008 Paralympic Games.

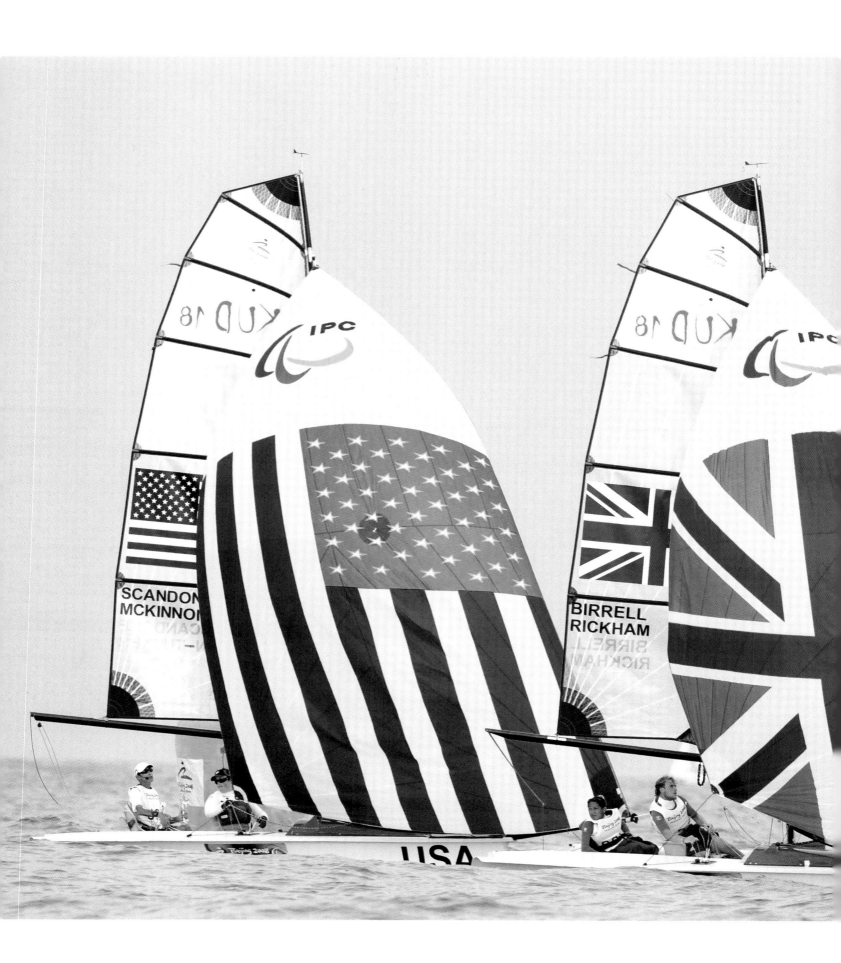

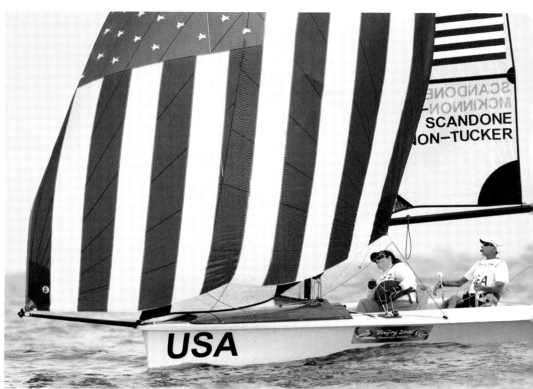

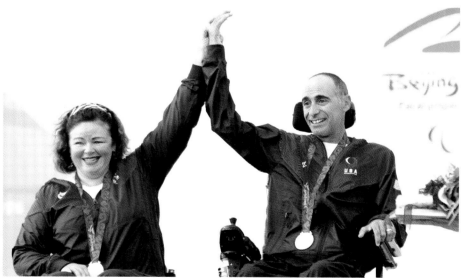

Left and top: Nick Scandone and Maureen McKinnon-Tucker compete at the 2008 Paralympic Games in the SKUD18.

Above: Nick Scandone and Maureen McKinnon-Tucker receiving their gold medal in the SKUD18 class at the 2008 Paralympic Games.

Adam Beashel and Teague Czislowski won the Australian selection trials for the 49er for the 2000 Olympics in Sydney, but the Australian Yachting Federation (AYF) nominated Chris Nicholson and Daniel Phillips instead. Beashel and Czislowski appealed to the Court of Arbitration for Sport, which ordered the AYF to reconsider. The AYF did so, but again Nicholson and Phillips were selected and they went to the Games, but didn't win a medal. Beashel went on to happier times – seen here at the top of Emirates Team New Zealand's mast during the challenger series for the 2007 America's Cup, which the Kiwis eventually won.

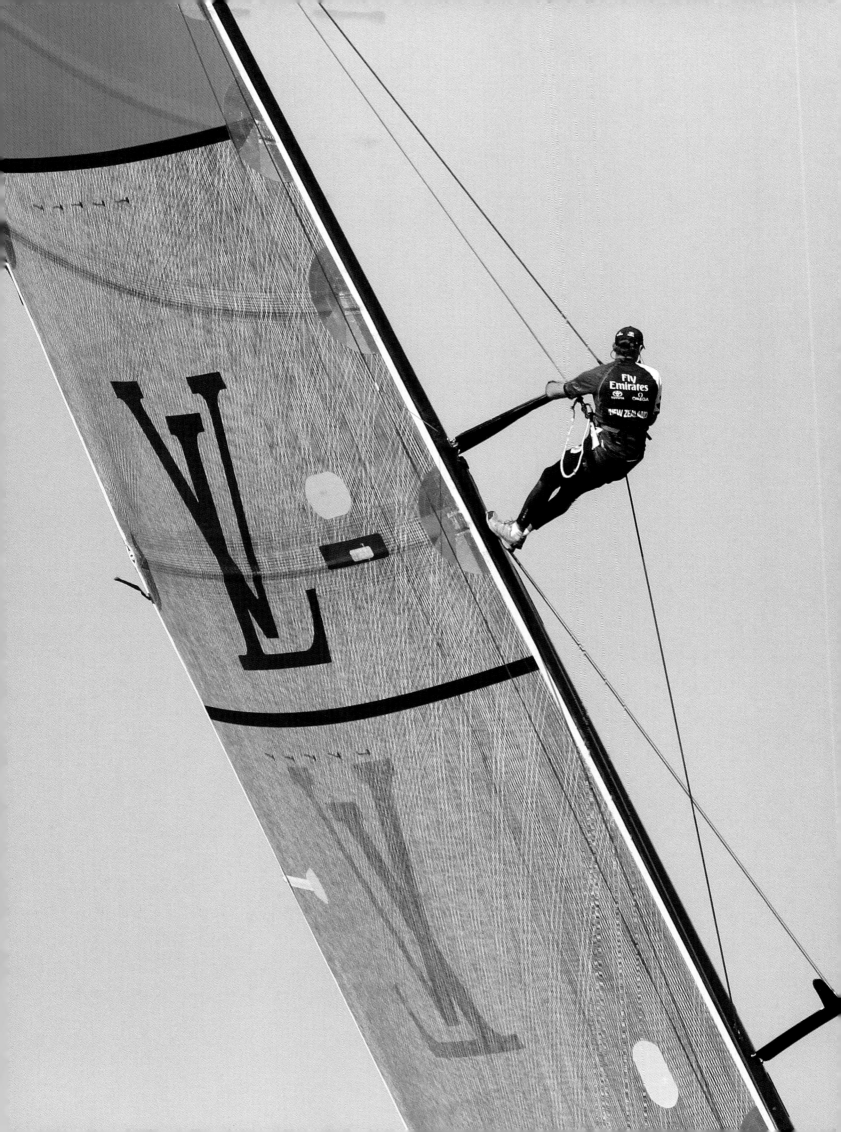

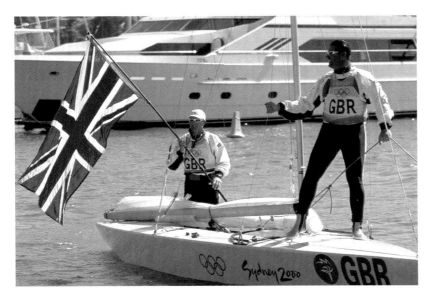

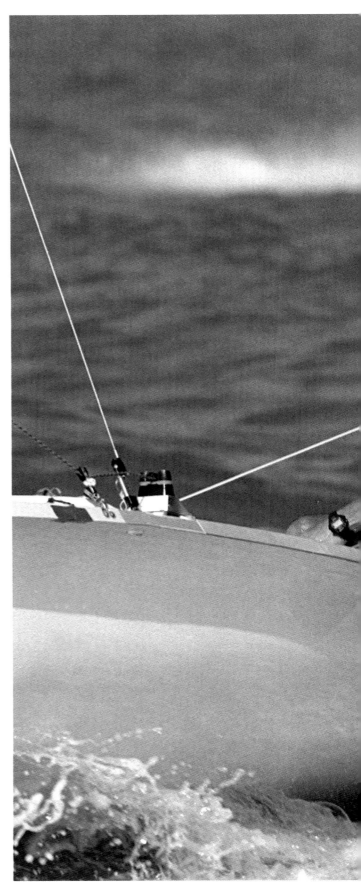

Top and right: Ian Walker and Mark Covell's Star silver medal at the Sydney Olympics was an emotionally charged moment (top). Both men had tragically lost their previous sailing partners. Ian Walker had won silver in the 470 in Atlanta in 1996 with John Merricks (right), who died in a road accident just over a year later. Mark Covell lost his Star helmsman, Glyn Charles, to the storm that hit the 1998 Sydney–Hobart Race.

Above: Australia's John Bertrand and the US's Dennis Conner most famously faced off in the 1983 America's Cup, when Bertrand led the Aussie team that finally ended a US winning streak of 132 years. Conner went on to recover the Cup for America four years later. Both men were less successful at the Olympics – Bertrand was fourth in the Finn in Kiel in 1972, but improved to pick up bronze four years later. Dennis Conner also won a bronze medal in Montreal in 1976, and his was in the two-man Tempest keelboat.

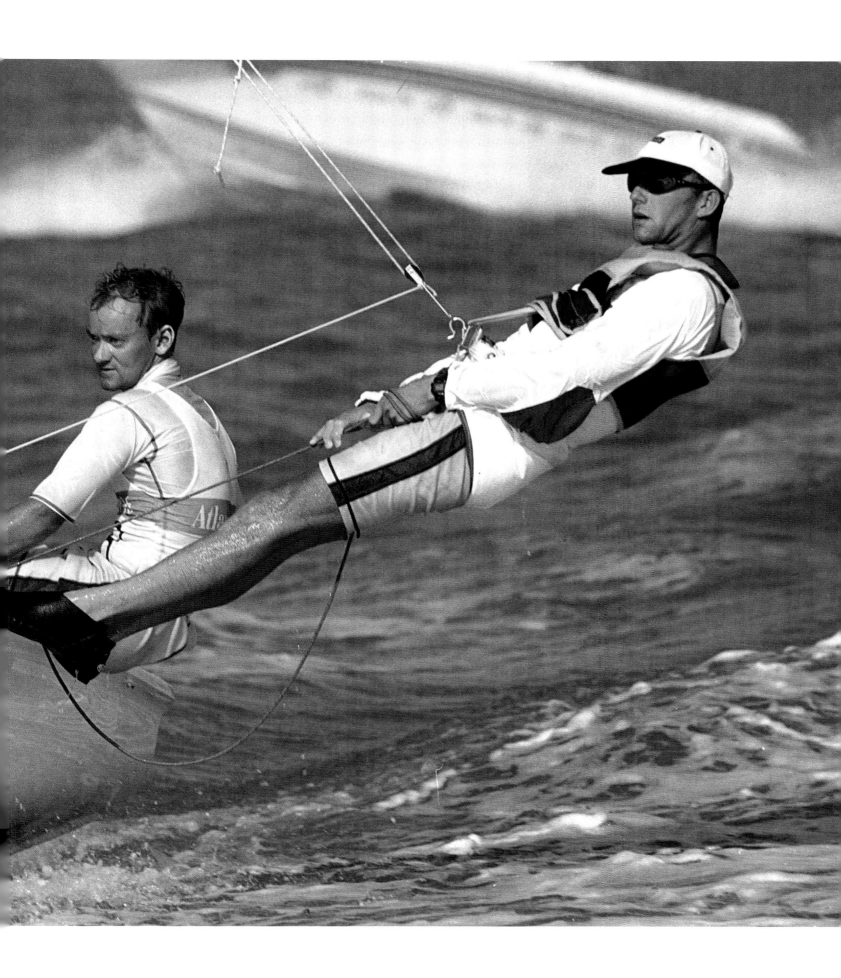

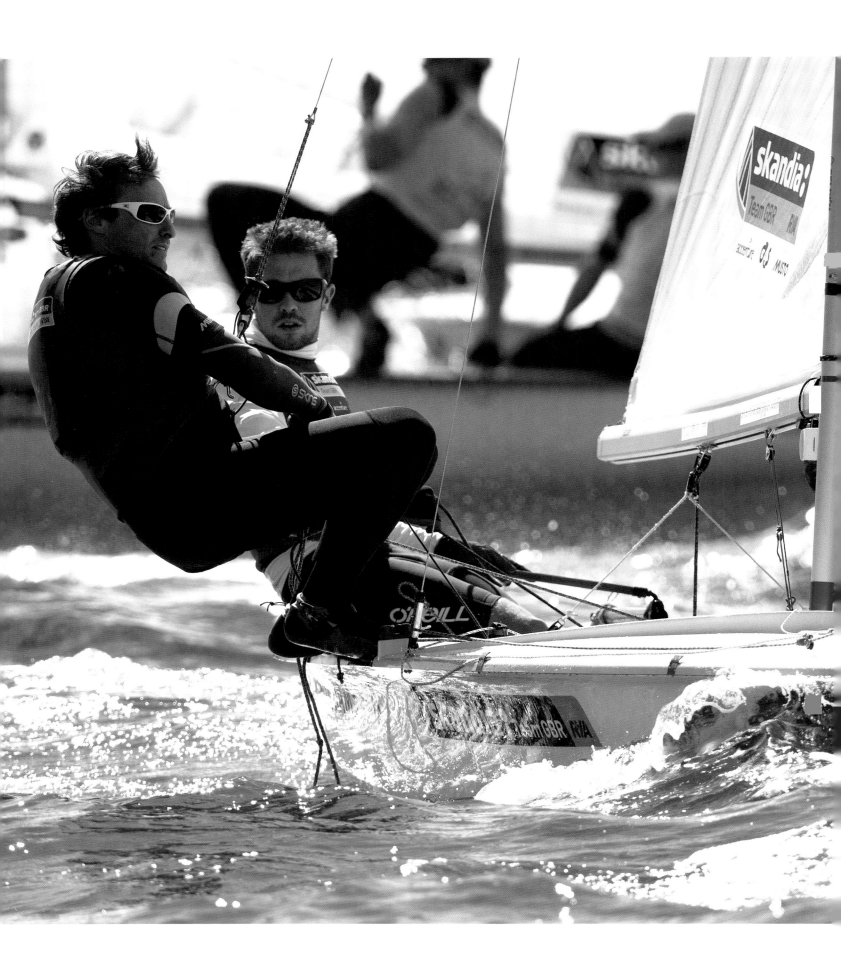

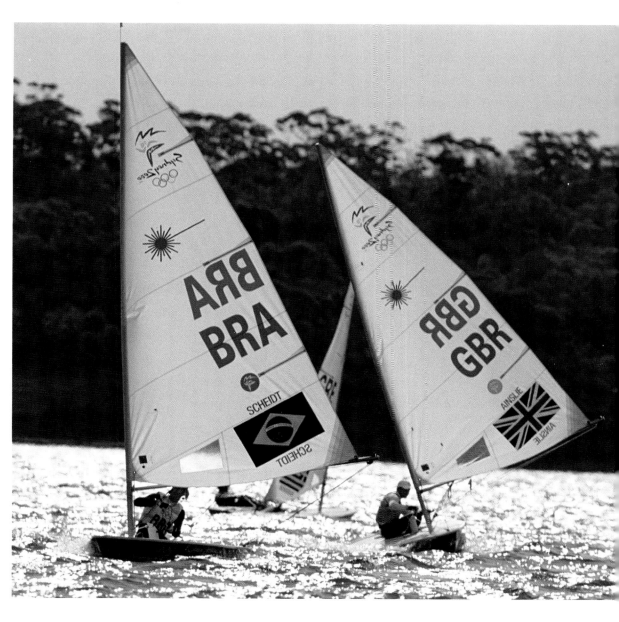

Above: Even the top guys lose sometimes – Robert Scheidt was famously beaten to gold by Ben Ainslie in Sydney in 2000.

Left: The British 470 sailors Nic Asher and Elliot Willis won two world titles in 2006 and 2008, but didn't get selected for the 2008 Olympics. They will be hoping to rectify that in 2012. The New Zealand team of David Barnes and Hamish Willcox, and the Americans Dave Ullman and Tom Lindskey, both won three 470 world titles, and never made it to the Games.

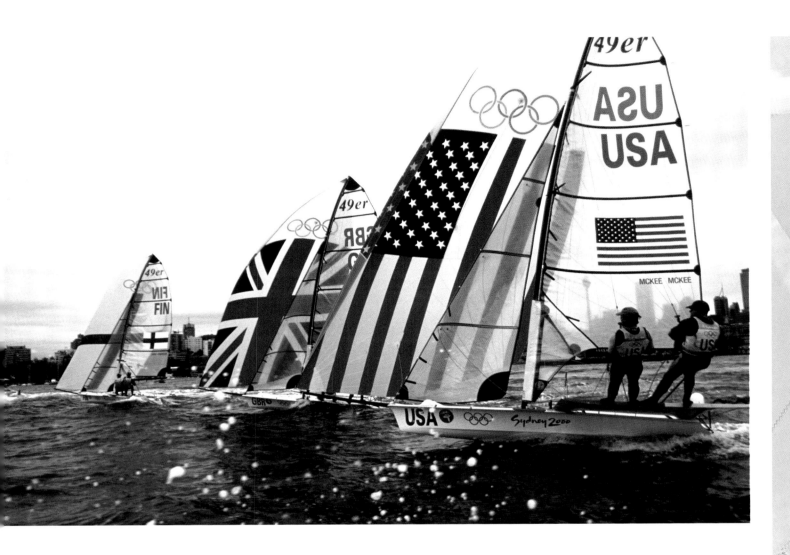

Above: The McKee brothers had already found Olympic success separately: Jonathan won gold in the FD in 1984, and younger brother Charlie won bronze in the 470 four years later. They then teamed up (at the ages of 40 and 38) to race the 49er in Sydney in 2000 – and came away with a bronze medal each.

Opposite: Another one for the never-give-up files: Paul Foerster already had two silver medals when (at the age of 40) he teamed up with Kevin Burnham for a shot at the Athens Olympics. Burnham had also already won silver in the 470 class – way back in 1992 with Morgan Reeser. He was 47 when he went one better with Foerster and took gold in 2004.

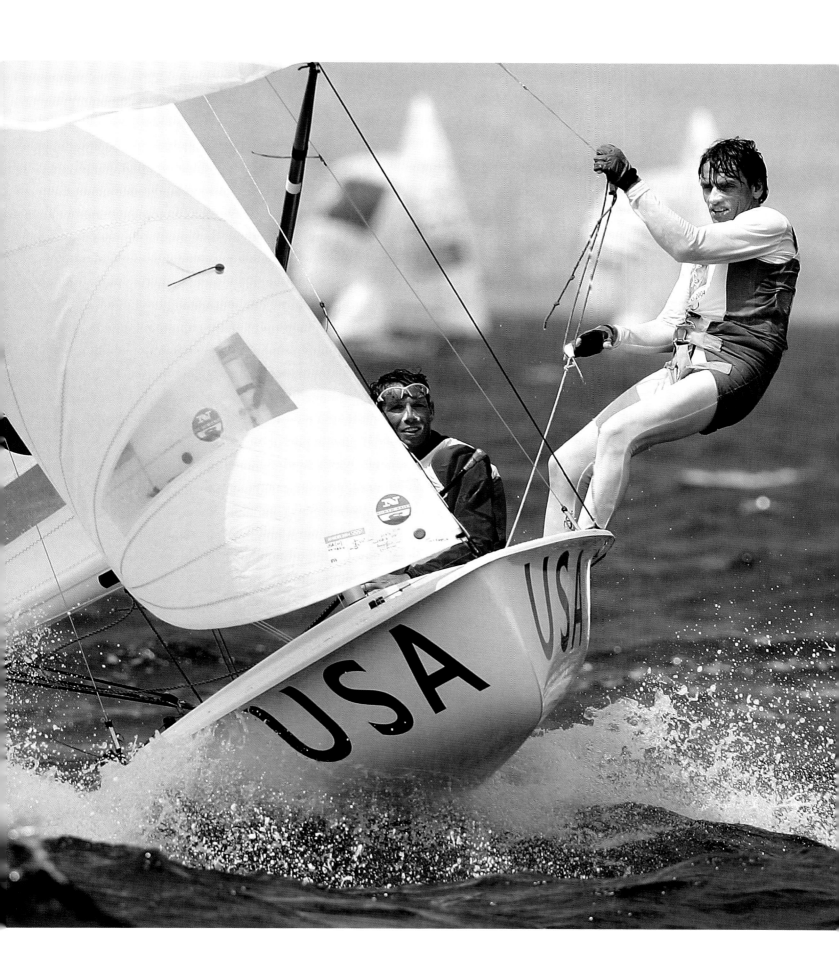

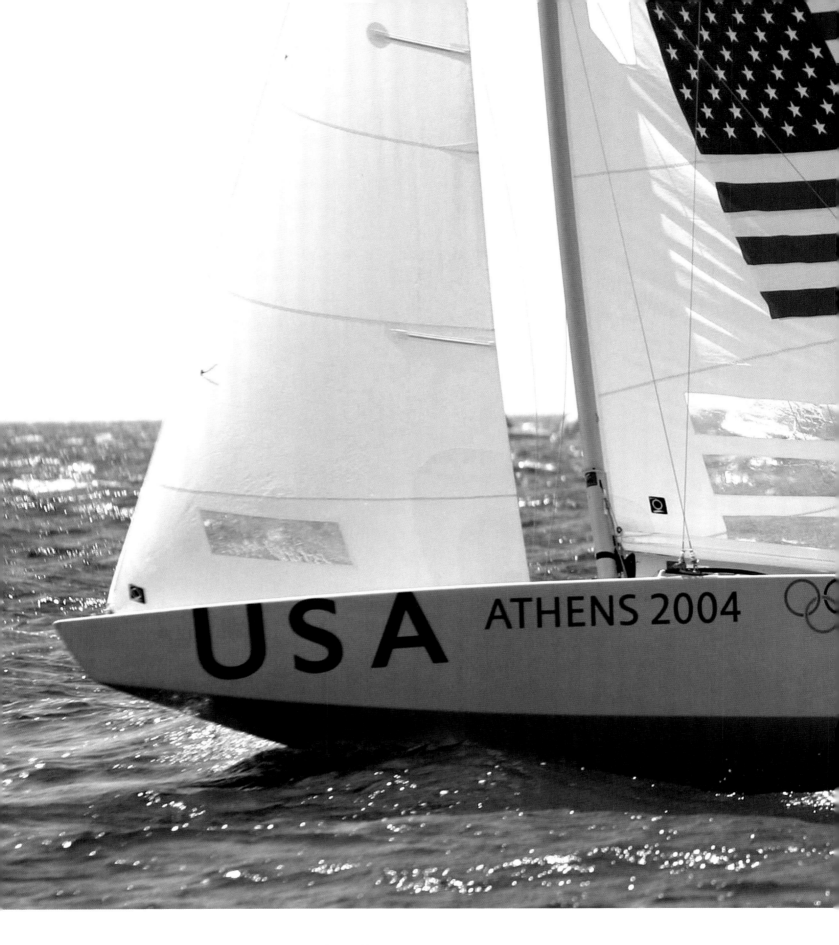

Paul Cayard's glittering professional sailing career includes notable success in the America's Cup and the Volvo Ocean Race, not to mention a 1988 Star class World Championship. But the actual Olympics eluded him until the age of 45, when he qualified for the US team in the Star with Phil Trinter — they came fifth.

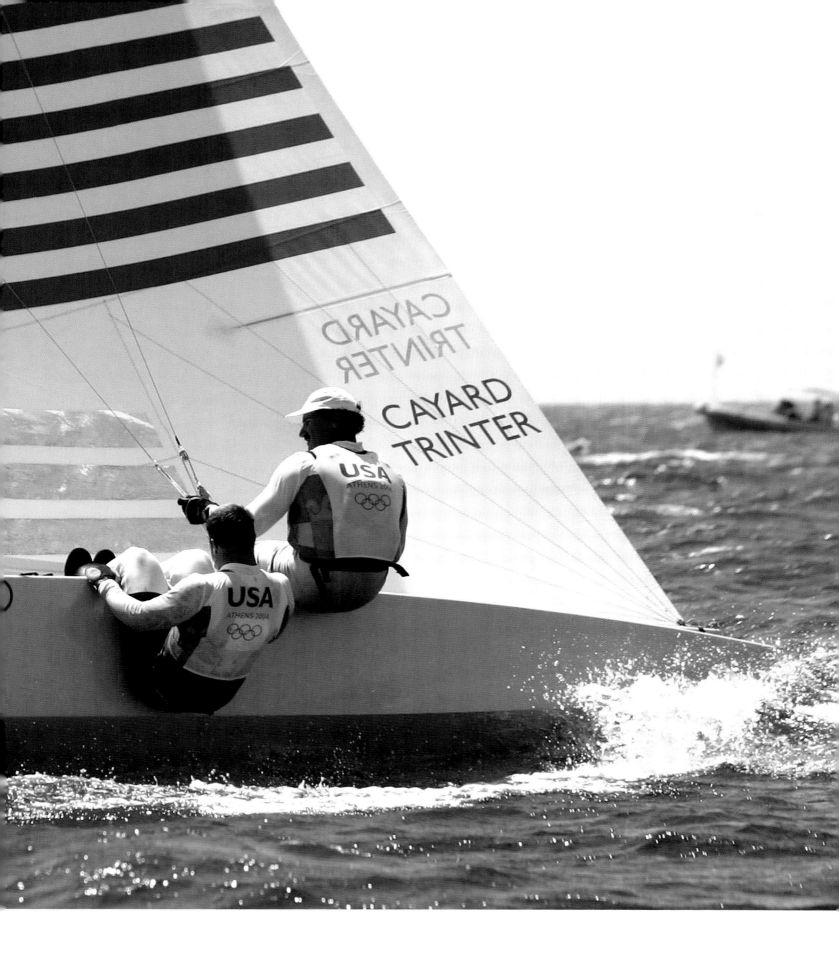

Legendary Classes

OLYMPIC SAILING emerged quickly from the choppy water of its origins as the newly developed International Rule boats established their pedigree. Two classes came to dominate this early era; the Eight Metre and Six Metre both appeared at every pre-war Olympics from 1908 onwards, and both are still being sailed and raced competitively today. The 1920s and 1930s were their peak, and they graced the world's ports and harbours with their classic looks and close racing. But nothing lasts forever, and the beginning of the end came in Depression-era Los Angeles in 1932. A low turn-out for both the Six Metre and Eight Metre started to resonate with complaints that the boats were now too expensive.

It was no coincidence that Los Angeles in 1932 saw the continued rise of the one design, and this was the year when perhaps the greatest of them all made its Olympic debut. The Star class is a two-person, one design keelboat that could be competitively raced for a fraction of the cost of the Six Metre. It was also a way of levelling the playing field – the tighter design constraints of the Star class meant that the gold medal was much more likely to go to the best sailors, rather than those with the best yacht design. The Star's incredible longevity means that it remains an Olympic class for the 2012 Games, but has finally been dropped for Rio in 2016. It's a decision that has left the Olympics without a men's keelboat.

A second important trend flickered into life in 1924, and although it only really flowered much more

Left: The Twelve Metre is better known as the post-war America's Cup class, but it also raced at the 1908, 1912 and 1920 Olympics.

The Star is perhaps the most legendary of all Olympic classes. Introduced in 1932 in Los Angeles, it survived the post-war changes to race in Helsinki in 1952 (far left) and is still going strong (opposite), dealing with some spectacular conditions in Qingdao in 2008 (overleaf).

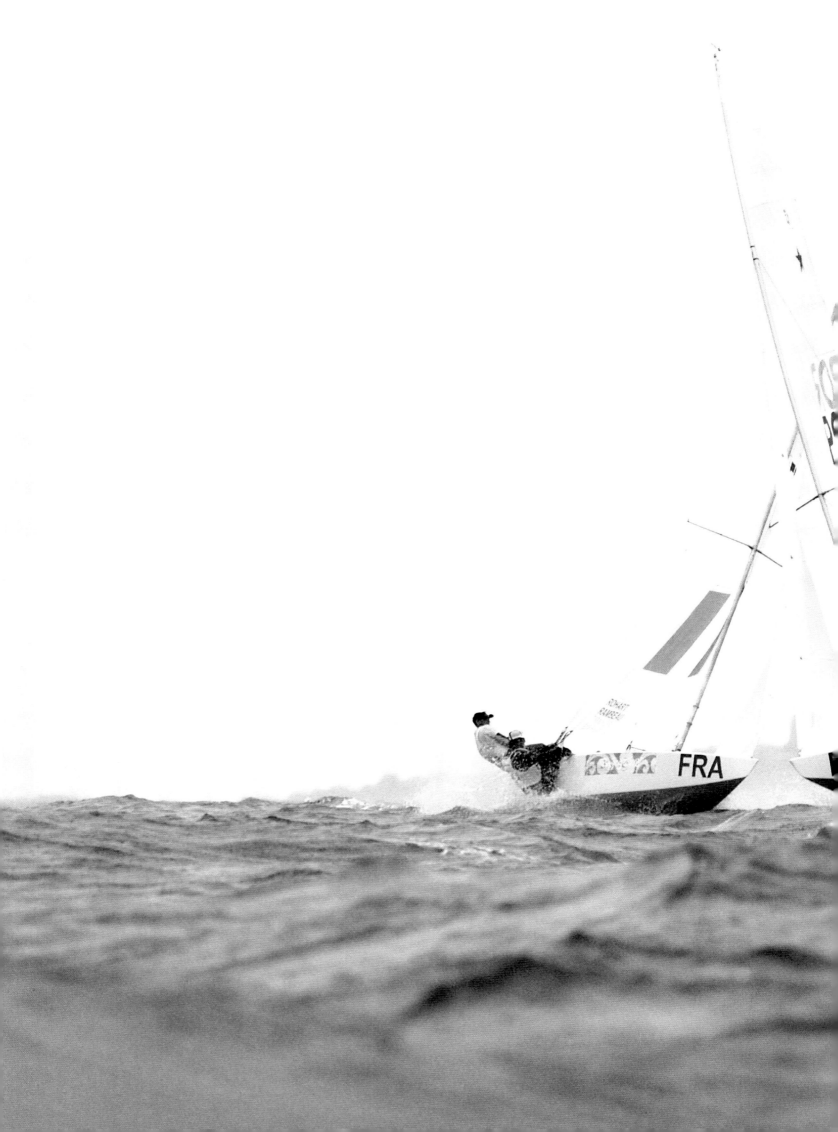

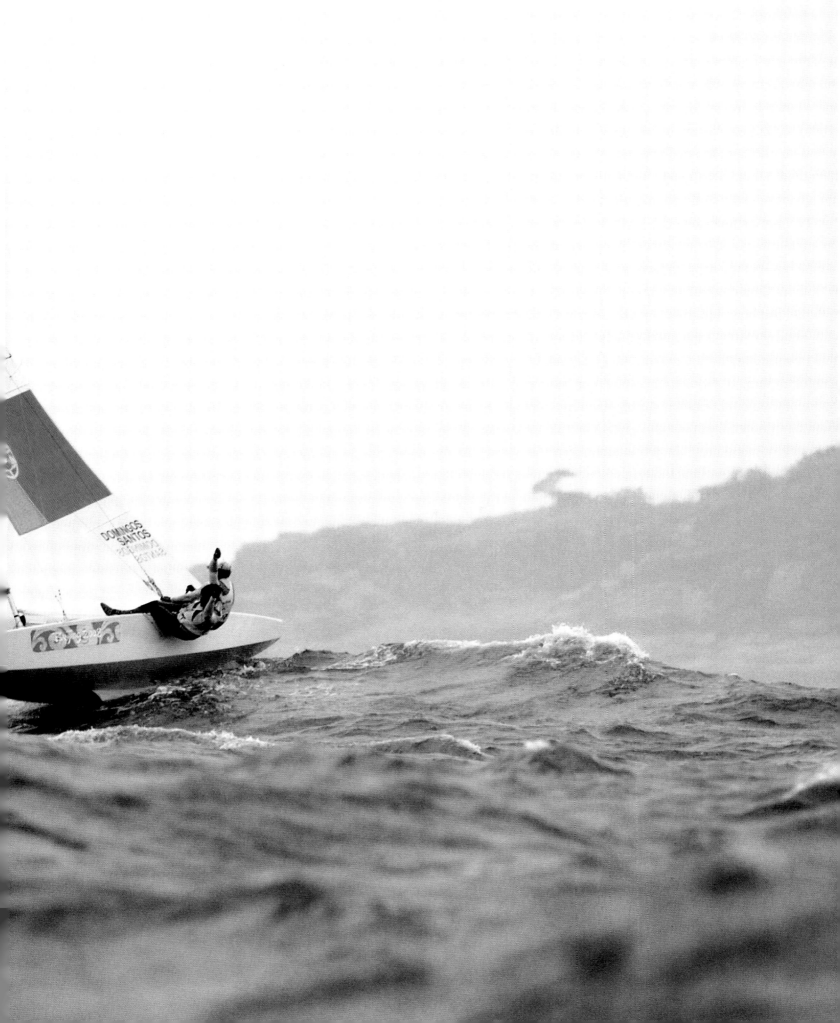

recently, it was closely allied to the adoption of one designs. The organisers of the second Paris Olympics in 1924 supplied all the competitors with French National Monotype dinghies – an idea that continued in 1932 with the Snowbird, and in 1936 with the Olympic Jolle. The idea was stronger than any of the individual boats, all of which only made one appearance, but its value was clear – when the equipment was supplied, those with more resources had less of an advantage. Nevertheless, it was the one design that really started to refocus Olympic sailing at the first post-war Games in London in 1948. Apart from the Six Metre, the other classes were new, and they were all smaller one designs. The elegant Dragon, a three-person keelboat, began a decent Olympic career lasting until 1972. The Six Metre was gone by 1952, replaced by the smaller and less expensive 5.5 Metre.

The single-handed Finn arrived with the 5.5 Metre at the 1952 Games, and with the Star and the Dragon

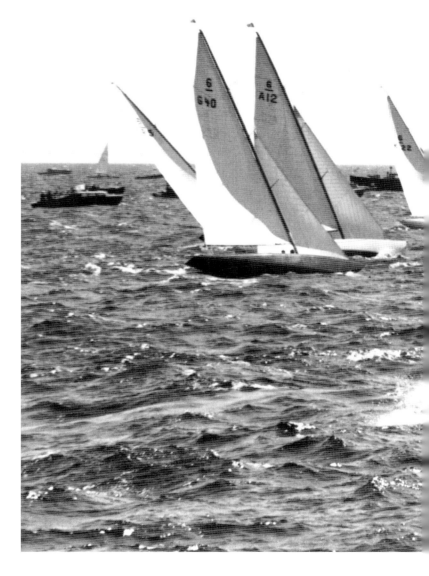

Right: The Six Metre is a classic racing yacht and graced the Olympics from 1908 to 1952. This photo was from the final appearance of the Six Metre at Helsinki in 1952.

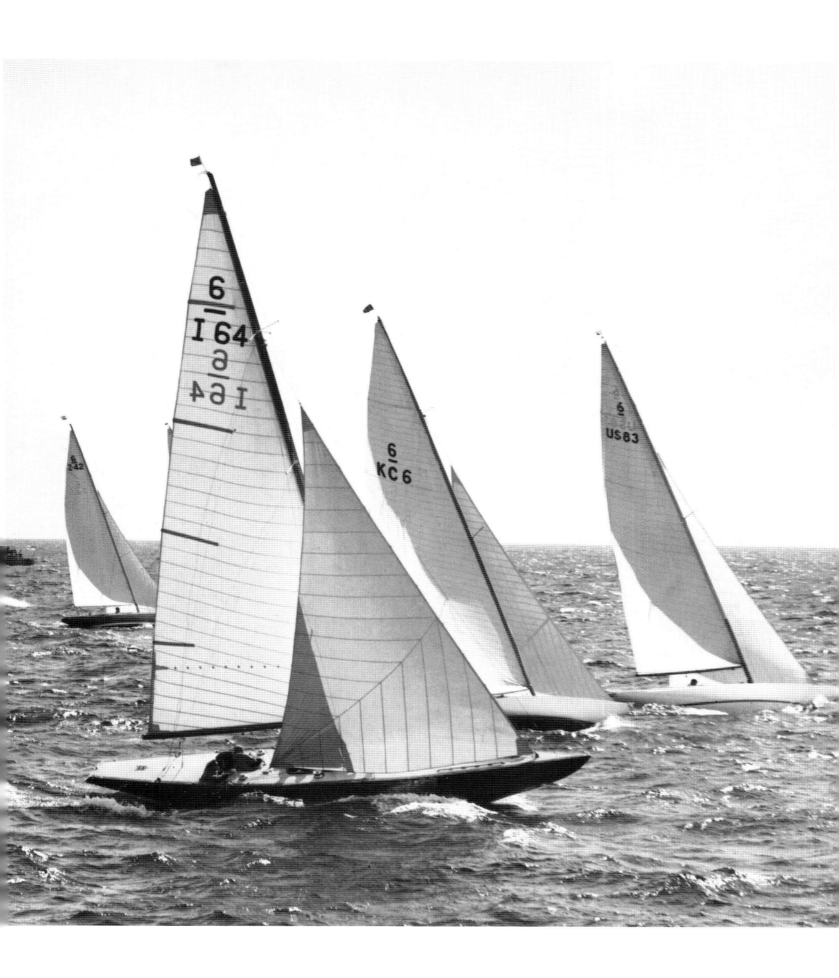

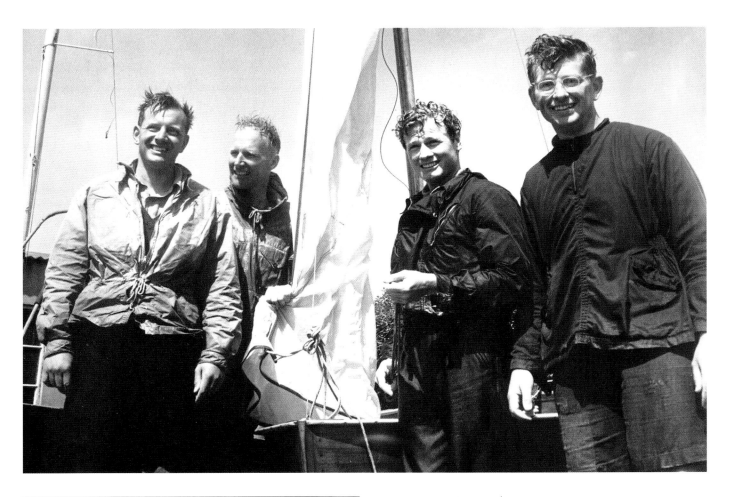

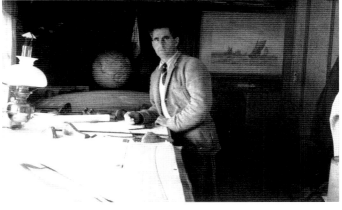

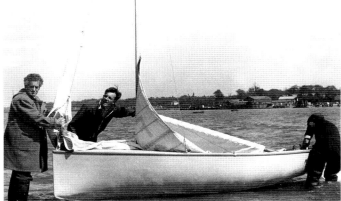

Top: Charles Currey (far left) worked for the Fairey Aviation Company that built the Firefly for the 1948 Games, and Currey was instrumental in its development. He was also responsible for the invention of the trapeze, now an integral part of any modern high-performance dinghy. Also in this picture are other famous names from the British post-war dinghy boom, left to right: Currey, Austin Farrar, Keith Shackleton and Bruce Banks.

Left: Uffa Fox (seen here in his Cowes, Isle of Wight drawing room c1930) was famous for many of the dinghy designs that transformed 'yachting' into 'sailing' after the Second World War. They included the Firefly, used in Torquay in 1948 as a single-handed Olympic class.

Above right: Uffa Fox and Charles Currey prepare to sail the second prototype Firefly.

Right: Charles Currey sailing the Firefly – accused of 'professional' status as a boat builder, Currey was blocked from racing for Britain in the boat at the 1948 Games in Torquay. But he went on to race the Finn at the 1952 Olympics, where he came second behind the great Paul Elvstrøm.

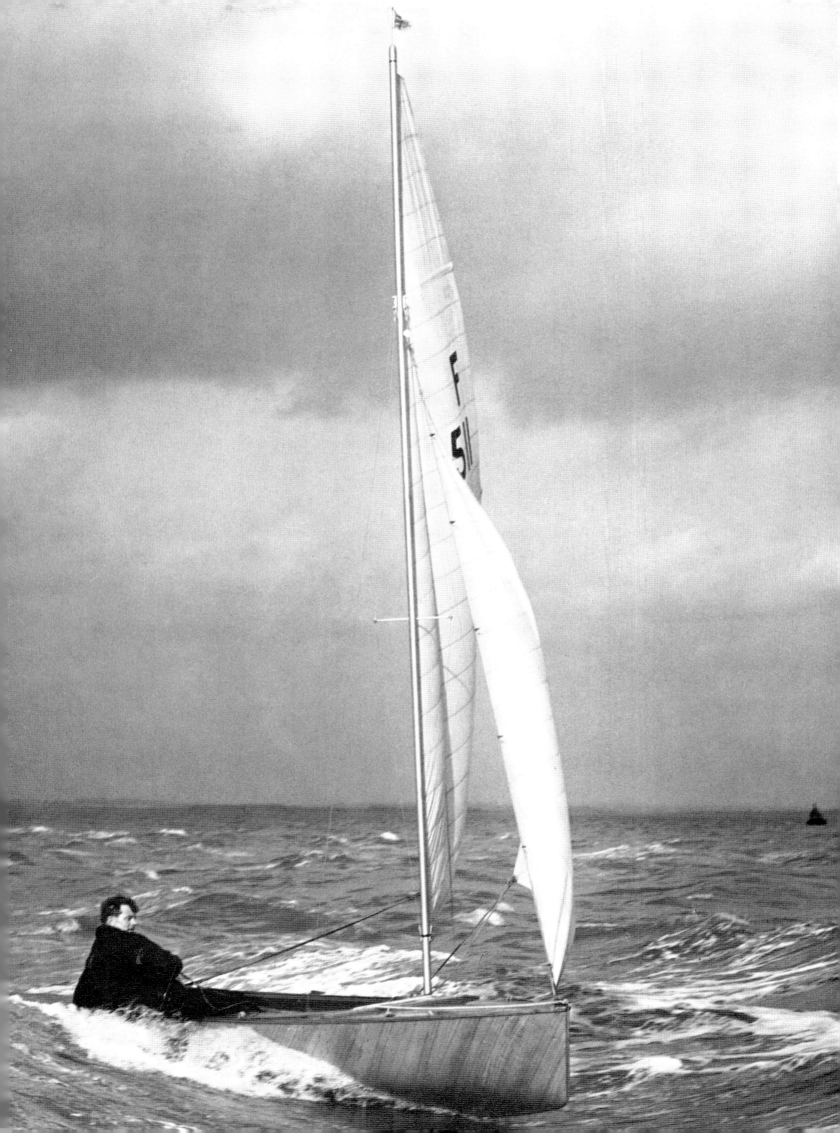

these four boats created the core of the Olympic Classes until the early 1970s. All four of them are legends: the Finn has been the weapon of choice for the two greatest Olympians – Elvstrøm and Ainslie – and is still going strong today. But by the end of the 1960s, the overall Olympic roster was starting to look outdated, and this was addressed with the addition of the Flying Dutchman. The Dutchman is another bona fide Olympic classic: a two-man, single-trapeze, high performance dinghy with an enormous genoa that stuck around until 1992. Another arrived when the Soling, a three-person, one design keelboat replaced the 5.5 Metre – and curtailed the Olympics as a yacht design contest. The Games now reflected the wider sailing world much more accurately.

Right: The Norwegian 5.5 Metre races on Port Phillip Bay at the 1956 Melbourne Olympics, coming fifth.

Below: The 5.5 Metre class was introduced at the 1952 Olympics in Helsinki, and raced until 1968 Olympics in Mexico, where this picture was taken.

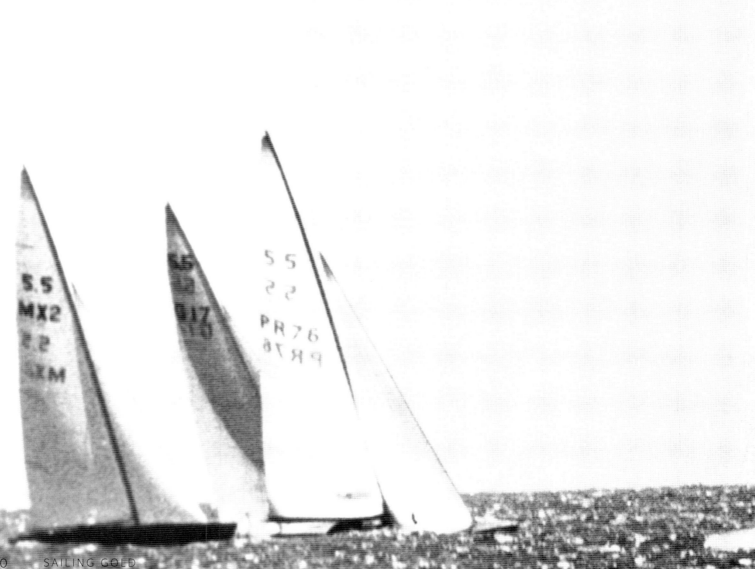

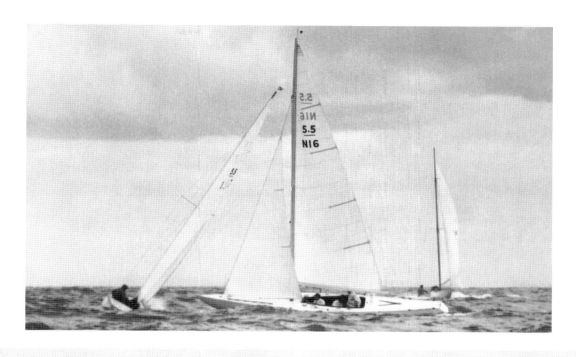

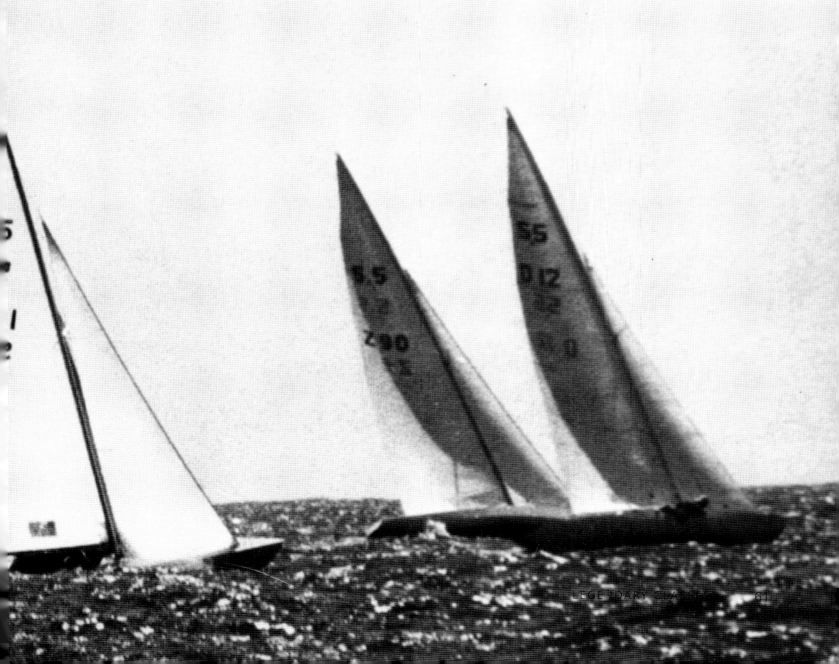

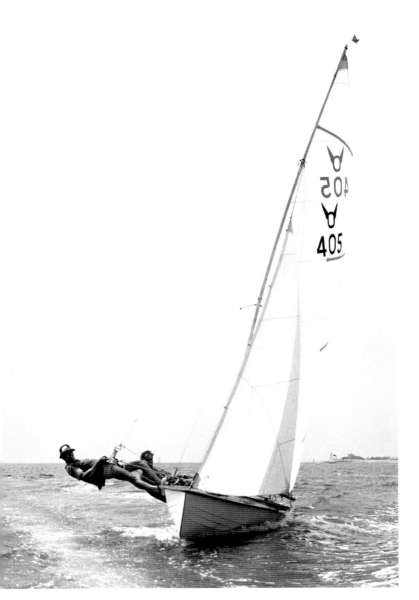

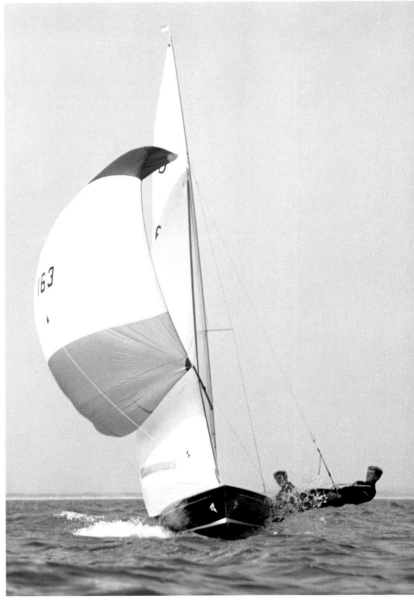

The driving factors up to this point were to promote greater accessibility by reducing the cost, and to continue to level the playing field, chiefly by switching to one designs, but also by supplying all the boats in a given class. There are two final trends that are taking the Olympics into the professional era – performance and inclusiveness. Both are exemplified by our final, legendary Olympic class – the 470. The 470 arrived in 1976: a cheap, lightweight, single-trapeze, high performance dinghy that is still going strong.

Above left: The International Sailing Federation often runs design competitions for things like International and Olympic status, and this is one boat that didn't make the cut. Ian Proctor designed the Osprey and, along with another 16 designs, it lost out to the Flying Dutchman in the contest for a new international high performance dinghy. The FD went on to be chosen for the 1960 Olympics.

There is one name indelibly linked with the Flying Dutchman class and that is the double Olympic gold and silver medallist, Britain's Rodney Pattisson, seen here (above right) with his gold meal winning 1968 crew, Iain MacDonald-Smith, and (opposite) his 1976 silver medal winning partner Julian Brooke-Houghton.

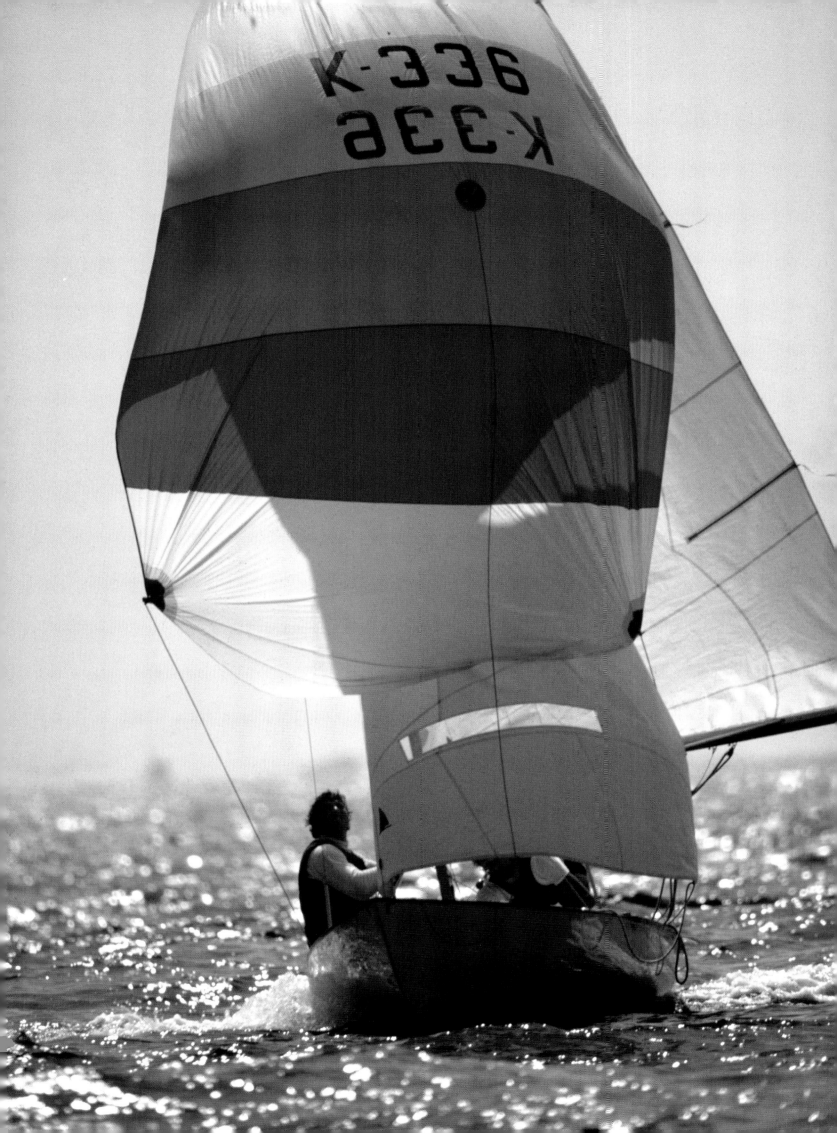

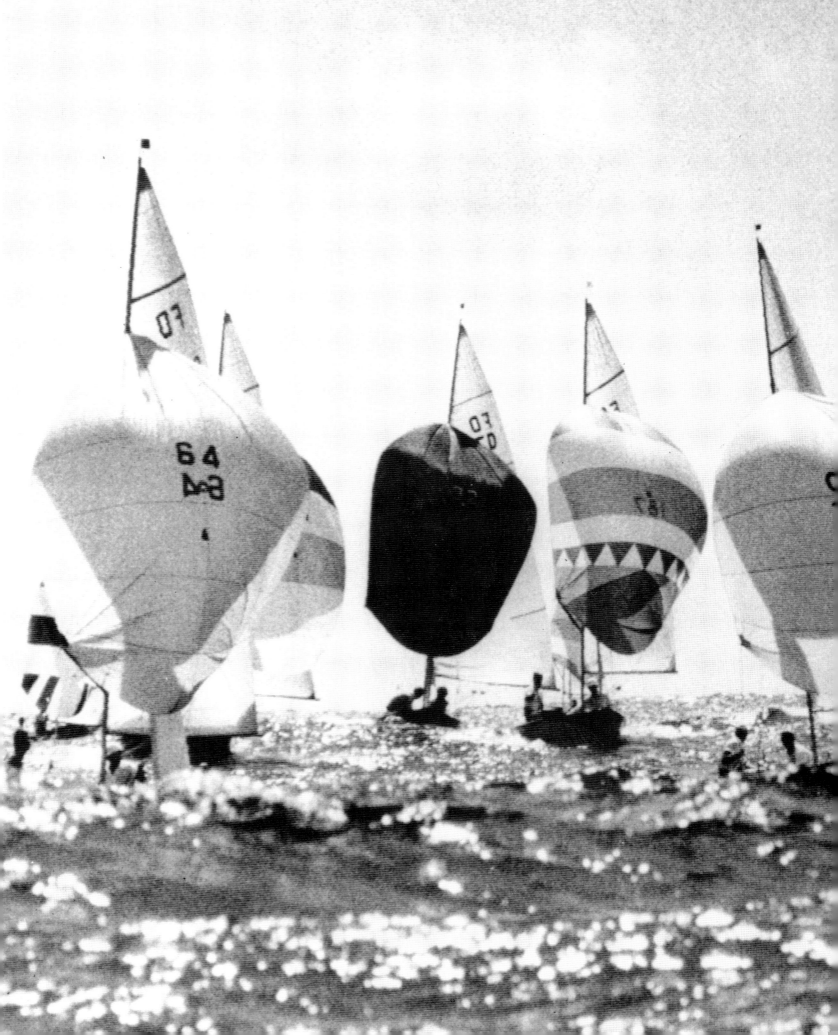

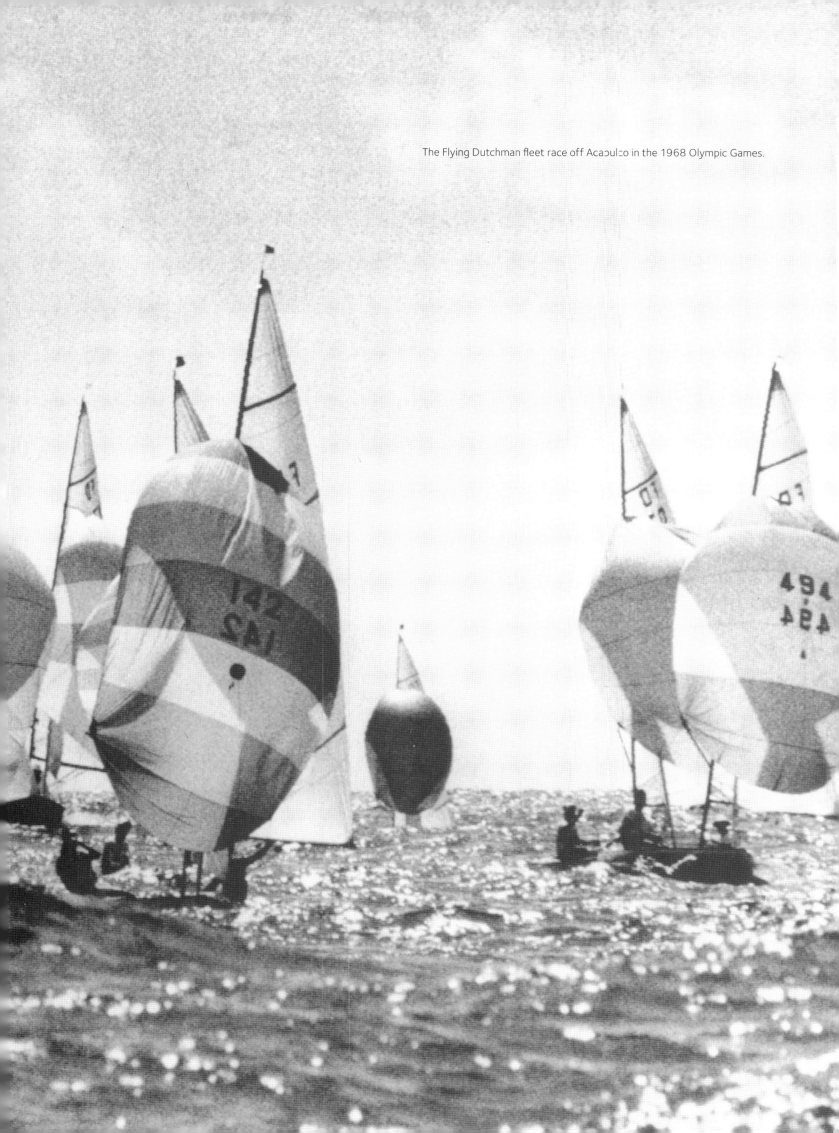

The Flying Dutchman fleet race off Acapulco in the 1968 Olympic Games.

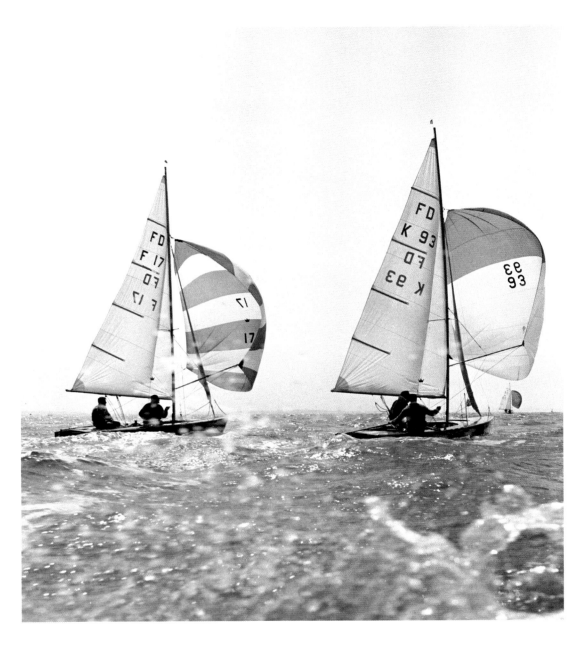

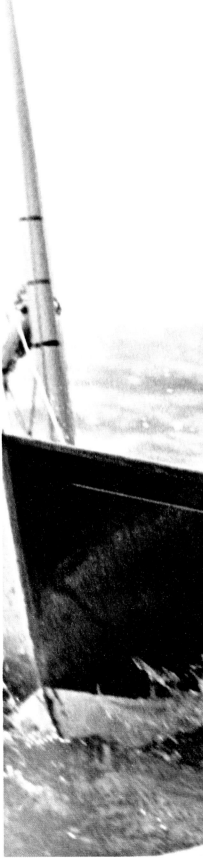

Above and right: Before Rodney Pattisson came to dominate the Flying Dutchman class, Keith Musto raced for Britain. Musto and Tony Morgan won a silver medal at the Tokyo Games in 1964. Musto went on to start the famous sailmaking and clothing companies that bore his name.

Overleaf: The Flying Dutchman was still going strong in the 1984 Olympics at Los Angeles.

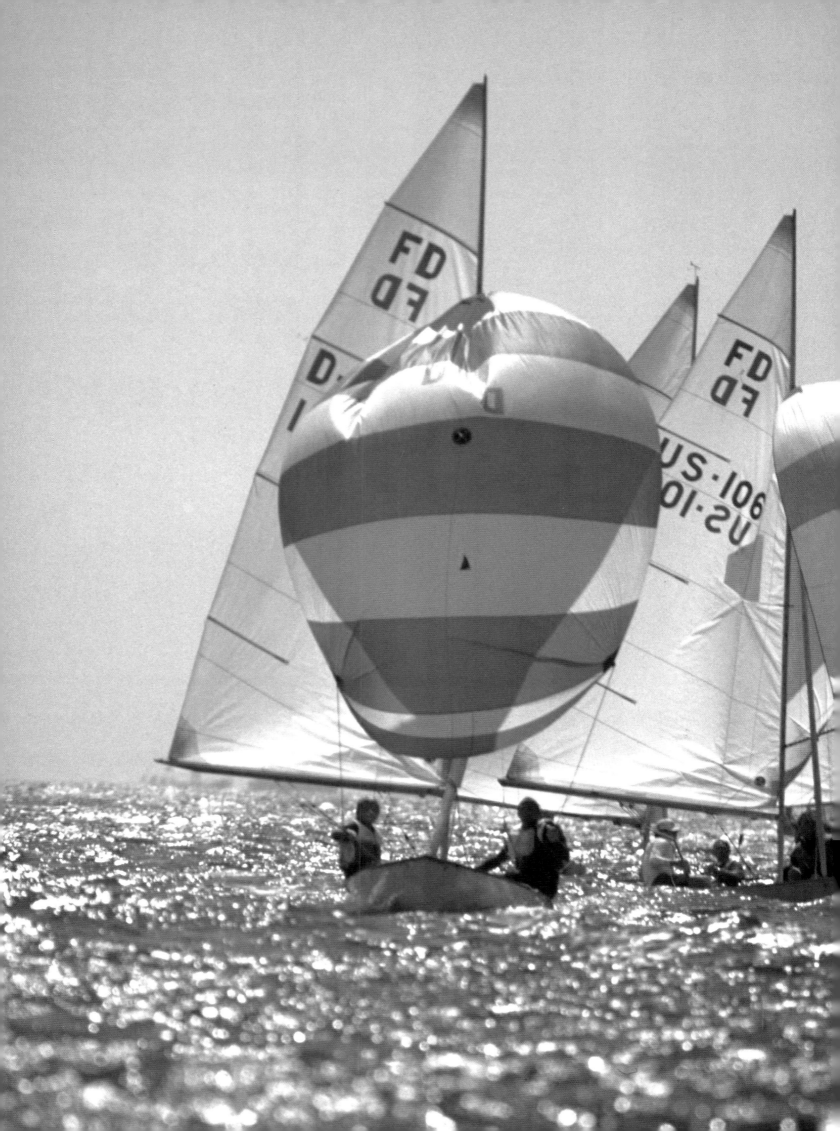

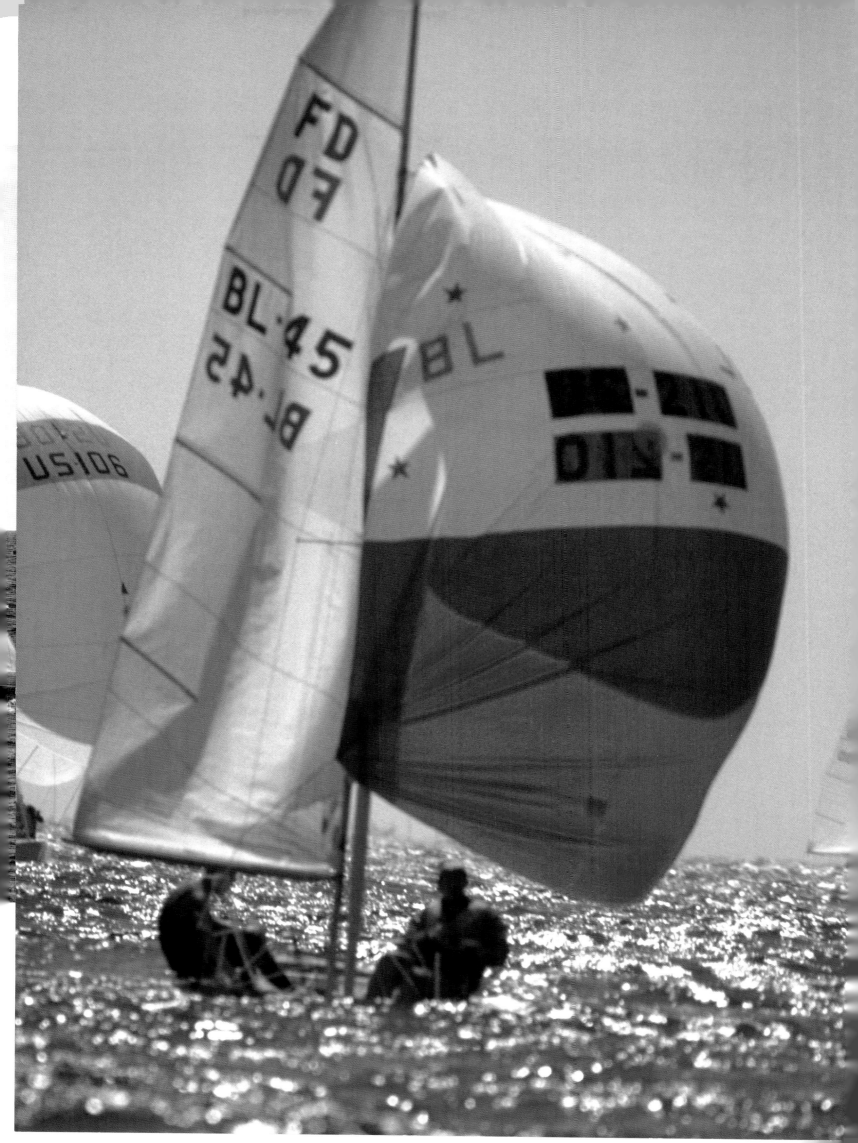

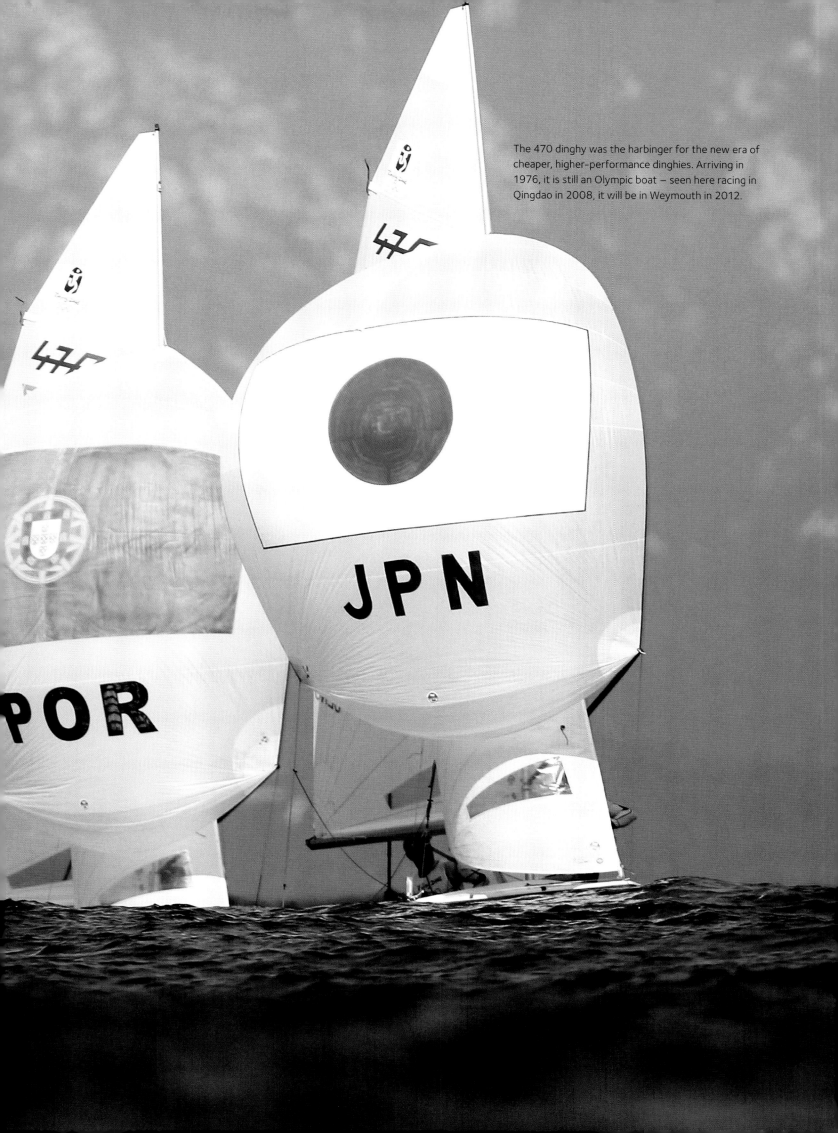

The 470 dinghy was the harbinger for the new era of cheaper, higher-performance dinghies. Arriving in 1976, it is still an Olympic boat – seen here racing in Qingdao in 2008, it will be in Weymouth in 2012.

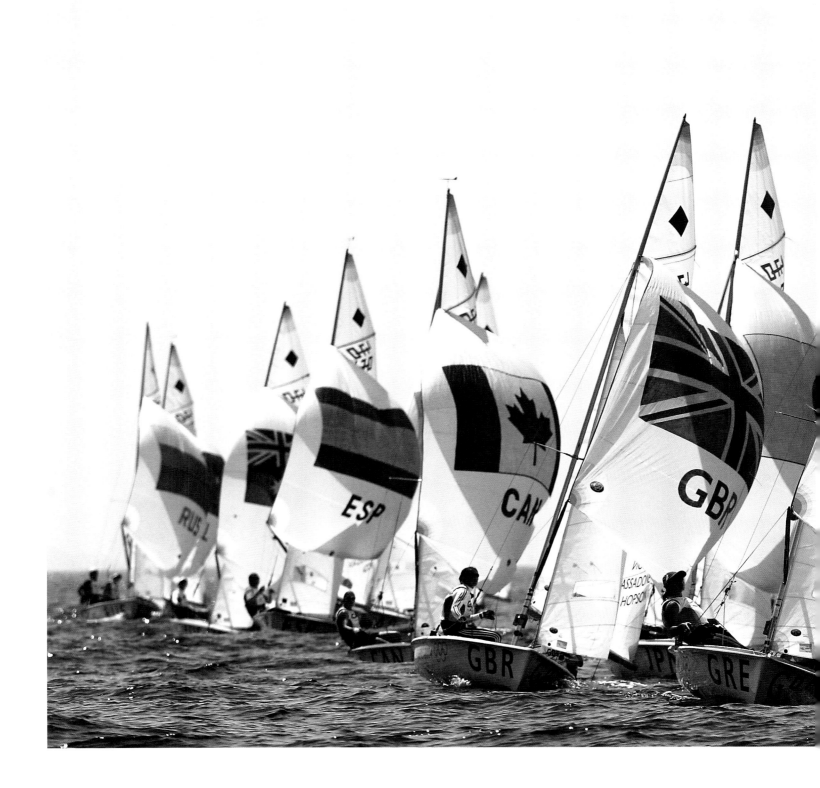

The 470 was the first class to introduce a separate women's event, and consequently ushered in a new era of greater access to the Olympic Games. Sofia Bekatorou and Aimilia Tsoulfa lead the Women's 470 fleet in front of the home crowd in Athens – they went on to win gold.

Above: Julian Bethwaite sits atop his capsized 49er – the game-changing boat that he designed and guided into his home Olympics on Sydney Harbour.

Overleaf: Marcelien de Koning and Lobke Berkhout won three consecutive Women's World 470 titles, before racing to the silver medal in Beijing in 2008.

Britain's Cathy Foster blazed a path for women's sailing in the 470 class. In 1984 she beat all the favourites – including the America's Cup and ocean racing superstar Lawrie Smith – for selection to the UK team, coming seventh in Los Angeles and winning the last race. By 1988 a separate Women's class had been introduced, but ironically Foster failed to win selection after breaking a mainsail halyard in the final race.

The 470 also became the gateway for women into Olympic sailing. In 1984 the British 470 representative in Los Angeles was Cathy Foster. She was arguably the most talented women's dinghy sailor of her generation, and a real trailblazer. Crewed by a man, Pete Newlands, she managed seventh overall and won a race. It was a great achievement, but highlighted how tough it was for women to compete in open classes. By Seoul in 1988 the 470 class had been split into male and female, which introduced women's only sailing events to the Olympics – the final and perhaps the most important trend to take us into the modern era of Olympic classes. The roster of boats had come a long way from the River Seine in 1900 and left a fine heritage of classic designs, but the sport was changing fast and, if anything, the pace was about to quicken.

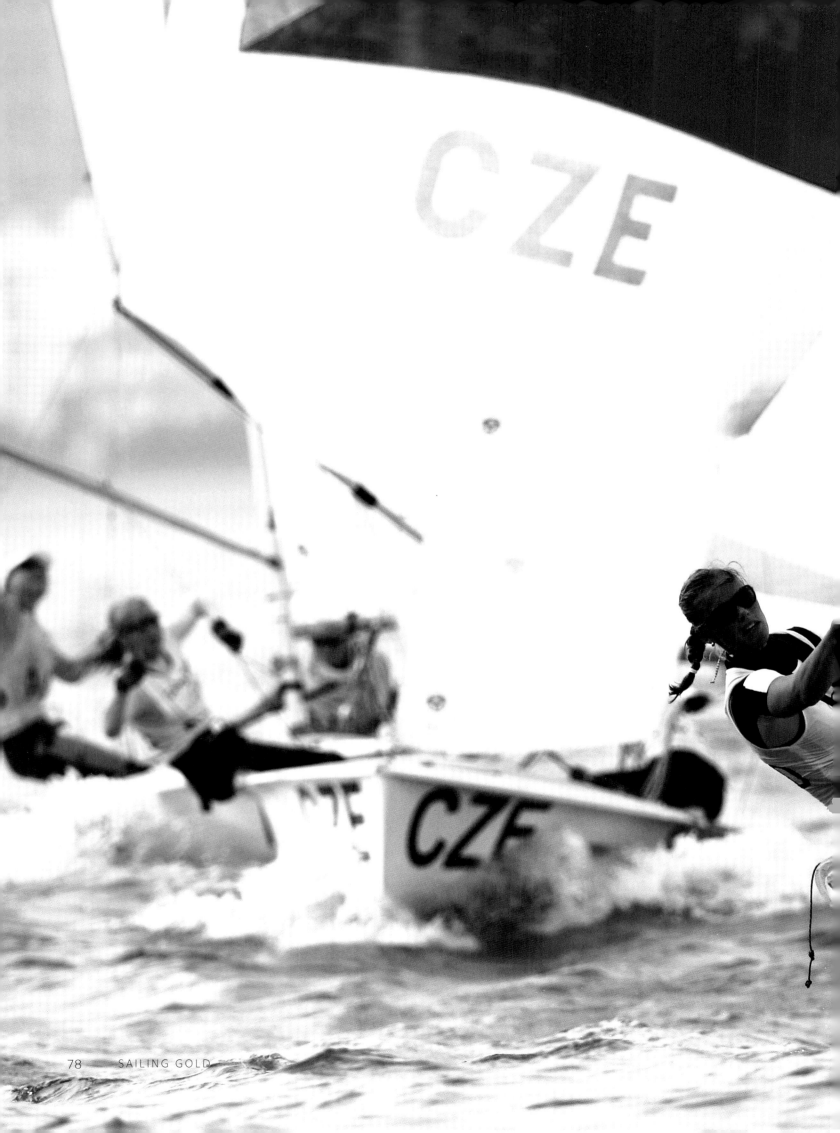

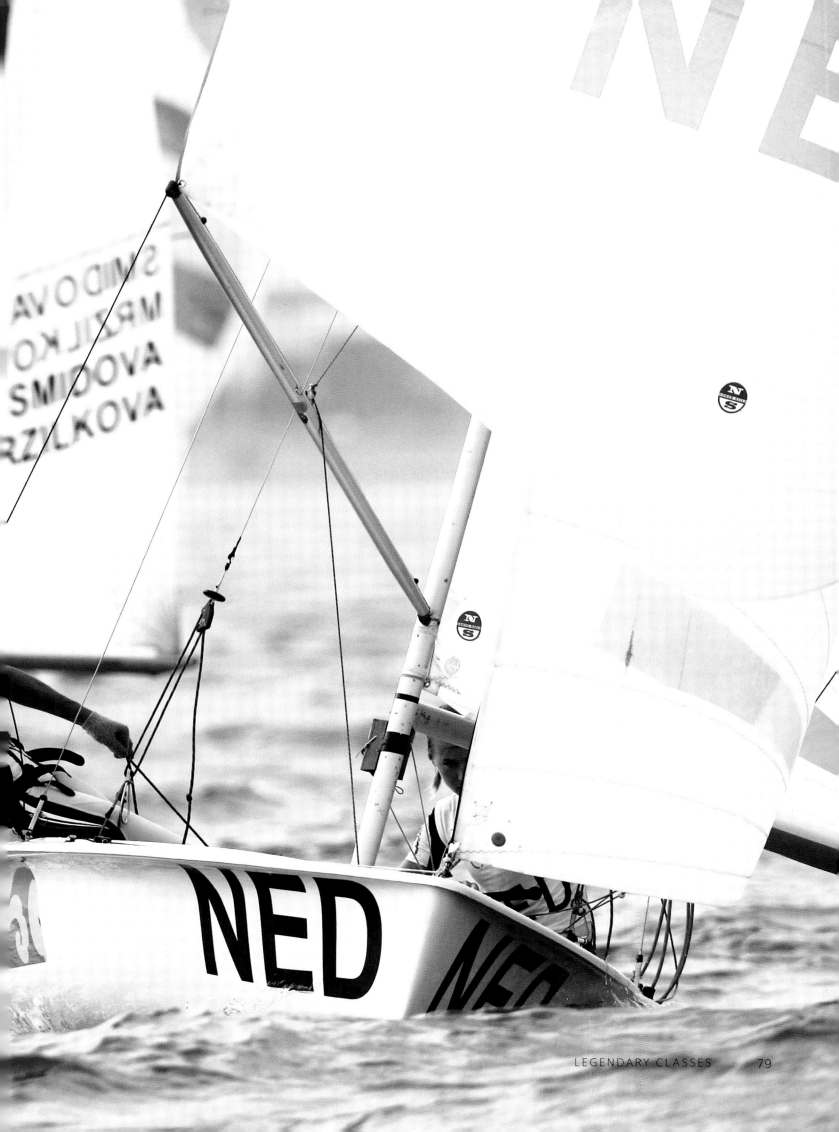

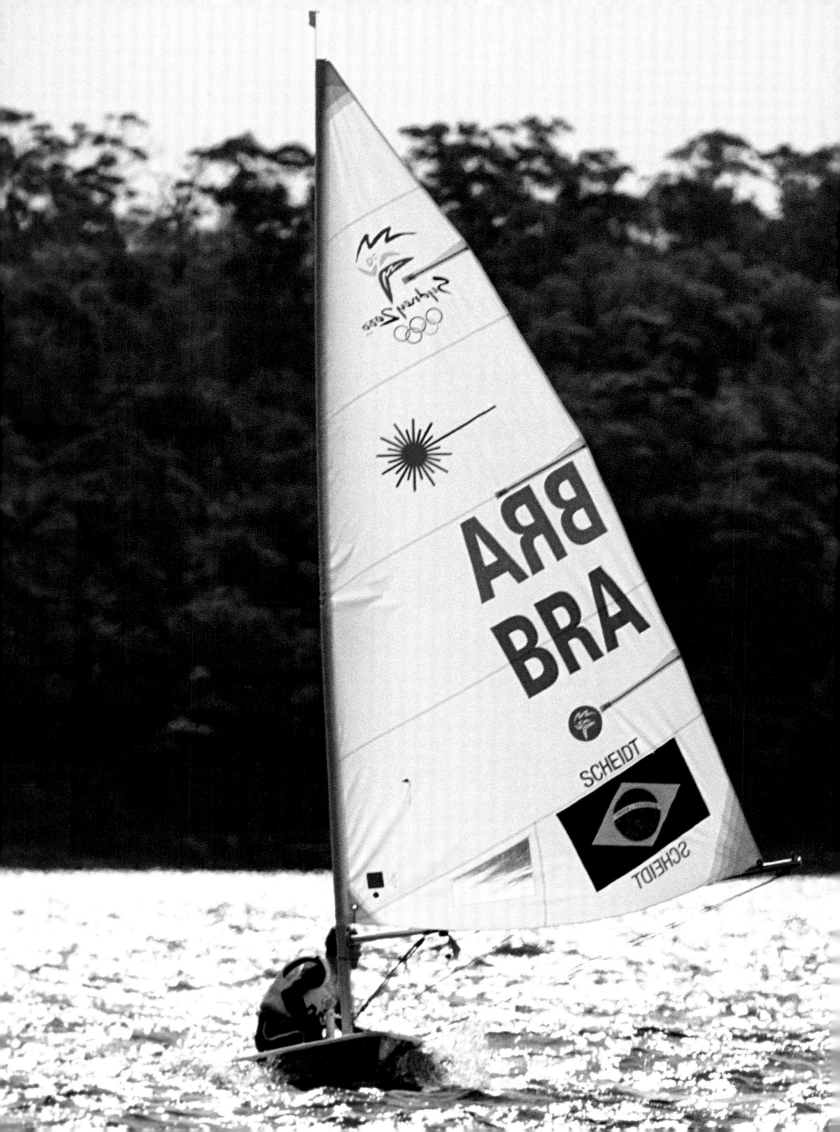

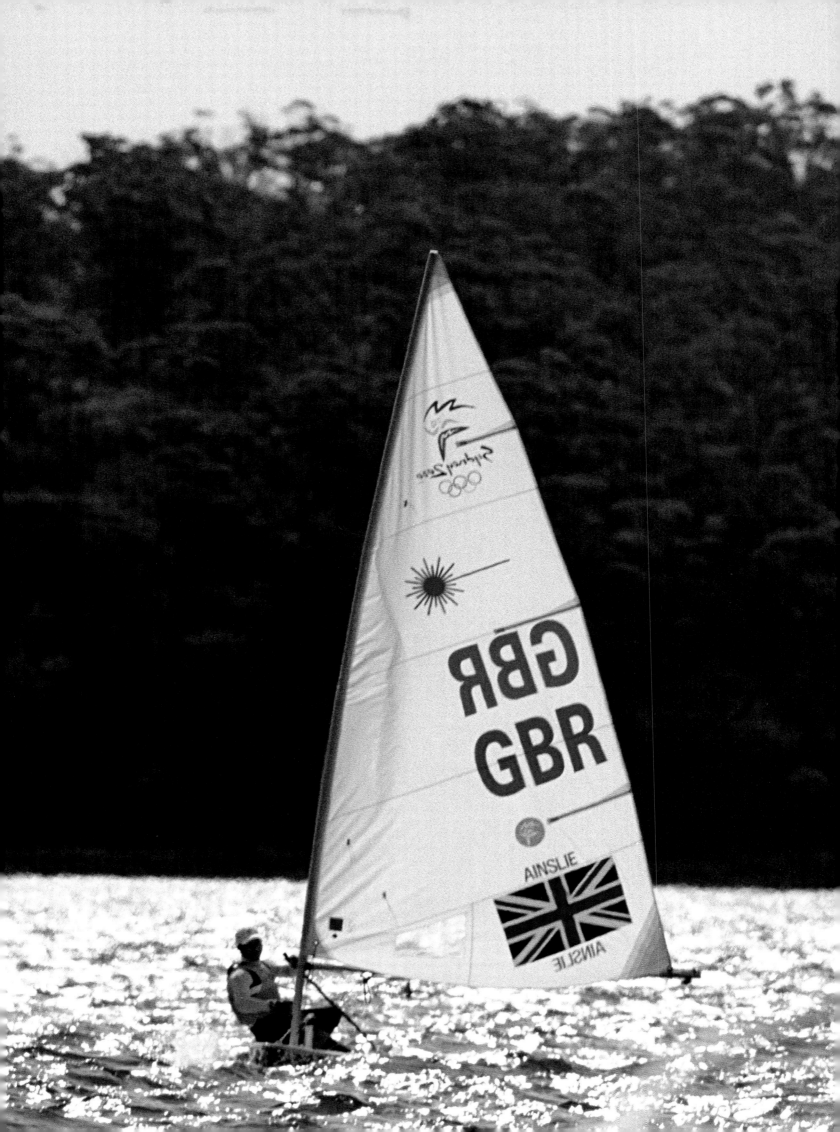

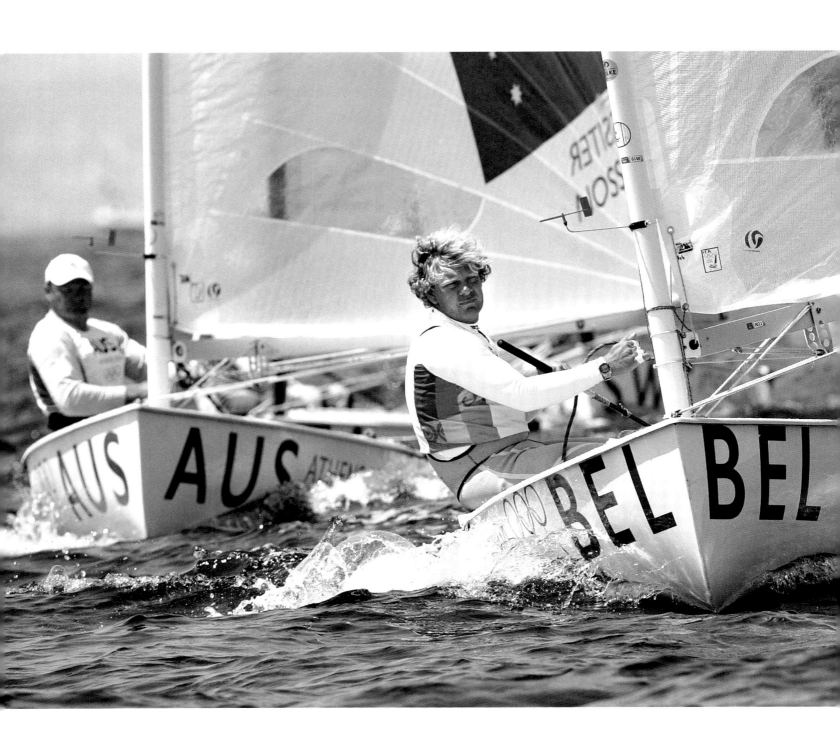

Previous page: The Laser was already one of, if not the most, ubiquitous and recognisable sailboats on the planet, before Robert Scheidt and Ben Ainslie's epic battle for Olympic gold in Sydney 2000 put it onto television screens all over the world.

Above: Belgian sailor Sébastien Godefroid has had a long career in the equally long-lived Olympic Finn. Godefroid won silver in Atlanta in 1996. He competed again in 2000, 2004 and 2008, but without another medal.

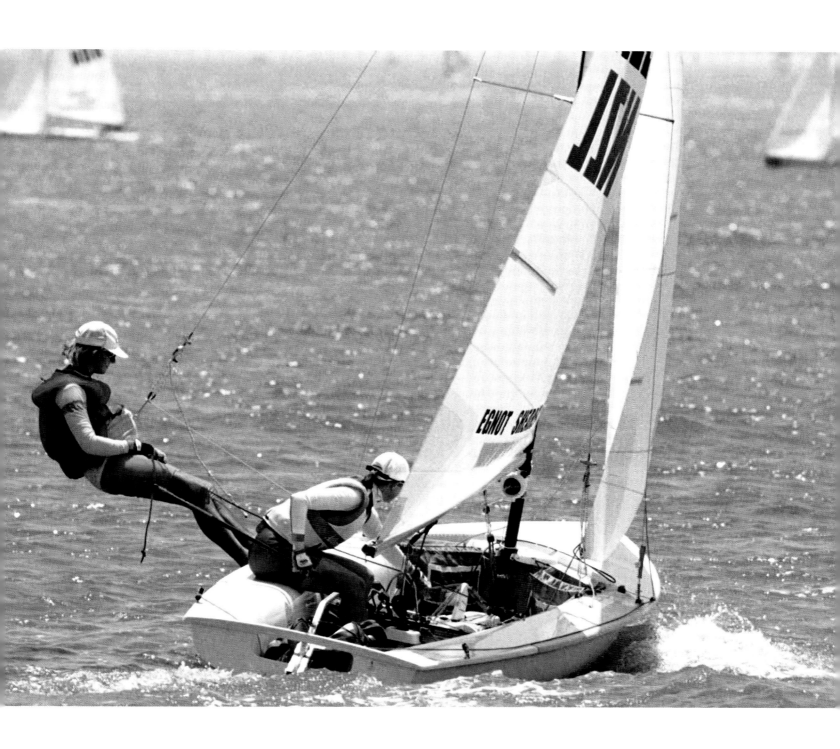

Above: By 1996, women were a well-established part of the Olympic scene. These are the New Zealand competitors in Atlanta – Leslie Egnot and Jan Shearer. They won silver in 1992, but slipped out of the medals table four years later.

Above: Jochen Schümann is one of many great names associated with the Soling: winning two gold medals in the class in 1988 and 1996, he was also fourth in 1992, and picked up a silver medal in Sydney in 2000. This picture was taken in 2000 when Schümann raced with Gunnar Bahr and Ingo Borkowski.

Left: The Soling had an unusual Olympic career, seen here racing off Sydney Heads in its final appearance at the 2000 Games. It joined the elite in 1972 as a three-man fleet racing class, then the final match racing rounds were introduced for the Barcelona Olympics in 1992.

Overleaf: The home team race the Soling at the Sydney Games in 2000 – Neville Wittey, Joshua Grace and David Edwards.

The New Era

IT WOULD BE SOMETHING of an understatement to say that the International Sailing Federation's selection of the events and classes of boat for the Olympic Games has been controversial. The methodology has been overhauled ahead of the choices being made for Rio in 2016, but it seems likely that the bitter in-fighting, acrimony and politics will survive intact. Despite that, some positive trends have also survived through the years – reducing the cost to competitors by using one designs and cheaper boats, and where possible supplying all the boats in a given class. Since the Olympic Games became a one-design-only competition in 1972, the number of classes supplied by the organisers has grown steadily – including 2012 Women's Match Racing, Windsurfing (RS:X) for men

and women, Laser (men) and Laser Radial (women). In total, that's about half of the sailing equipment at the Games, and more than half of the competitors, as these are some of the biggest classes.

It's no coincidence that, apart from the Women's Match Racing, the supplied boats have the highest entry. A more recent trend has been towards quicker, more exciting and more visual boats. The high performance Flying Dutchman, Tornado and 470 led the way, but the poster child for this shift is the 49er.

By 1996, ISAF had accepted that the Olympics needed a new, supercharged boat, so they organised trials at Lake Garda in Italy to find one. The 49er had been designed by one of the main advocates for change (the Australian skiff sailor and builder, Julian Bethwaite)

Below left and right: The poster-child for the new era of high-performance Olympic dinghies is the 49er – appropriately introduced for the 2000 Games, and seen here (left and right) on the home waters of skiff sailing, Sydney Harbour.

Opposite: The US team of Tim Wadlow and Pete Spaulding blast across the Athens 49er race course in 2004 – they finished fifth.

Overleaf: The British 49er team of Chris Draper and Simon Hiscocks won bronze in Athens in 2004.

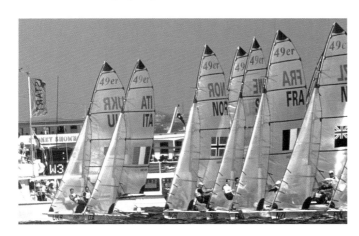

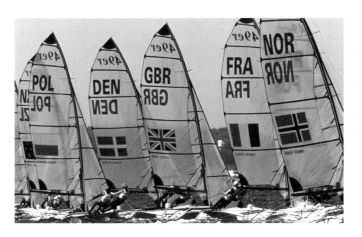

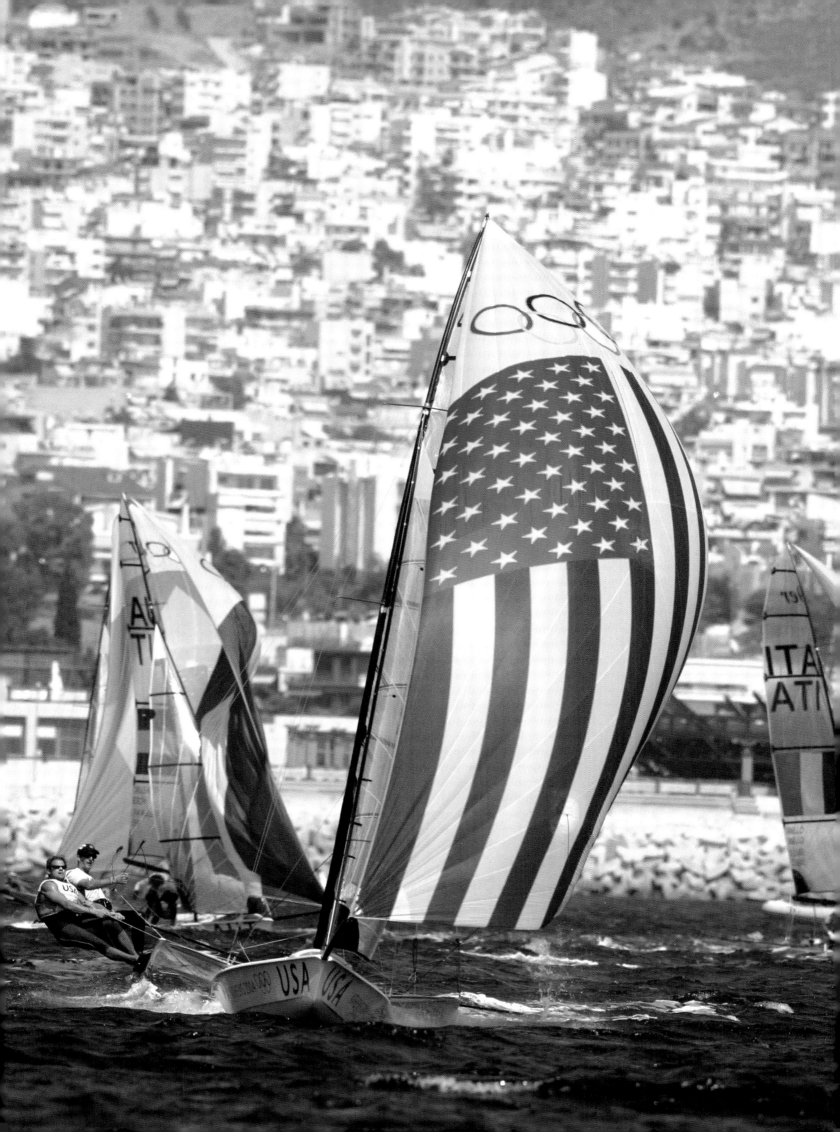

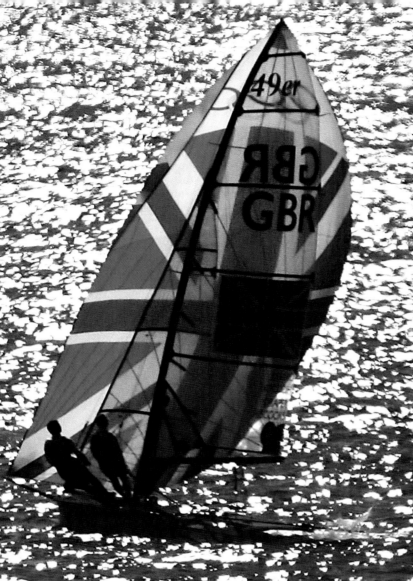

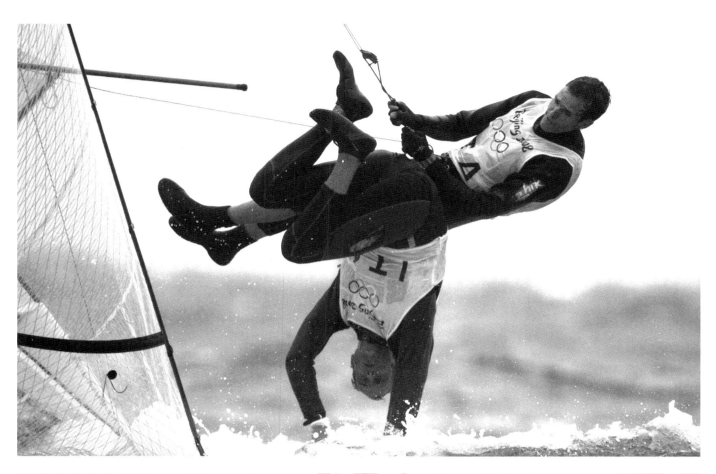

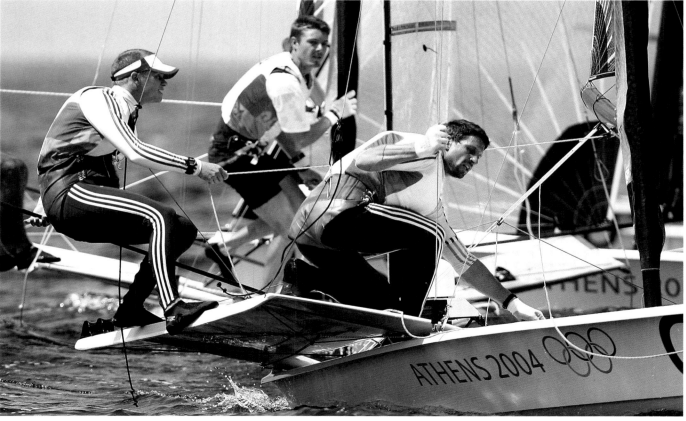

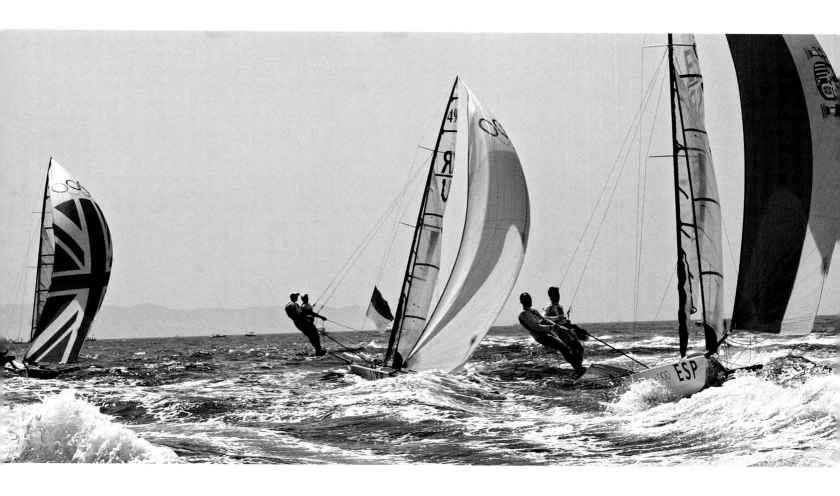

with just this moment in mind. The 49er was the winner and by November 1996 it was ratified as the new Olympic class; appropriately, its first appearance was at the Sydney Games in 2000, the home of skiff sailing. It's been a fixture ever since, providing some of the best spectator action and – an increasingly important aspect of the modern professional Games – great television images.

Windsurfing has also done a lot for the presentation of sailing in the era of rock-star surfers and extreme sports television channels. The event was first adopted in 1984, and it has provided colour, athleticism and a level playing field ever since, using one design supplied equipment. The actual board has changed frequently in its 28 year Olympic tenure. The Windglider led the way, followed by the Division II and the Lechner A-390 boards, each of which lasted for just one quadrennial cycle. The next up was the Mistral One Design and it

Above: Chris Draper and Simon Hiscocks chase the Ukraine's Rodion Luka and George Leonchuk (silver), and Spain's Iker Martínez and Xabier Fernández (gold) in a tidy representation of the overall 49er results in Athens.

Opposite top: The 49er is one of the most photogenic of the Olympic classes – here the Italian brothers Pietro and Gianfranco Sibello take a tumble at Qingdao in 2008.

Opposite bottom: A close-up of Britain's Athens 49er bronze medallists, Chris Draper and Simon Hiscocks in action.

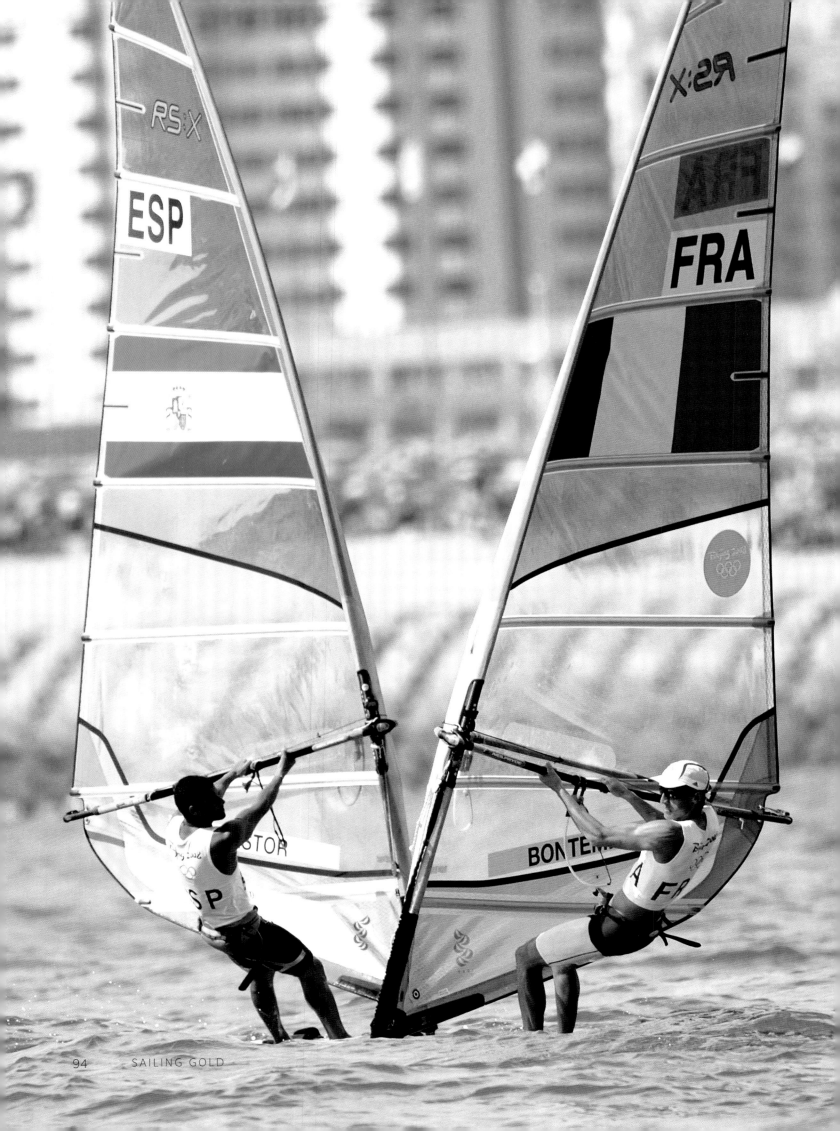

survived for three Olympics to 2004, replaced for 2008 by the current incumbent, the RS:X.

The new Olympic era also marked the importance of inclusiveness. Initially that meant gender equality, but we've also seen a growing Paralympic movement. Sailing joined the Paralympics at Sydney in 2000 with the adoption of the single-person 2.4mR and the three-person Sonar keelboat. In 2008, these were supplemented by the two-person skiff-style keelboat, the SKUD18 (which must have a mixed gender crew), co-designed by the very same Julian Bethwaite of 49er fame. There have also been several new boats for women, after the 470 led the way with the first split fleet in 1988. In 1992 the Windsurfers were divided into men's and women's fleets at Barcelona, and the single-handed Europe dinghy was introduced (it lasted until 2004, when it was replaced by the Laser Radial).

Opposite: Windsurfing has been an important part of Olympic sailing since it was added to the Games roster in 1984, although the equipment has changed several times. Julien Bontemps crosses in front of van Pastor on his way to a silver medal in the Men's event on the current board, the RS:X, at the 2008 Games in Qingdao.

Below: A separate Women's Windsurfing event was added to the Olympic Games in 1992. They have used the same equipment as the men and here, France's Faustine Merret competes on the Mistral board that was provided at the three Olympic Games from 1996 to 2004. Merret won the gold medal in Athens, where this photo was taken.

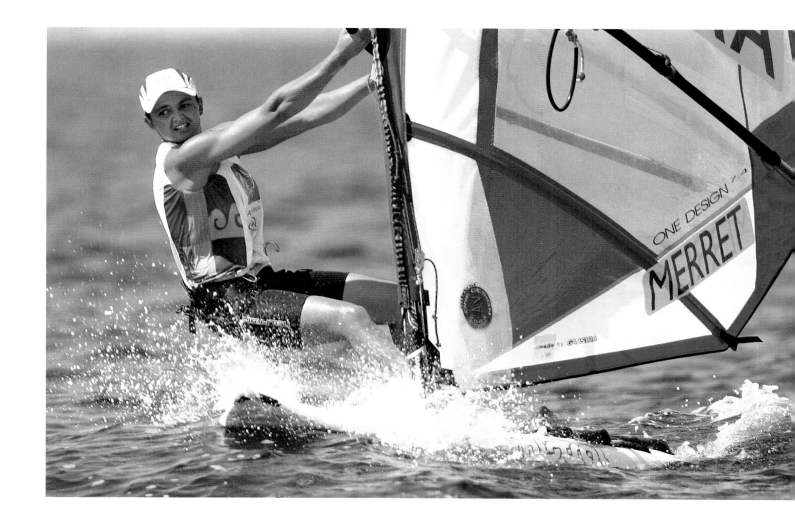

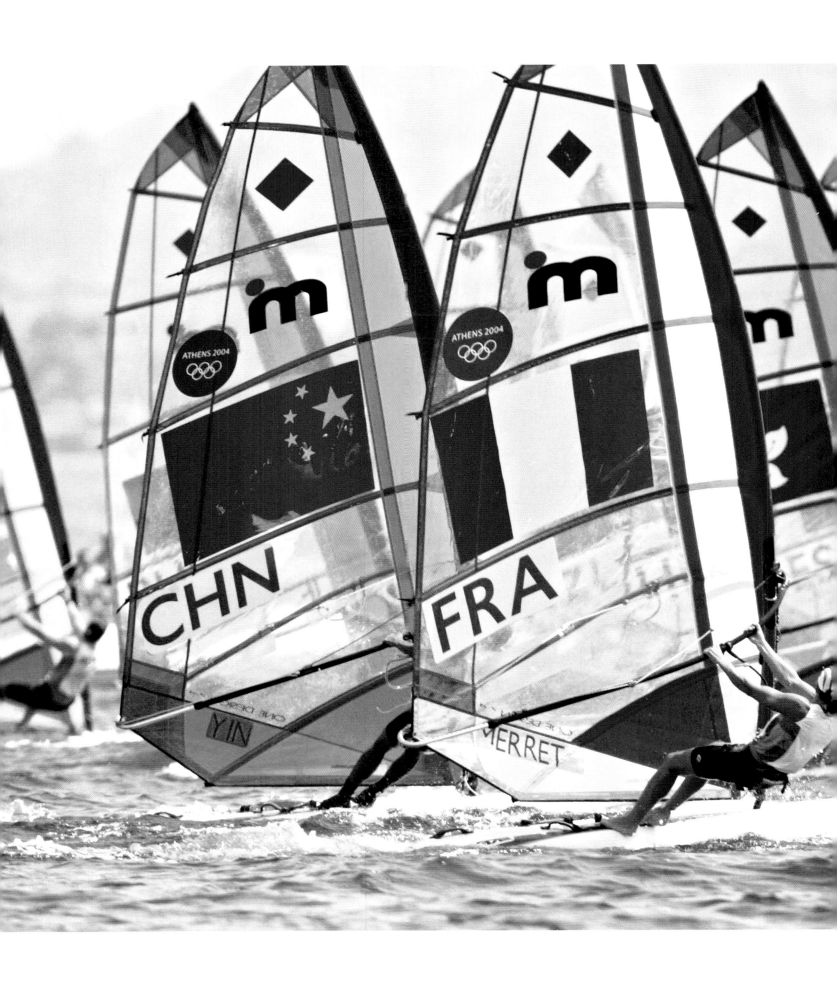

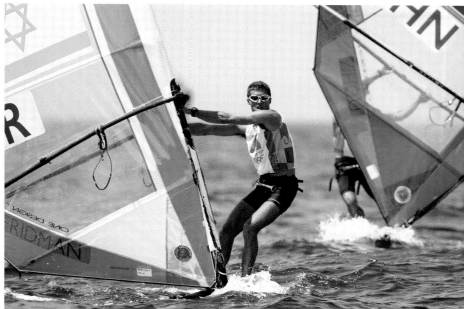

Top: Israel's Gal Fridman on his way to winning the Men's Windsurfing event in Athens in 2004.

Above: New Zealand's Bruce Kendall won a bronze medal at the first ever Olympic windsurfing competition in Los Angeles in 1984. He is seen here racing at Seoul in 1988, where he won gold.

Left: Faustine Merret dominates a start on her way to gold in Athens, 2004.

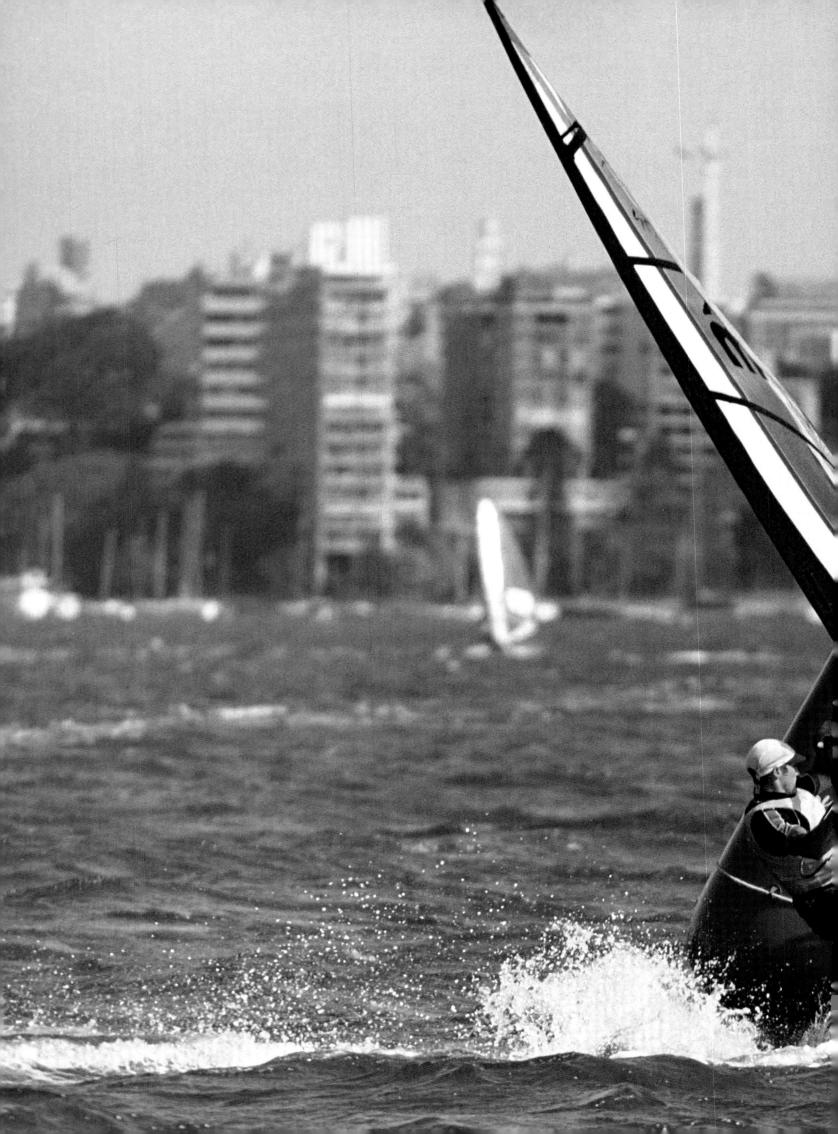

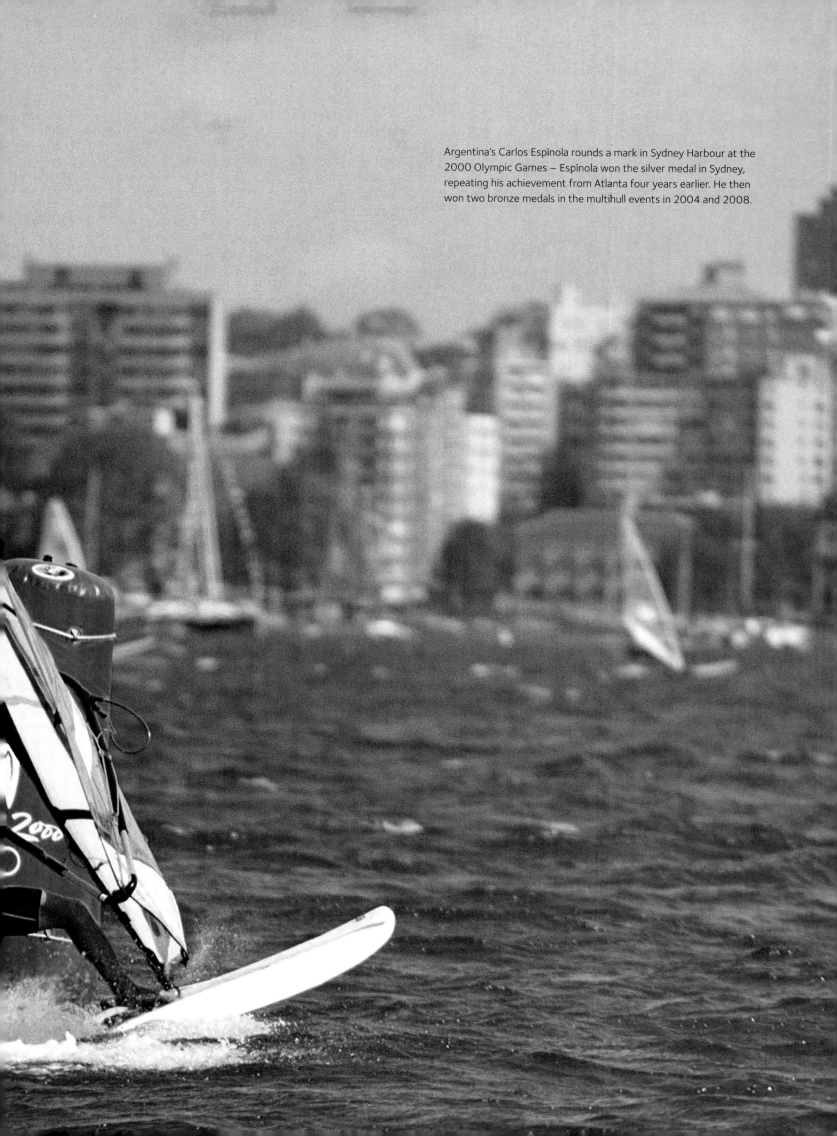

Argentina's Carlos Espínola rounds a mark in Sydney Harbour at the 2000 Olympic Games – Espínola won the silver medal in Sydney, repeating his achievement from Atlanta four years earlier. He then won two bronze medals in the multihull events in 2004 and 2008.

Women's keelboat racing arrived in the shape of the Yngling (like the Soling, designed by Jan Herman Linge) which survived just two Games (2004 and 2008) before being replaced by Women's Match Racing in the rather more modern Elliott 6m.

But if any two events define the modern Olympic era it's the men's and women's single-handed classes: the Laser and Laser Radial. The Bruce Kirby designed Laser has been around since 1971 and is one of the world's most popular boats, found on beaches, rivers and in sailing clubs large and small. It joined the Olympics in Atlanta in 1996 as a single-handed class for lightweight men and, together with the Laser Radial for women, combines all the necessary attributes: strict one design and cheap enough that the equipment can be supplied by the organiser. It doesn't get much more accessible, or the playing field much more level, than in the two Laser classes.

The Laser's performance might not quite match that of more contemporary designs, but the fact that the world's most recognisable small boat is racing at the

Below and right: Yngling raced as the Women's keelboat in both the 2004 and 2008 Olympic Games. On both occasions the gold medal was won by British crews.

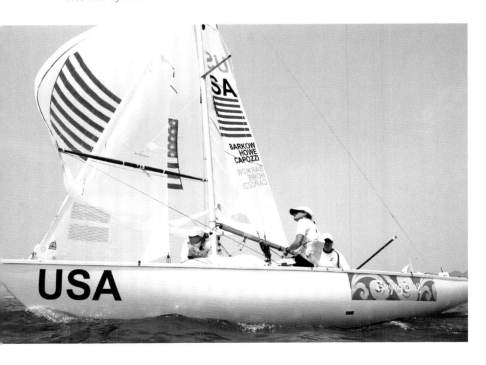

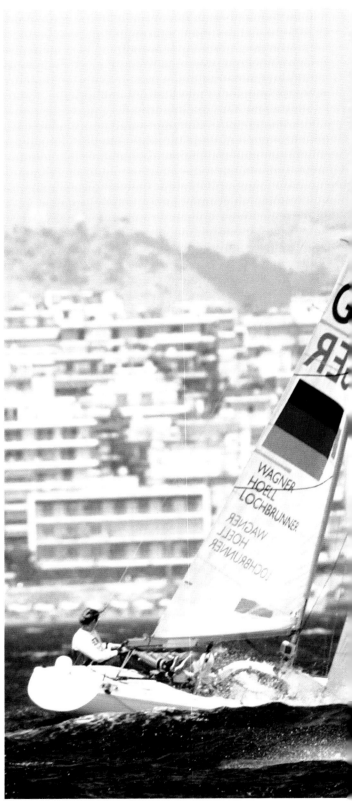

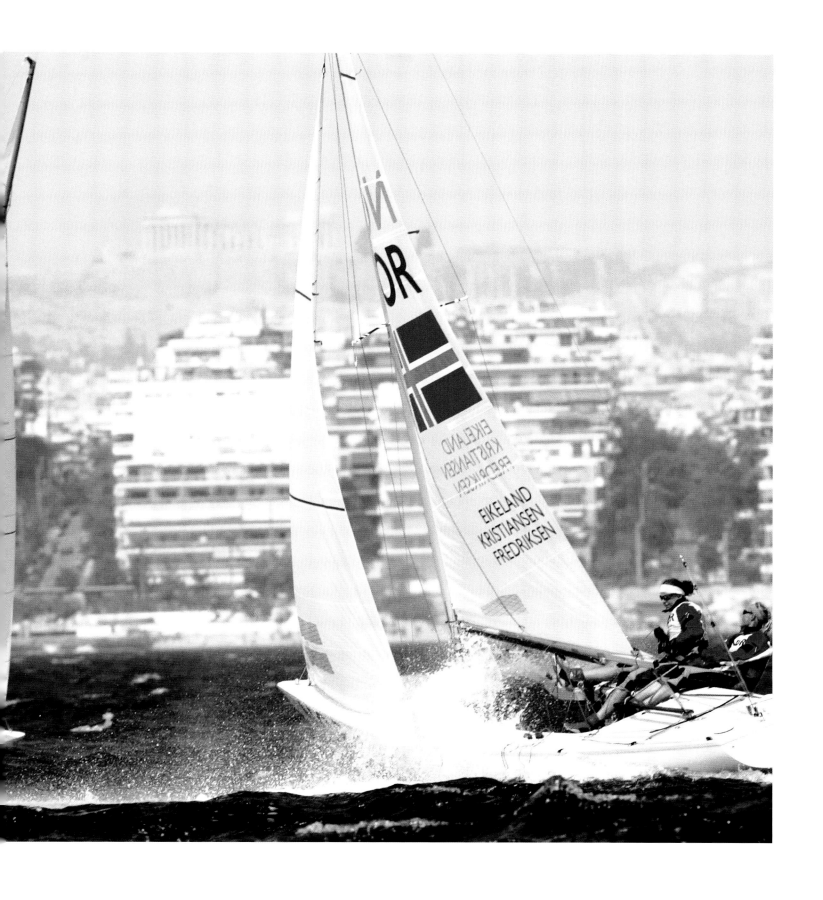

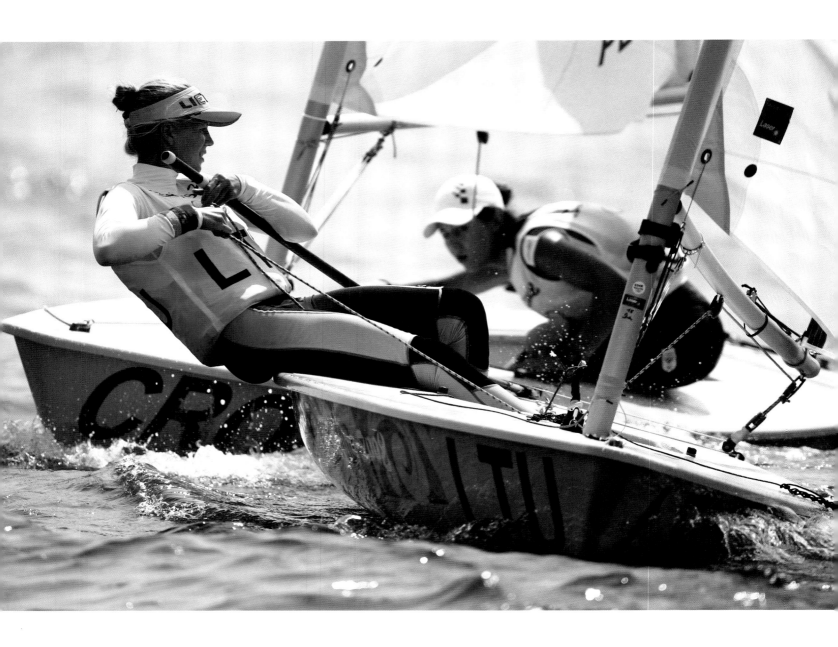

Games goes a long way towards fulfilling the modern Olympic ideal. And the superstars of the class have produced some of the most epic and inspiring moments in the modern era; not least of which was Ben Ainslie sailing Robert Scheidt off the race course at the finale of their battle at the Sydney Olympics. The BBC played the sequence over and over again to a disbelieving home audience, unused to seeing such a ruthlessly effective British winner. When the venerable, and original, four-minute-miler Sir Roger Bannister accused his compatriot of unsportsmanlike behaviour, Ainslie retorted that Bannister simply knew nothing about sailing. Although he could have added, 'Welcome to the new era.'

Left: The Laser began its Olympic career as an Open event (for men and women) in 1996. But the women got their own event when the Laser Radial (with a smaller sail) replaced the Europe as the Women's single-hander in 2008.

Below: Spain's Susana Romerc competes in the Laser Radial in Qingdao in 2008.

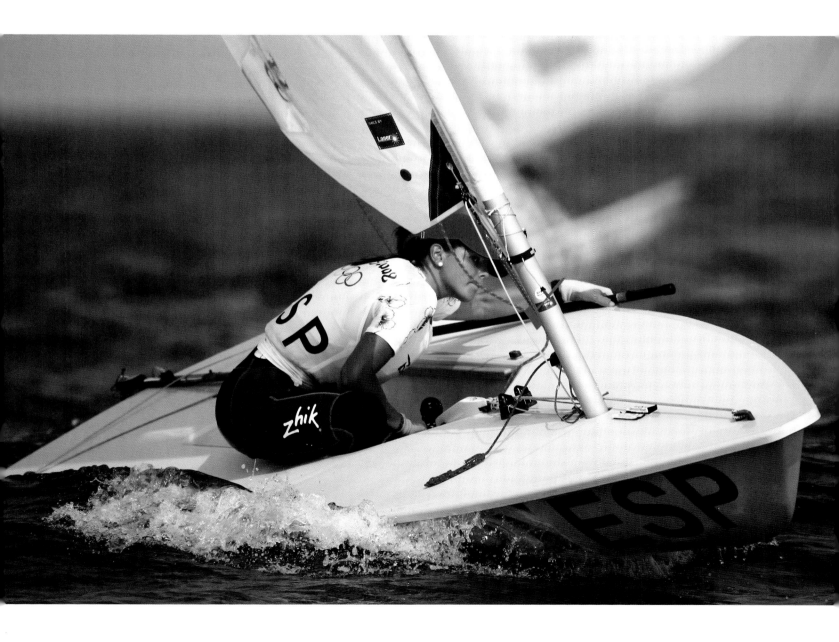

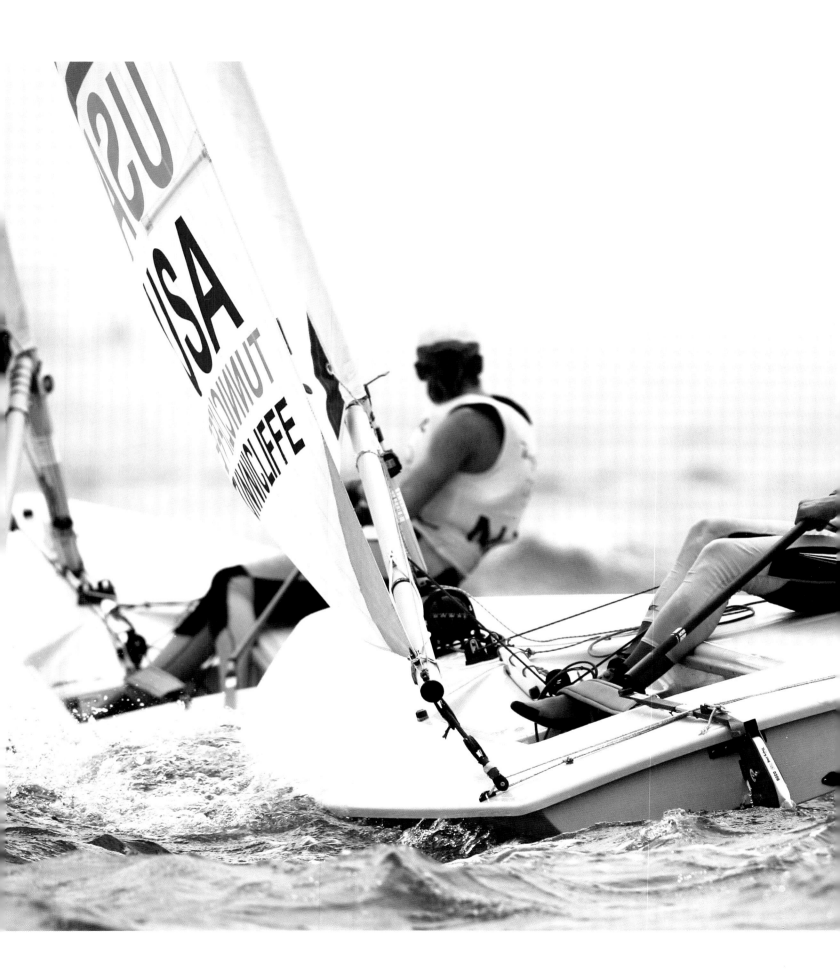

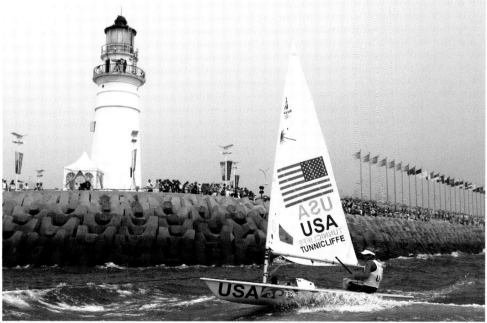

Anna Tunnicliffe from the US won the Laser Radial gold medal in Qingdao from Lithuania's Gintarè Scheidt (née Volungevičiūté – she is married to multiple Olympic medallist Robert Scheidt) and China's Lijia Xu.

Overleaf: It was 2008 when the Laser Radial replaced the Europe dinghy as the Women's single-hander. The Europe was the previous incumbent at four Olympics, from 1992 to 2004. This is the battle for medals in Sydney Harbour in 2000.

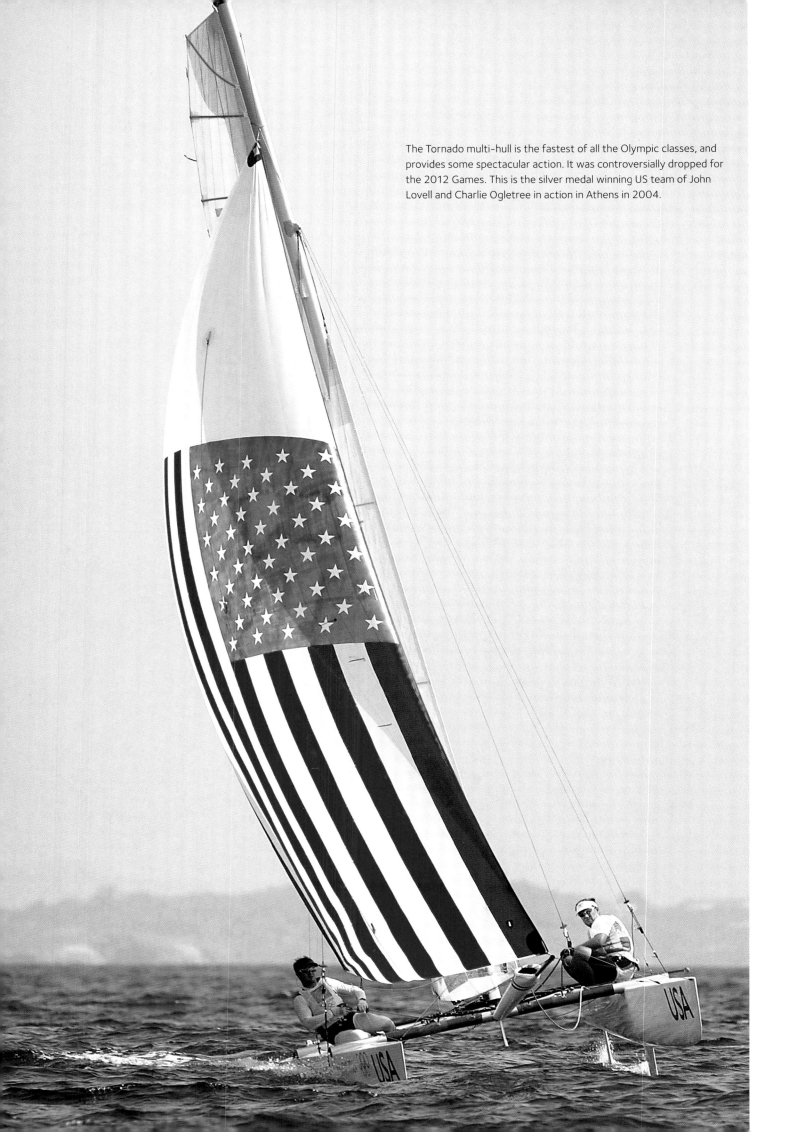

The Tornado multi-hull is the fastest of all the Olympic classes, and provides some spectacular action. It was controversially dropped for the 2012 Games. This is the silver medal winning US team of John Lovell and Charlie Ogletree in action in Athens in 2004.

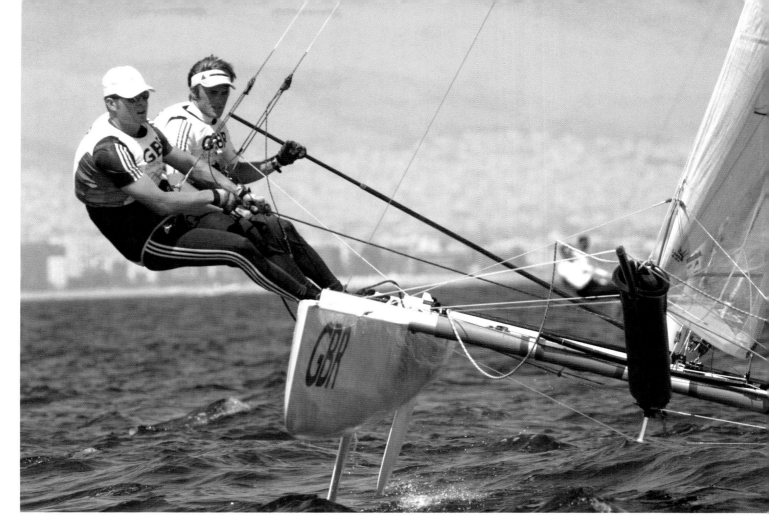

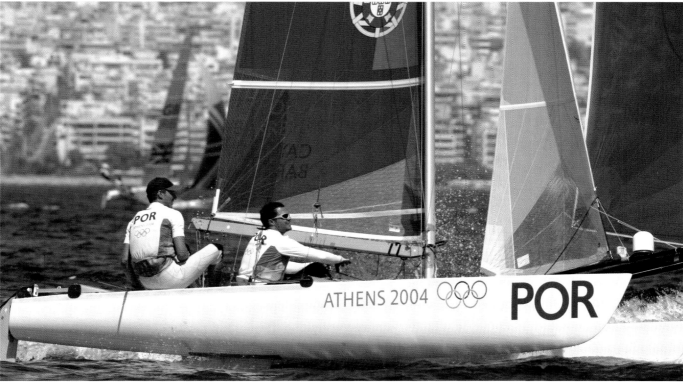

Top: The British Tornado team in Athens in 2004 was Leigh McMillan and Mark Bulkeley who were 13th – McMillan changed crews for 2008 and sailed with Will Howden, but still fell short of a medal with a sixth place.

Above: Diogo Cayolla and Nuno Barreto from Portugal race in the Tornado event in Athens in 2004. The addition of the spinnaker in 2000 made the boat an even bigger handful!

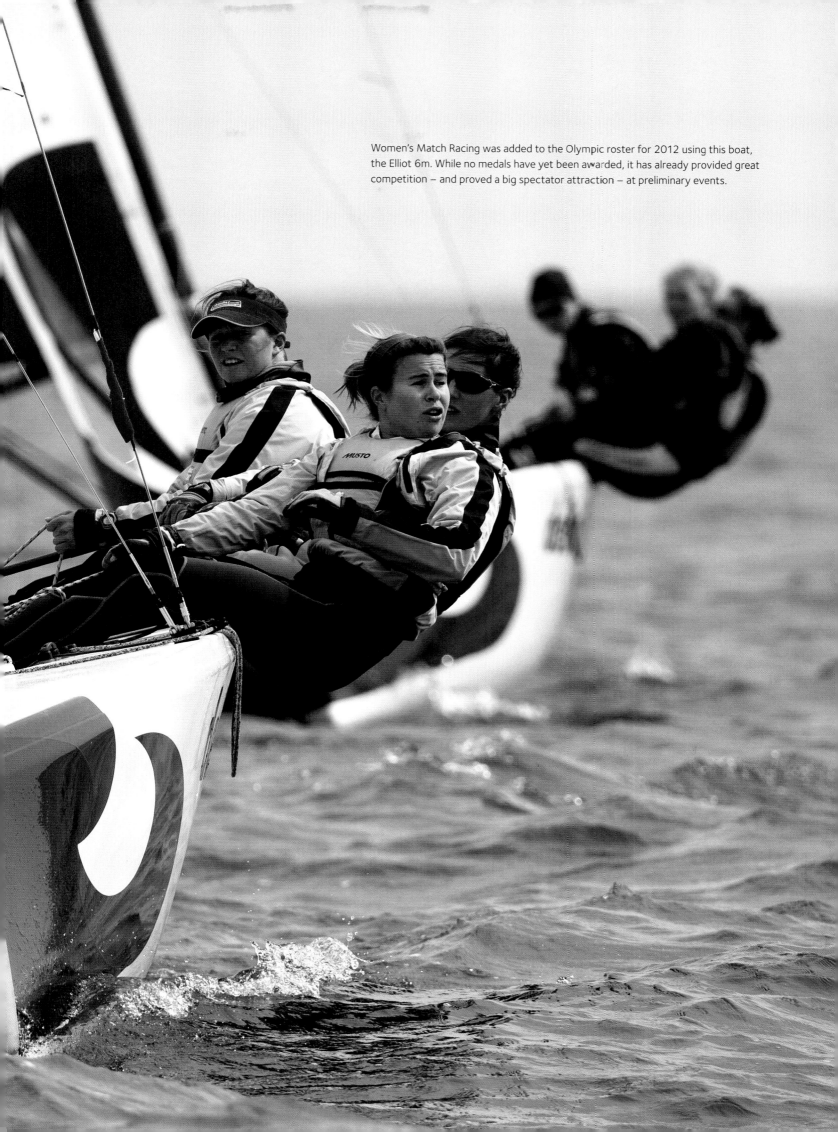

Women's Match Racing was added to the Olympic roster for 2012 using this boat, the Elliot 6m. While no medals have yet been awarded, it has already provided great competition – and proved a big spectator attraction – at preliminary events.

Fabulous Locations

IF THE SELECTION of the Olympic sailing classes and events has often been accompanied by controversy, it's nothing compared to the brouhaha that goes with the International Olympic Committee's choice of venue – and whatever factors redoubtable IOC members take into account when they cast their votes every four years, it's almost certainly not the appropriateness of the sailing site. The result has been a wide range of locations for the Olympic racing, from the weird to the truly wonderful.

Many of the early venues fall into the former category. The River Seine at Meulan, 30km downstream from Paris, was not a good place to go sailboat racing, and yet the Olympic regatta took place there not once, but twice; in 1900 and 1924 (although on both occasions the bigger boats got a better deal, racing at the mouth of the Seine at Le Havre). The Paris venues are in a rare category having twice hosted the Olympic sailing; only Long Beach in Los Angeles and Kiel in Germany can also make that claim – not counting the regatta that never happened in Athens in 1896. Los Angeles was the Olympic venue in 1932 and 1984, while Kiel was chosen to host the sailing for Berlin in 1936 and Munich in 1972.

In 1936, Kiel was primarily a military base, and the sailing had to accommodate the wishes of Hitler's burgeoning navy. By 1972 it couldn't have been more different – the Germans built what are still exceptional facilities, now the centrepiece of the annual Kiel Week regatta. If Kiel had a flaw it was a common

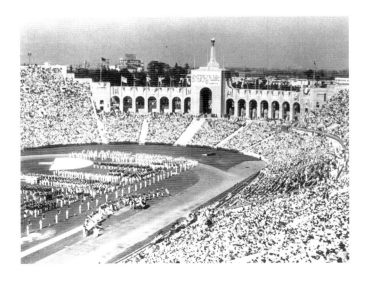

Left: The opening ceremony at the Los Angeles Olympic Games in 1932 – in post-Depression America, the Games needed a lot of subsidy and this one saw the first Olympic Village built.

Opposite

Top: The view through the Olympic ring shaped windows in the hostel built to house the sailing teams at Kiel for the 1936 Berlin Games – Kiel was largely a military base at the time.

Bottom: German submarines in the harbour at Kiel in 1936 – Kiel is one of only three places to have hosted the sailing twice; it was also the venue for the 1972 Munich Games. The other two are Los Angeles (1932 and 1984) and Paris (1900 and 1924).

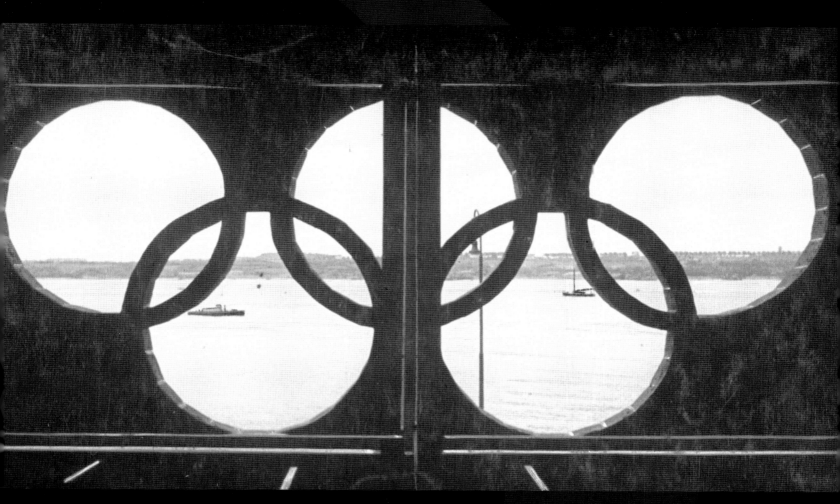

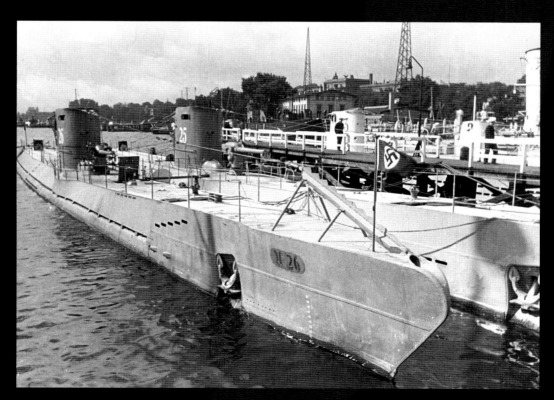

Left: A postman delivers a letter to the French sailors in Kiel harbour during the 1936 Games.

Below: Three race areas were created in the Firth of Kiel for the six events at the 1972 Olympics.

Opposite: Long Beach, just south of Los Angeles, was host to the Olympic sailing in 1984. Four race courses were set up to the south of the harbour for the seven events.

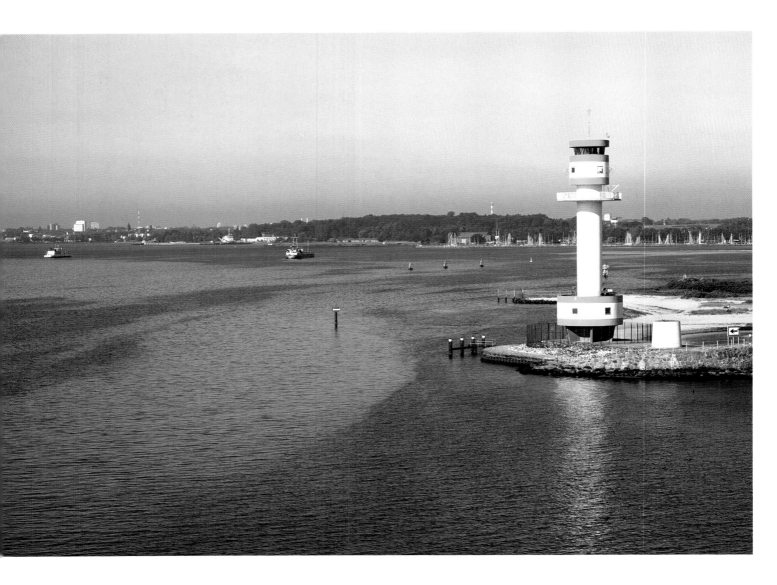

one – distance from the main event site. Too often, sailing has been stuck miles from the Olympic city and as easily forgotten as a mislaid pencil. The honourable exceptions amongst the early regattas were in 1952 when the racing was on the waters due south of Helsinki, and four years later at Melbourne when all the sailing was on Port Philip Bay.

It was Los Angeles in 1984 before sailing was once again part of the main event, and since then the sport has fared better. The great coastal cities of Barcelona in 1992, Sydney in 2000 and Athens in 2004 all provided stunning backdrops and a home in the heart of the action – more than making up for any question marks over the quality of the venues for the actual racing. Unfortunately it was impossible to put the sailing close to the main site at the other three recent Olympics

(Seoul, Atlanta and Beijing), so you'd think that with a whole country to choose from the selected venue would be wonderful. History tells us otherwise.

The 1988 Olympics were centred on the South Korean capital of Seoul, but the sailing was dispatched to the far south of the country – Pusan, the second city and main port. Olympic myth has it that the weather records indicated light winds, but when everyone got there it blew dogs off chains for days on end. The story was that the measurements were taken in the lee of a hill, and from then on all the teams with the resources have done their own meteorological research. Eight years later, the main problem with the venue chosen for the Atlanta Games was different; it was seriously inaccessible. The sailing had to be based at temporary marinas created from barges, located off the marshland

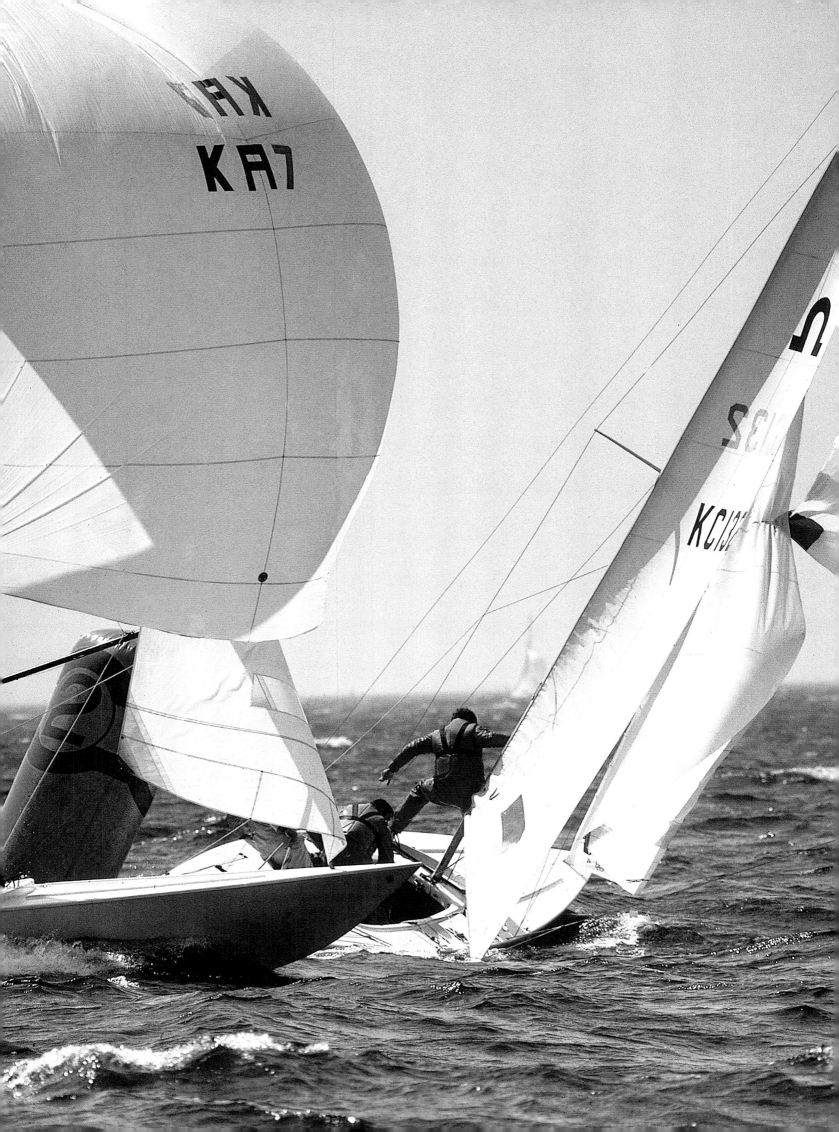

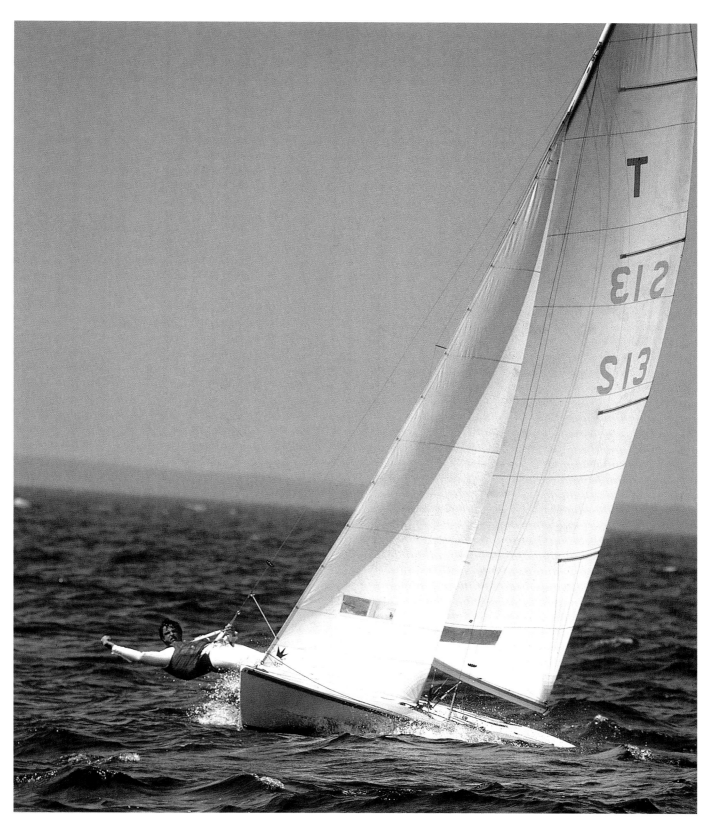

Facing page: Soling action at the gybe mark during the 1976 Montreal Games, held on Lake Ontario. It's the only Olympics to have sailed all the races on fresh water.

Above: Sweden's John Albrechtson and Ingvar Hansson race their Tempest to a gold medal on Lake Ontario at the 1976 Games. Three course areas were set up south of Portsmouth Olympic Harbour in Kingston.

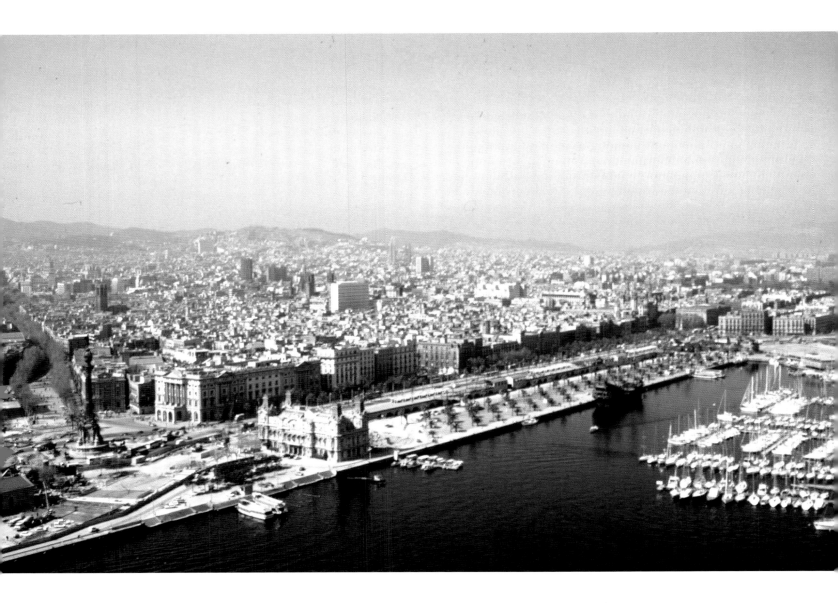

In 1992 the stunning Spanish city of Barcelona provided one of the most beautiful ever Olympic backdrops, and sailing was right at the heart of the Games.

surrounding Wilmington Island, a suburb of Savannah. The racing was out on the shallow Wassaw Sound, and then prone to intervention by thunder, lightning and calms.

There was never any question of the 2008 Olympic sailing venue being close to land-locked Beijing, but there were plenty of concerns about the eventual choice of Qingdao, on the west coast of the Yellow Sea. There were strong tides, not much wind (except when there

was too much) and thousands of troops and fishing boats had to spend weeks clearing an estimated million tonnes of algae from the race course so the regatta could start. There have been better sailing venues. The competitors are probably affected by the site of sailing's four yearly field of dreams to a greater degree than in any other Olympic sport – but coping with what is dealt to you is all part of being a true champion.

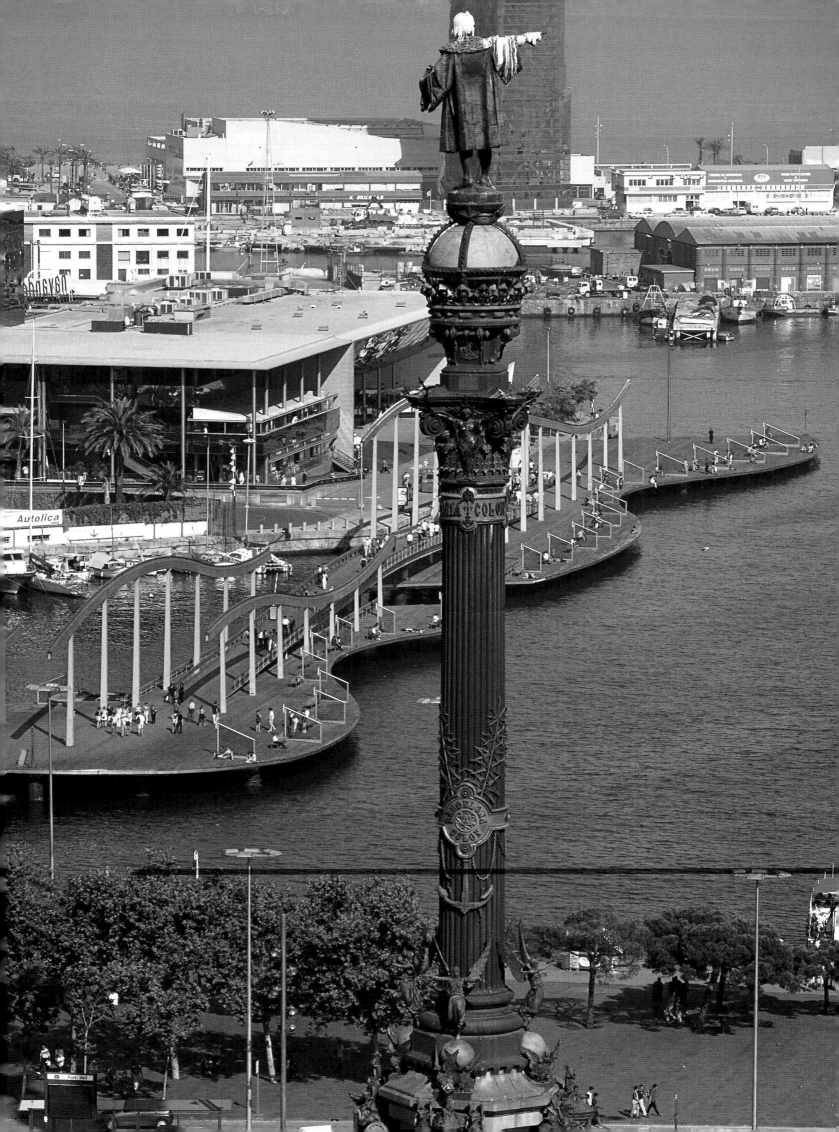

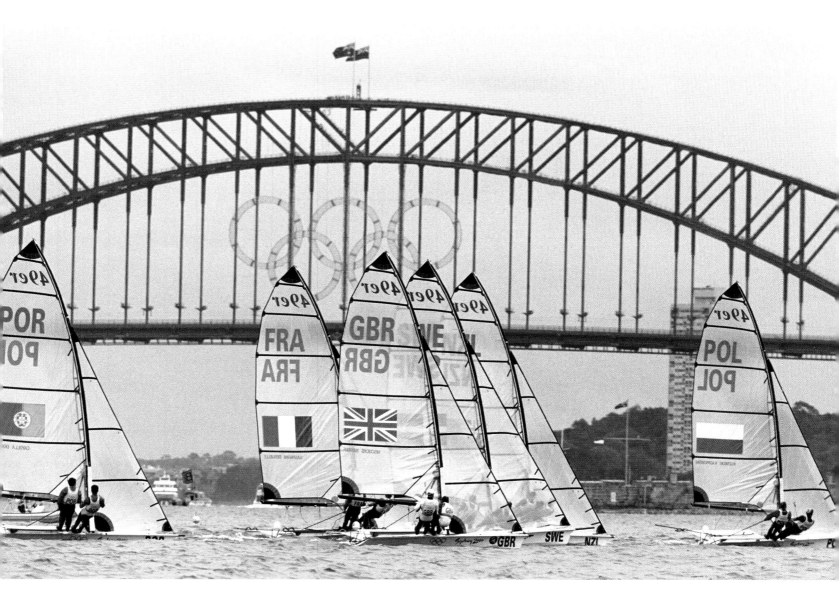

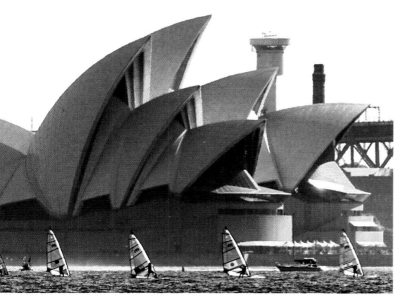

After Barcelona it was 2000 when sailing next found itself at the centre of the action. Many of the sailing events were held on Sydney Harbour against the backdrop of the famous Coat Hanger bridge and the iconic Opera House.

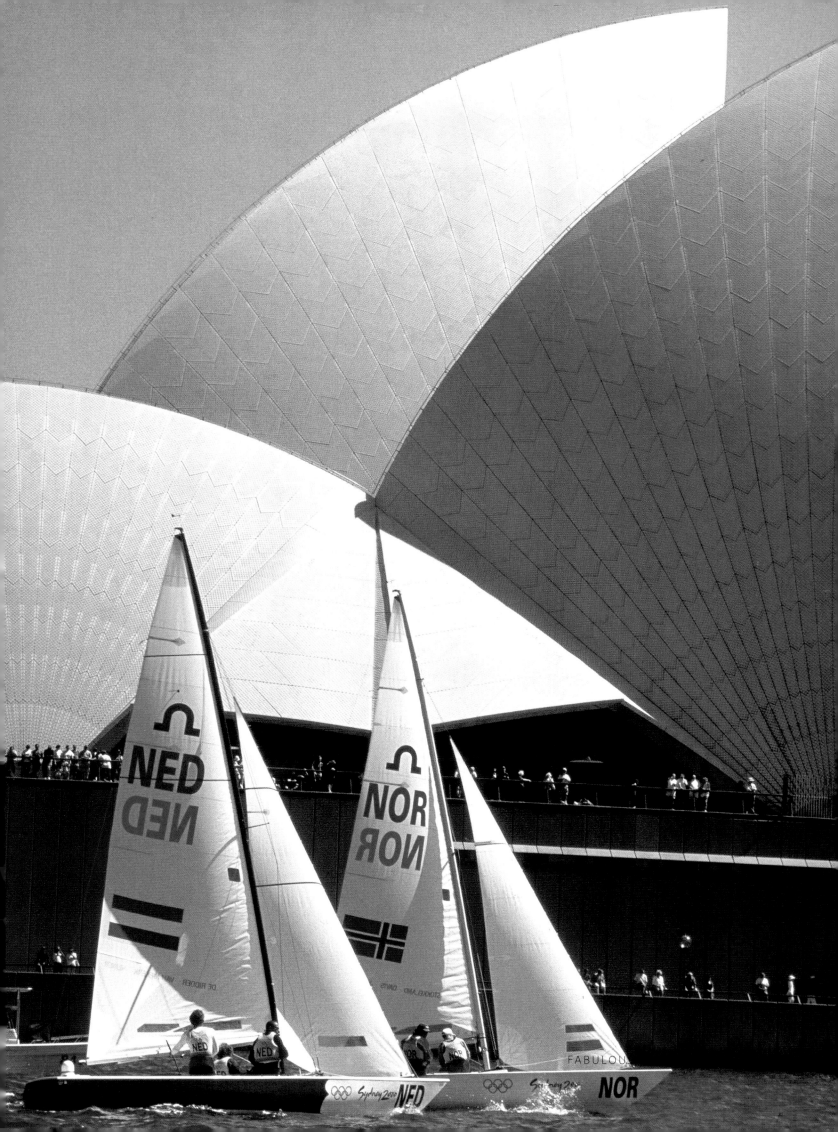

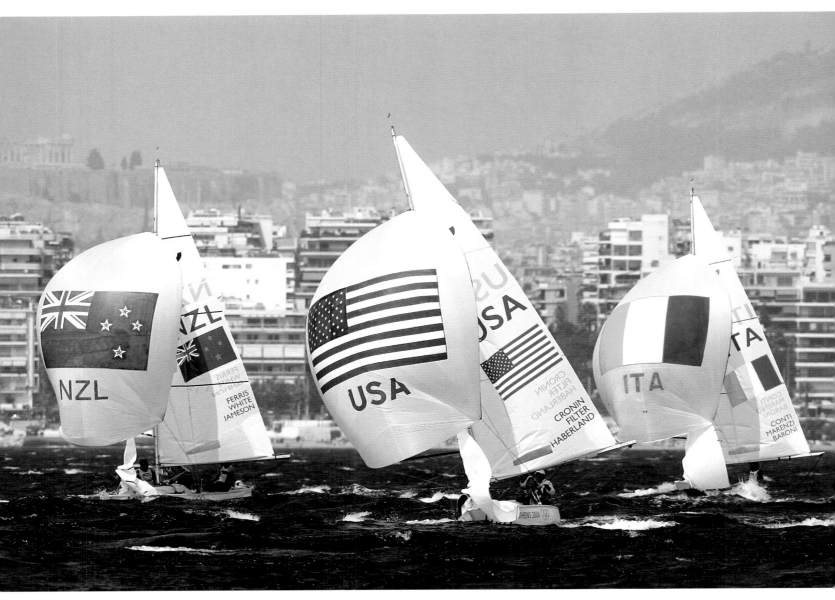

Above and left: After the fabulous locations of Barcelona and Sydney came Athens in 2004 – the Women's Yngling (top) and the Men's Star class (bottom) race in full view of the Acropolis.

Opposite: The Finns race downwind in a strong Athens breeze – the wind conditions varied markedly during the Games.

It wasn't anywhere near Beijing, the host city for the 2008 Games, but the coastal city of Qingdao nevertheless provided a spectacular and uber-modern backdrop for the Olympic sailing – in this case for a 49er race start.

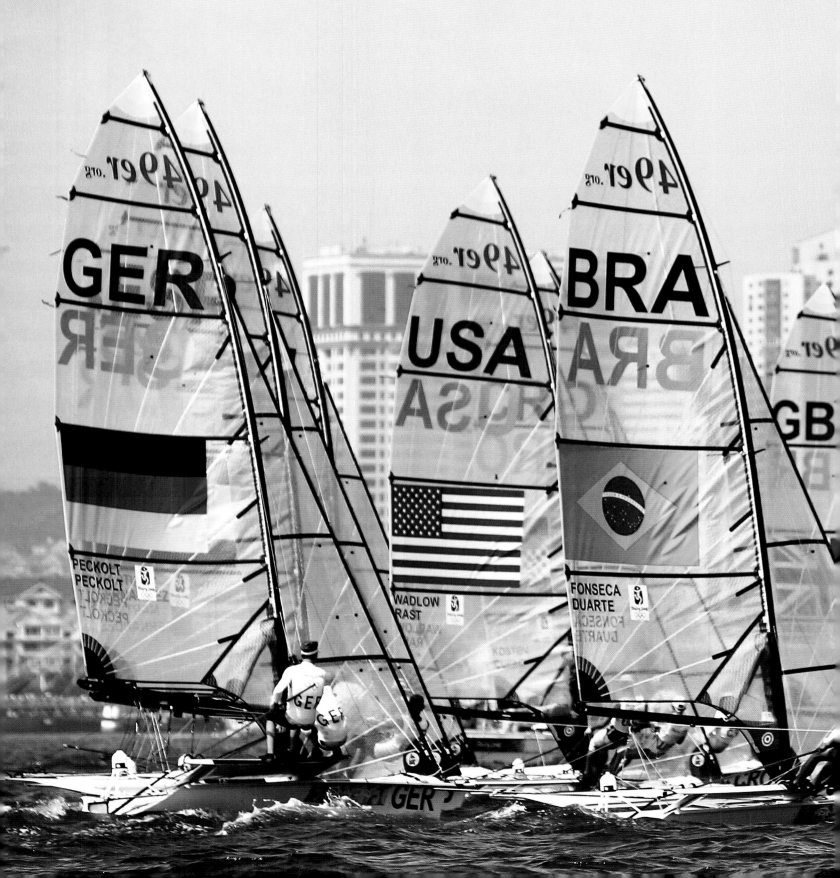

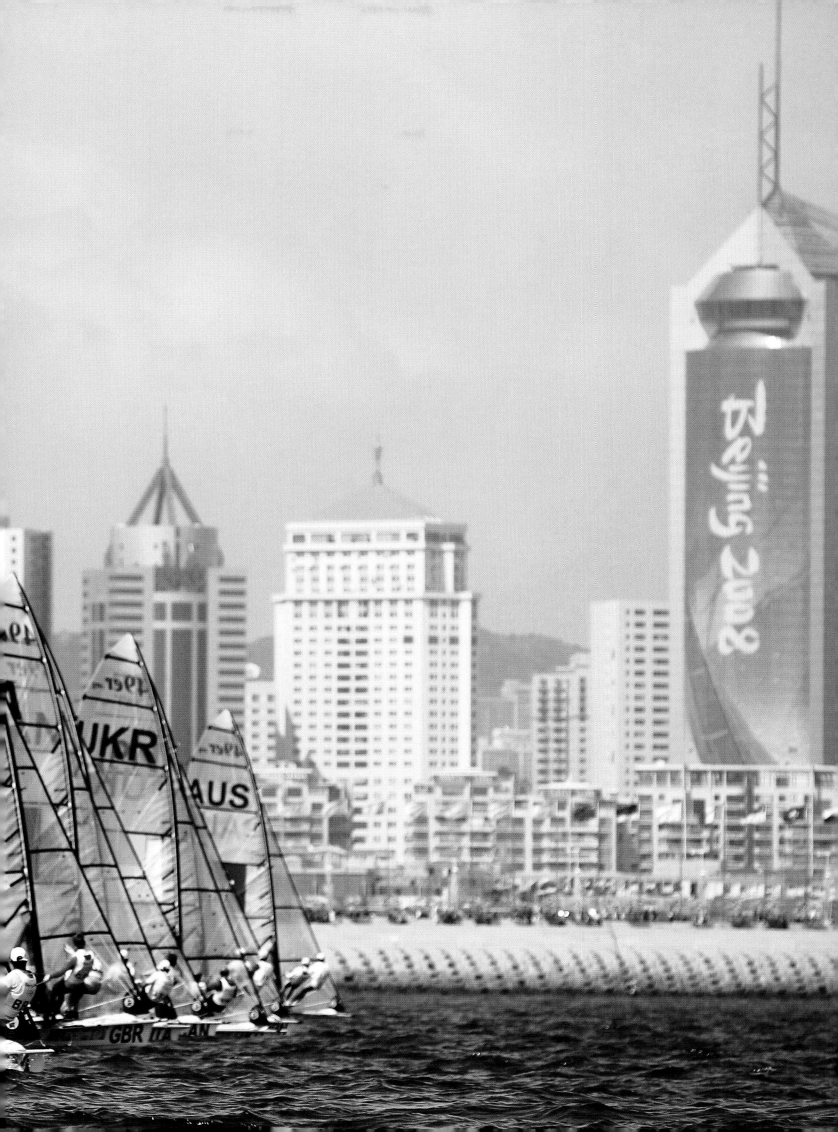

This page: Despite Qindgao's distance from the main events in Beijing, the sailing still attracted plenty of media attention for the competition.

Opposite: The Netherlands' Mitch Booth and Pim Nieuwenhuis chase Britain's Leigh McMillan and Will Howden against a Qingdao cityscape. The overall results were reversed, with Booth and Nieuwerhuis fifth, one place ahead of McMillan and Howden. Booth had previously won a bronze and silver medal representing Australia in 1992 and 1996.

Overleaf: Britain's Iain Percy and Andrew Simpson won gold in the Star class in Qingdao. It was Percy's second medal, after winning gold in the Finn in Sydney in 2000.

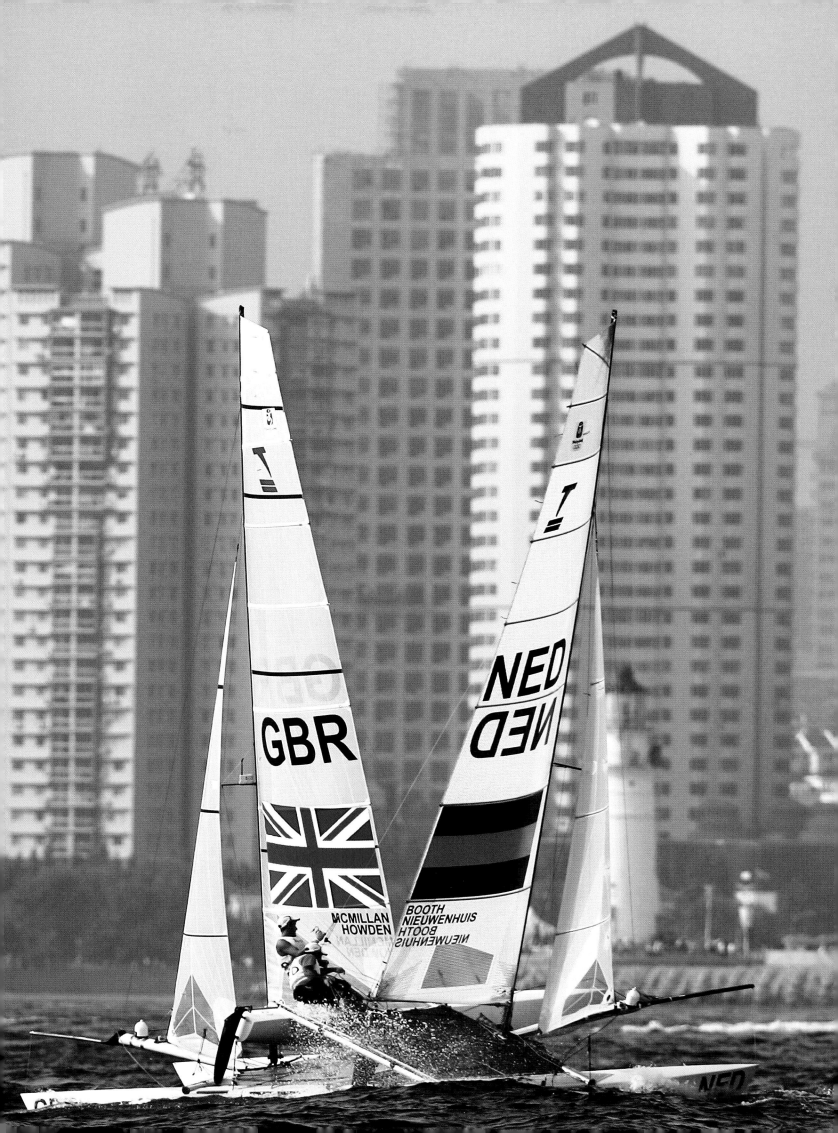

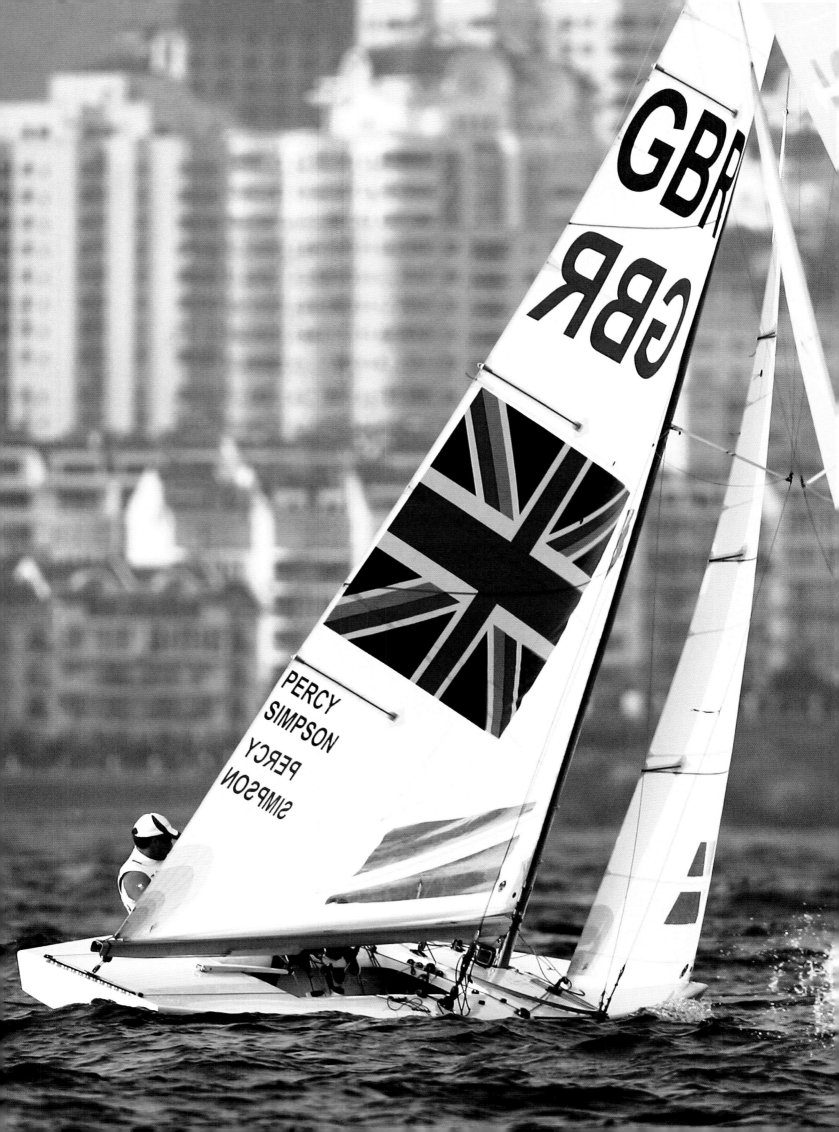

It wasn't just the extraordinary cityscape: Qingdao proved to be a vibrant Olympic sailing venue.

Overleaf: The 2012 Olympic venue at Weymouth was finished in plenty of time and in 2011 hosted Skandia Sail for Gold, which is part of the ISAF Sailing World Cup. In this picture, the Star fleet race against a backdrop of the English coastline.

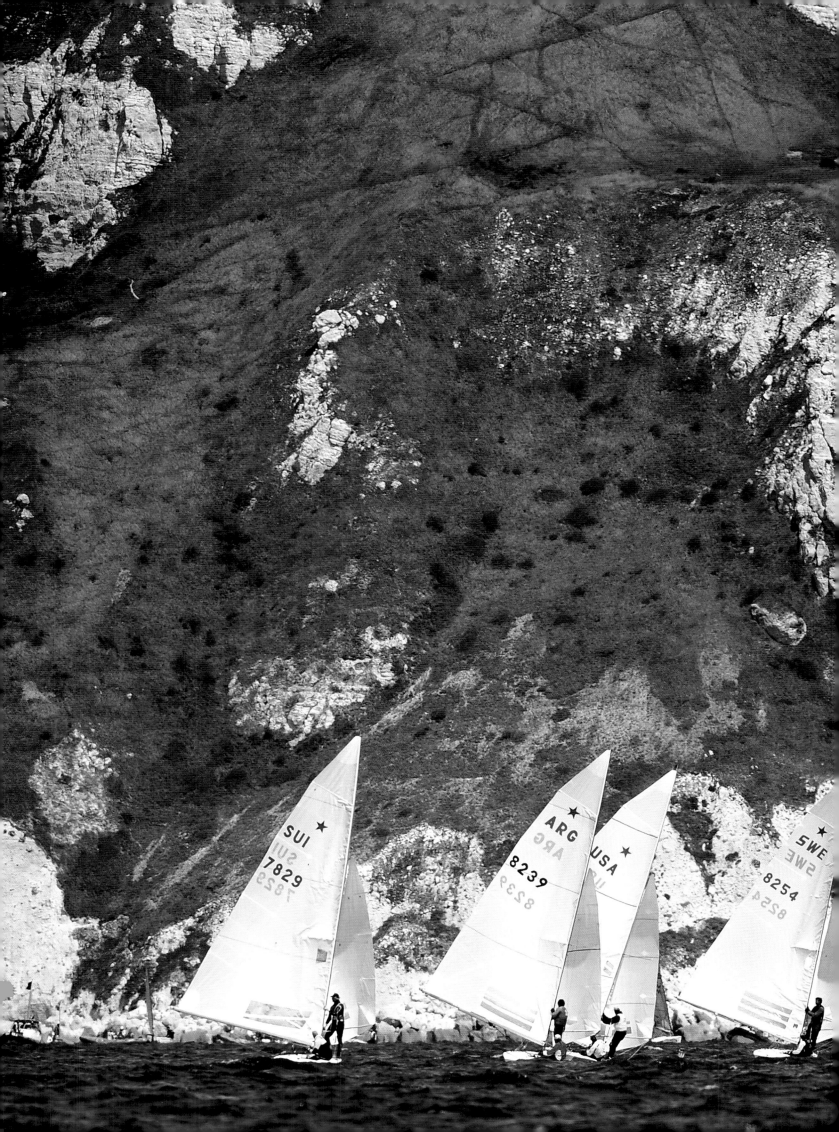

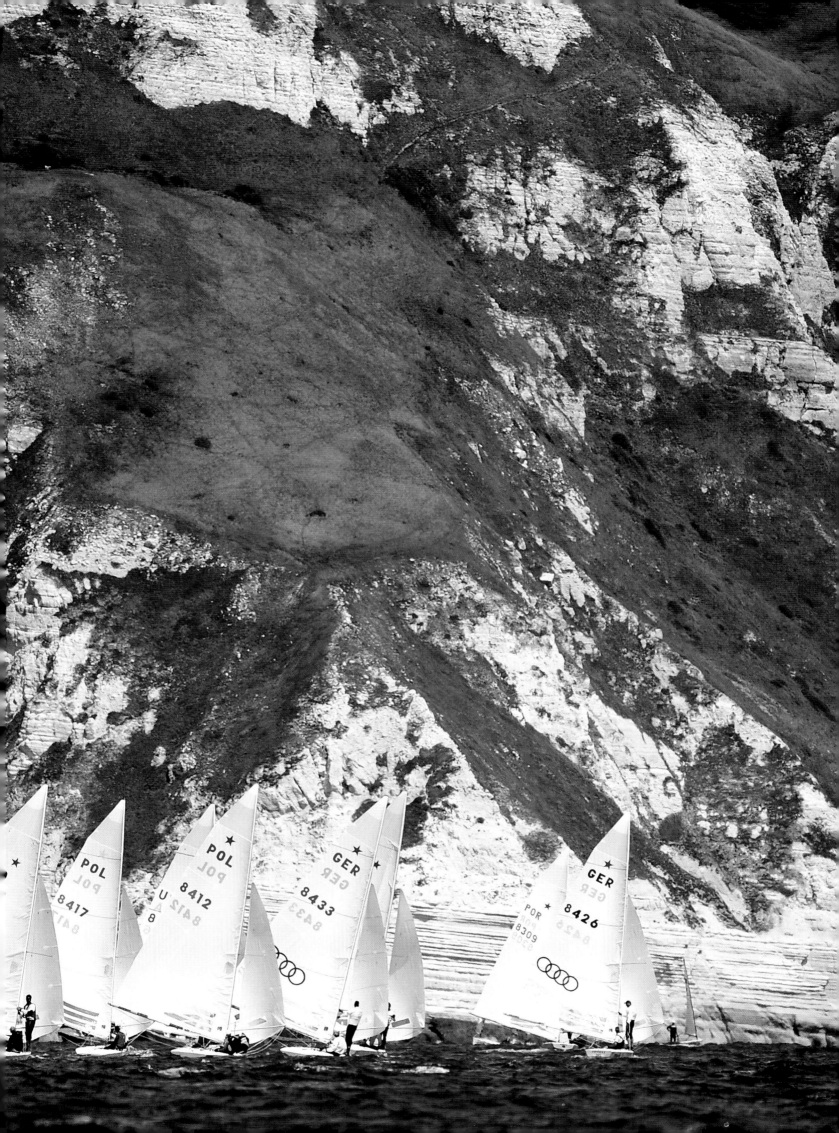

Above: To win his fourth gold medal, Ben Ainslie (gold spray top) first has to qualify for Team GBR – at this 2011 Weymouth qualifying regatta, compatriot Giles Scott (blue spray top) was doing everything he could to stop him.

Top right: The 49er fleet races downwind at Skandia Sail for Gold 2011 – there were five British boats in the top ten overall.

Bottom right: Mark Mendelblatt and Brian Fatih of the US race at Skandia Sail for Gold 2011. They face a tough battle for selection for 2012, as America has traditionally been strong in the Star class.

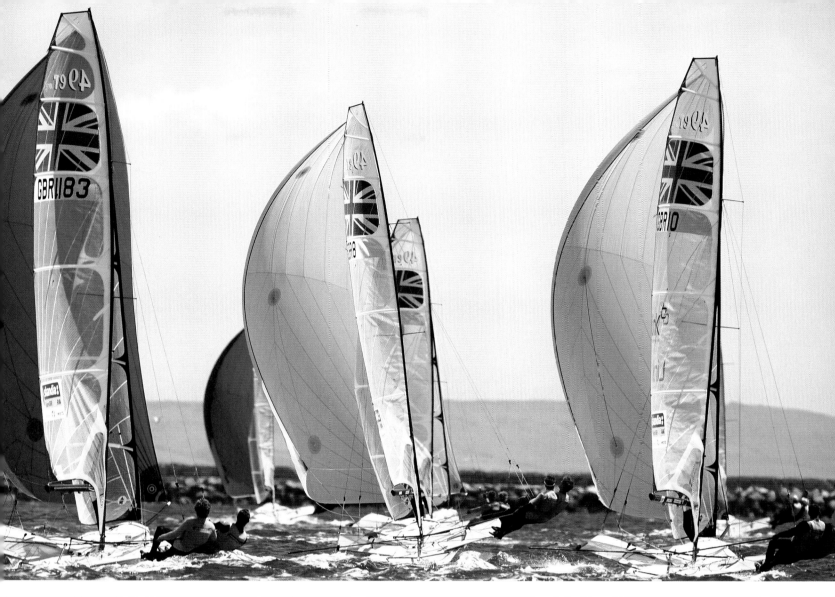

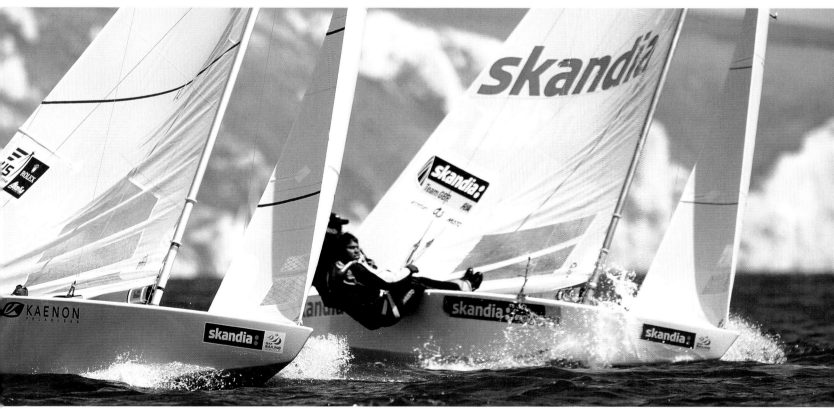

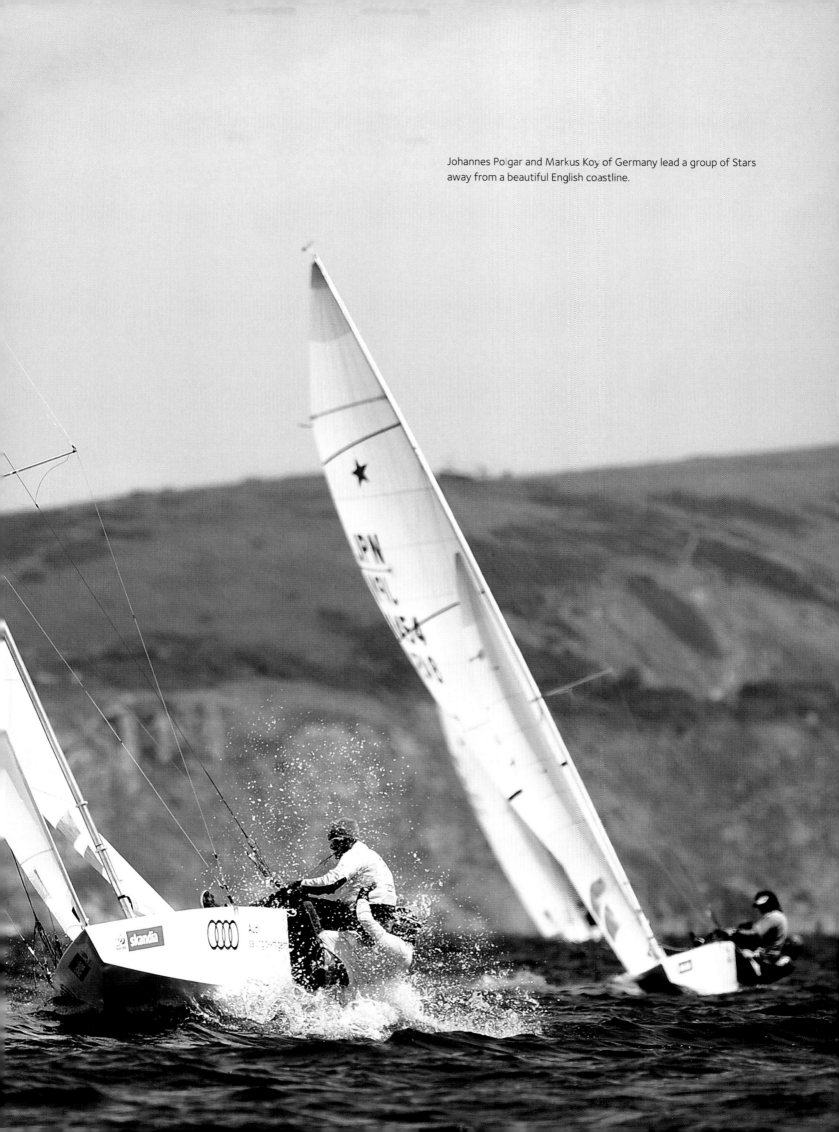

Johannes Polgar and Markus Koy of Germany lead a group of Stars away from a beautiful English coastline.

Icons, Gold and Glory

OLYMPIC GREATNESS is measured in quality, not quantity; it's gold that counts for glory and iconic status, which makes Paul Elvstrøm the undisputed Olympic master approaching the 2012 London Games. Before Elvstrøm began to dominate the sport in the 1950s, winning medals had been a little different. The use of the International Metre Rule yachts emphasised the role and importance of both the designer and the boat, compared to contests that took place after the Olympic movement's widespread adoption of one designs. And as some of those Metre Rule yachts allowed for crews of ten or more, the medals were generally a less potent reflection of individual prowess.

But given those parameters, one man still stands out for his record in the first half of the twentieth century; Tore Holm was a highly successful yacht designer, sailing in four pre-Second World War Olympics as well as the 1948 Games in Torquay. He won two gold and two bronze medals in boats that he had designed – a remarkable effort. We should also doff our caps to the Norwegian Magnus Konow, who sailed in the Six Metre, Eight Metre or Twelve Metre classes in five of the pre-war Games, and was still going in Torquay in 1948 at the age of 60. He finally retired with a tally of two golds and a silver.

It was 1956 before Paul Elvstrøm eclipsed these two men with his third gold medal, and 1960 when he set the bar to its current high level. The sailing world had to wait until 1976 before anyone got close to beating

Below and right: Virginie Hériot was one of the earliest women sailing icons – she was a yachtswoman all her life, and won a gold medal in the Eight Metre class at the 1928 Amsterdam Olympics.

Opposite: Torben Grael holds the record for the greatest number of Olympic sailing medals won, with two golds, two bronzes and a silver. He's seen here racing in the Star in Athens with his long-term crew, Marcelo Ferreira – this was one of their gold medal victories.

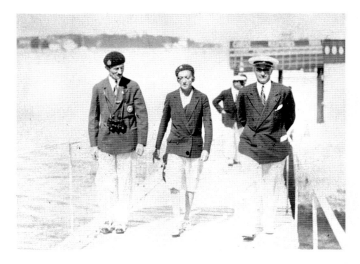

Elvstrøm and then, like buses, two men came along at once – both with two golds and a good shot at a third. Britain's Rodney Pattison was chasing his third Flying Dutchman win, after dominating the class in 1968 and 1972. He started well, but faded in the last three races to be pushed back into the silver medal. It was Pattison's last appearance at the Olympics. He was unable to attend in 1980 because of the boycott, and was beaten for selection in 1984 by Jo Richards and Peter Allam, who went on to win bronze in Los Angeles.

The second man chasing gold medal number three was Valentin Mankin of Russia. He won his first gold in the Finn in 1968, and swapped to the Tempest to get his second in 1972. In 1976 he was back in the

Above: After women gained their own events, the Netherlands' Margriet Matthijsse was one of the early stars, winning silver medals in the single-handed Europe dinghy in 1996 and 2000.

Opposite: Britain's Rodney Pattisson dominated the Flying Dutchman class in the late sixties and early seventies, winning two golds and one silver medal. This is Pattisson in his pomp – racing with Iain MacDon-ald-Smith, winners of the Flying Dutchman gold medal at the Mexico City Olympics in 1968.

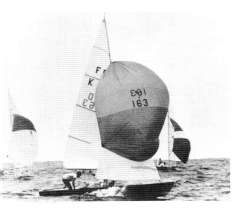
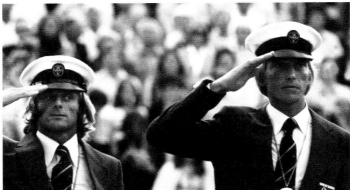

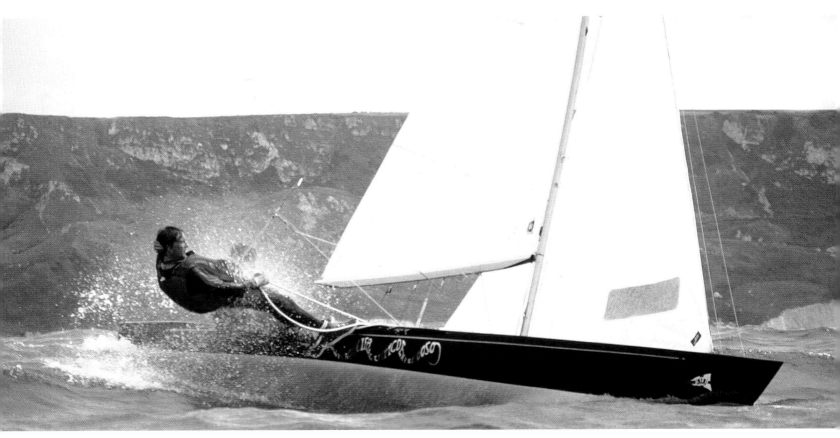

Tempest, but just like Pattison, Mankin fell short with a silver. However, the Russian wasn't done, and when the Games came to Moscow in 1980 he produced a great performance in the Tempest, winning three races to take a third gold and his fourth medal at the age of 41. It placed him alone and just one rung lower than Elvstrøm in the pantheon. But by the end of that decade both Mankin and Pattison were out of the running for Elvstrøm's record, and others were pushing hard at Olympic immortality.

Above: From 1976 until he was finally surpassed by Ben Ainslie in 2008, Rodney Pattisson was Britain's top Olympic sailor. Clockwise from top left: racing to gold off Acapulco in 1968; saluting with Julian Brooke-Houghton, winning silver in Kingston in 1976; in 1979, just before the RYA's 1980 boycott stopped him getting any closer to Paul Elvstrøm's record; and doing what he did best.

Opposite: With three golds and a silver, Germany's Jochen Schümann (seen here racing to his final silver medal at Sydney in 2000) is one of three sailors sitting just below Paul Elvstrøm's record of four gold medals – the others are Ben Ainslie and Russia's Valentyn Mankin. Ainslie is the only one still competing at Olympic level.

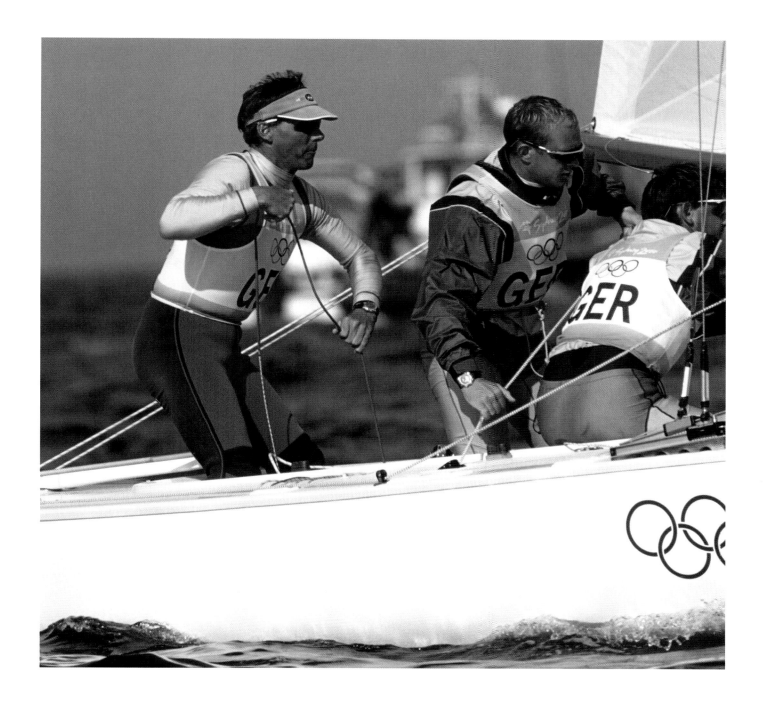

Jochen Schümann started his long Olympic sailing career representing East Germany. Behind the Iron Curtain, access to boats and gear was often limited; Valentin Mankin had the only Tempest in the whole of Russia when he won his gold medal in 1972. Schümann faced the same problem in 1976, but despite not having had a boat to trial against and never having won a big Finn regatta before the Games, he somehow found the speed to come away from Montreal with the gold medal. He then fell short in Moscow in 1980 with a

fifth in the same boat, missed the 1984 Games because of the boycott before finally winning a second gold in Seoul in 1988 after switching to the Soling.

The Soling and its mixed format of fleet and match racing obviously suited Schümann. Despite missing out in Barcelona in 1992 with a fourth, he went on to win his third gold medal in 1996 in Atlanta. So in 2000, at the age of 46, Schumann went to the Sydney Olympics with a chance of levelling Elvstrøm's record. He made it through to the match racing final against his great

Left: Jochen Schümann went to Sydney in 2000 with three gold medals and every chance of equalling Paul Elvstrøm's record. He met Denmark's Jesper Bank in the match racing final to settle gold and silver. At three-all in a seven race series Schümann was one win away from equalling Elvström – but Bank took the race and the gold medal.

Above: Jesper Bank, Henrik Blakskjær and Thomas Jacobsen celebrate their gold medal win in Sydney. It was Bank's second gold, along with a bronze from 1988. Between them, Bank and Schümann won all four gold medals in the Soling class between 1988 and 2000 – an epic rivalry.

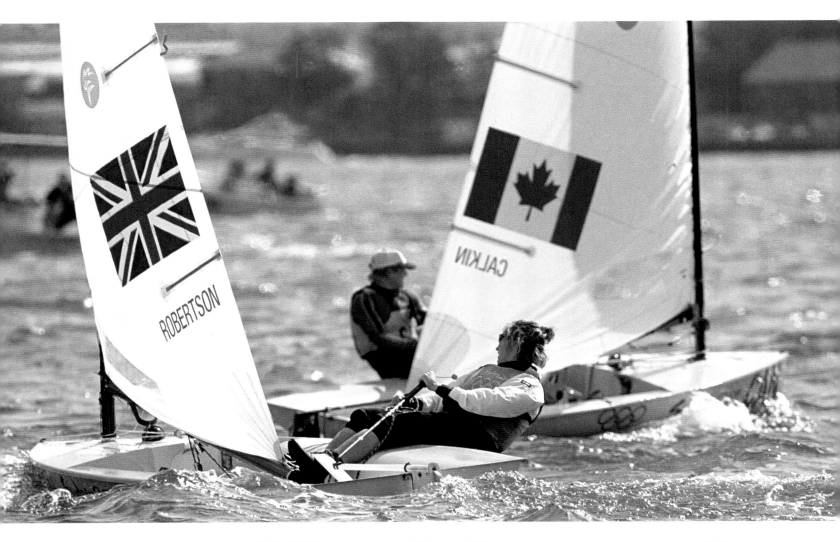

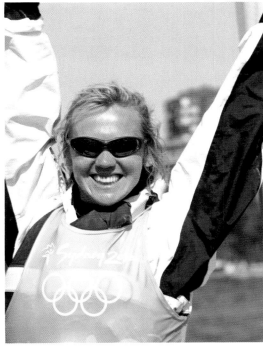

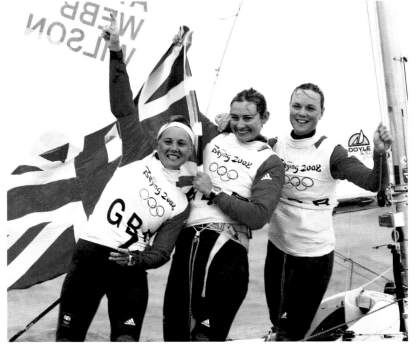

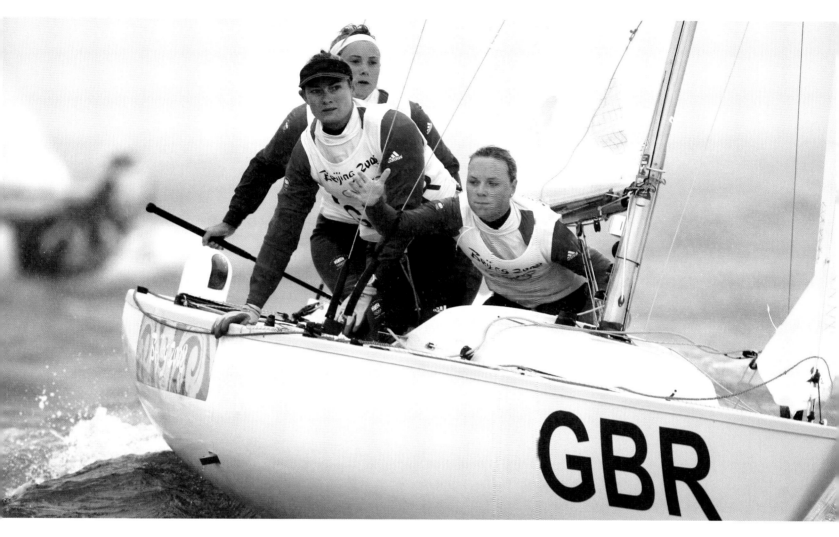

A remarkable quartet of British women sailors: Shirley Robertson starts the ball rolling with a gold medal in the Europe class in Sydney 2000 (opposite page top and bottom left); Sarah Ayton, Sarah Webb and Pippa Wilson win Yngling gold in Qingdao in 2008 (opposite page bottom right and above) – between those two triumphs, at the 2004 Olympics Robertson, Ayton and Webb won gold together in the Yngling.

Overleaf: Theresa Zabell wins her second 470 gold medal for Spain at the 1996 Atlanta Games, this time with Begoña Vía-Dufresne crewing.

rival in the class, Denmark's Jesper Bank. They traded blows until it was three-all in a seven race series, with Schümann just one short race win away from equalling Elvstrøm. It wasn't to be: Bank took the race and the gold medal (his second), leaving Schümann equal with Mankin on three golds and one silver.

Women have had a tougher time amassing serious metal. Forced to compete against the men until 1988, opportunities have been slowly opening up ever since. If it's gold that counts, then four women have forced their way to the top of the pile. First to go double was Spain's Theresa Zabell who won gold in the 470 at two successive Olympic Games, starting at home in

Barcelona in 1992 and then repeating the feat four years later in Atlanta. The other three are all British: Shirley Robertson started the ball rolling in 2000 with gold in the Europe single-hander in Sydney. She then switched to the Yngling to sail with Sarah Ayton and Sarah Webb and together they won gold in 2004. Ayton and Webb then split to sail with Pippa Wilson, beat Robertson to qualify for 2008 and went on to win gold again. All four double gold medallists have now retired from Olympic racing – but that makes it a rare record that definitely won't be beaten in 2012.

If the women haven't had much time to hoard gold, silver and bronze, then the Paralympians have had even

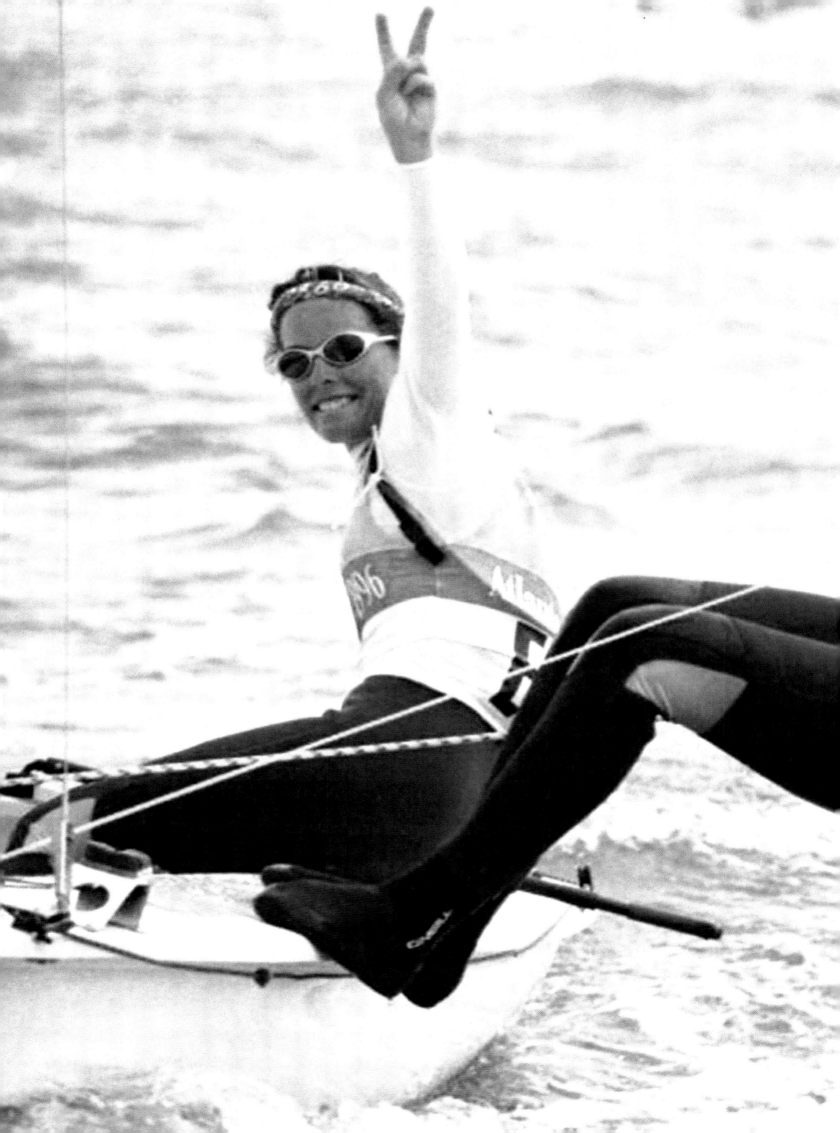

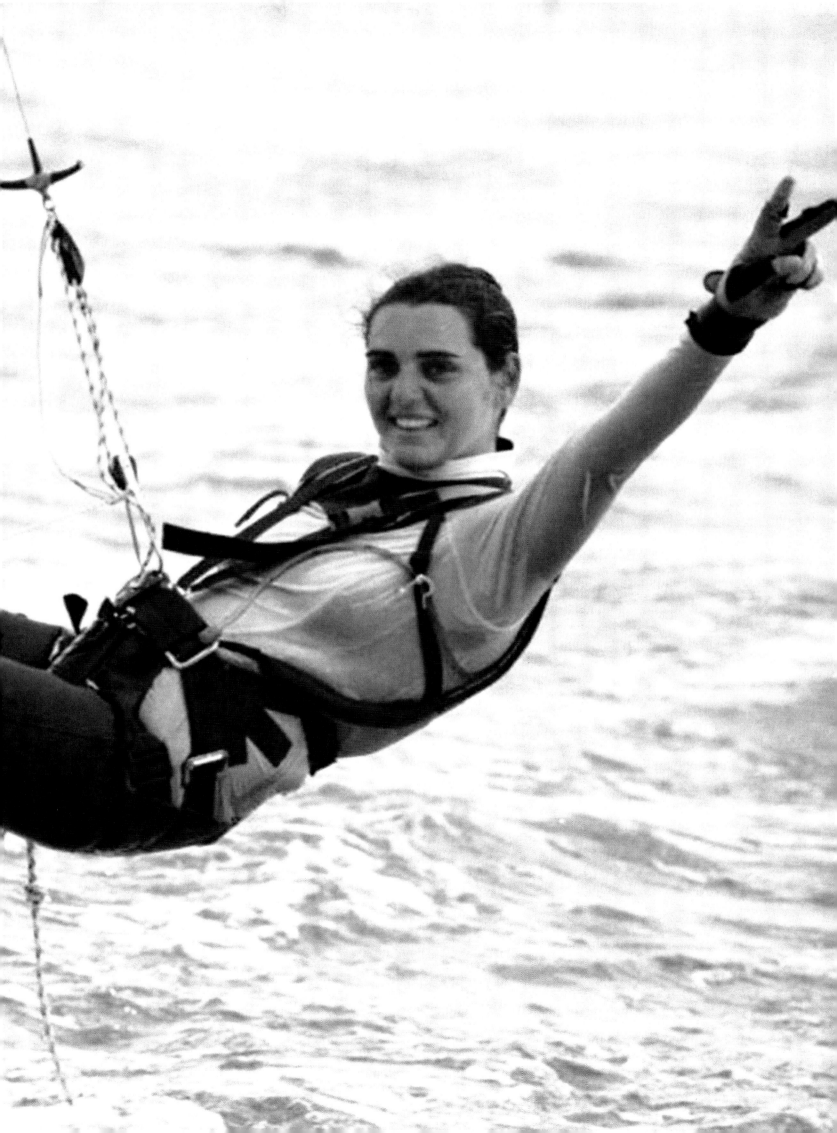

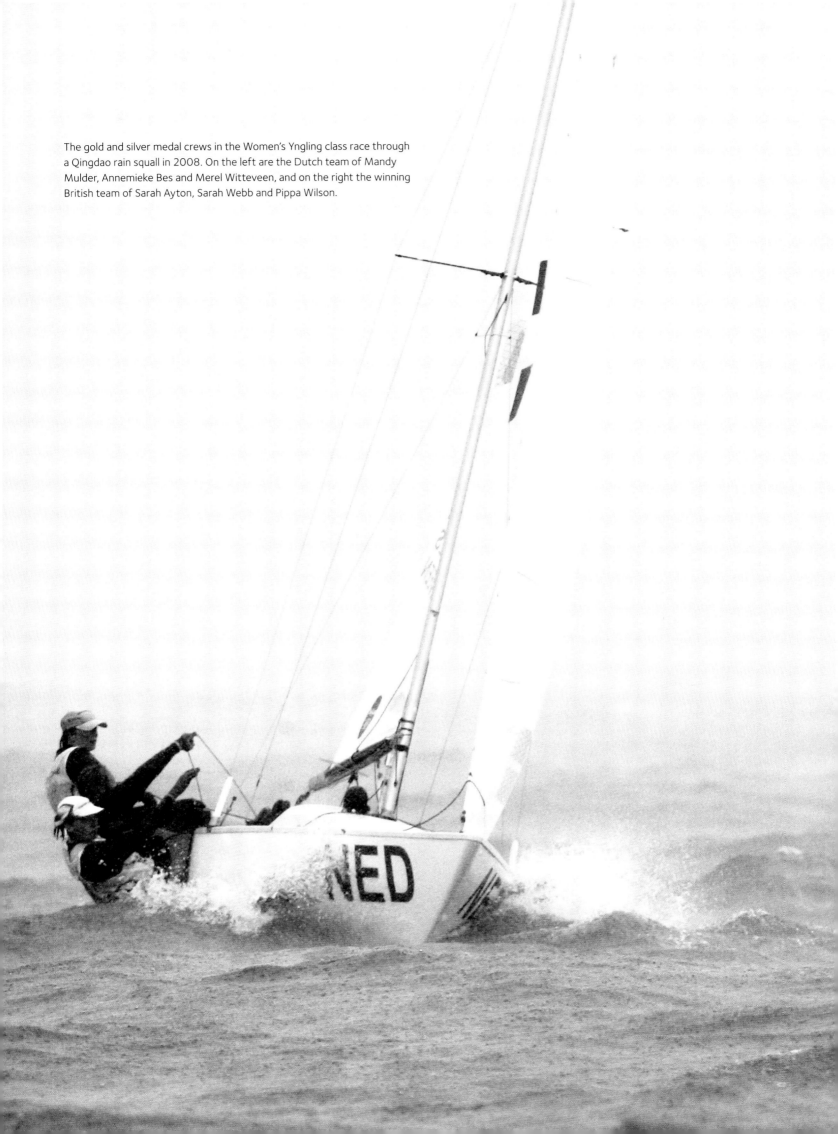

The gold and silver medal crews in the Women's Yngling class race through a Qingdao rain squall in 2008. On the left are the Dutch team of Mandy Mulder, Annemieke Bes and Merel Witteveen, and on the right the winning British team of Sarah Ayton, Sarah Webb and Pippa Wilson.

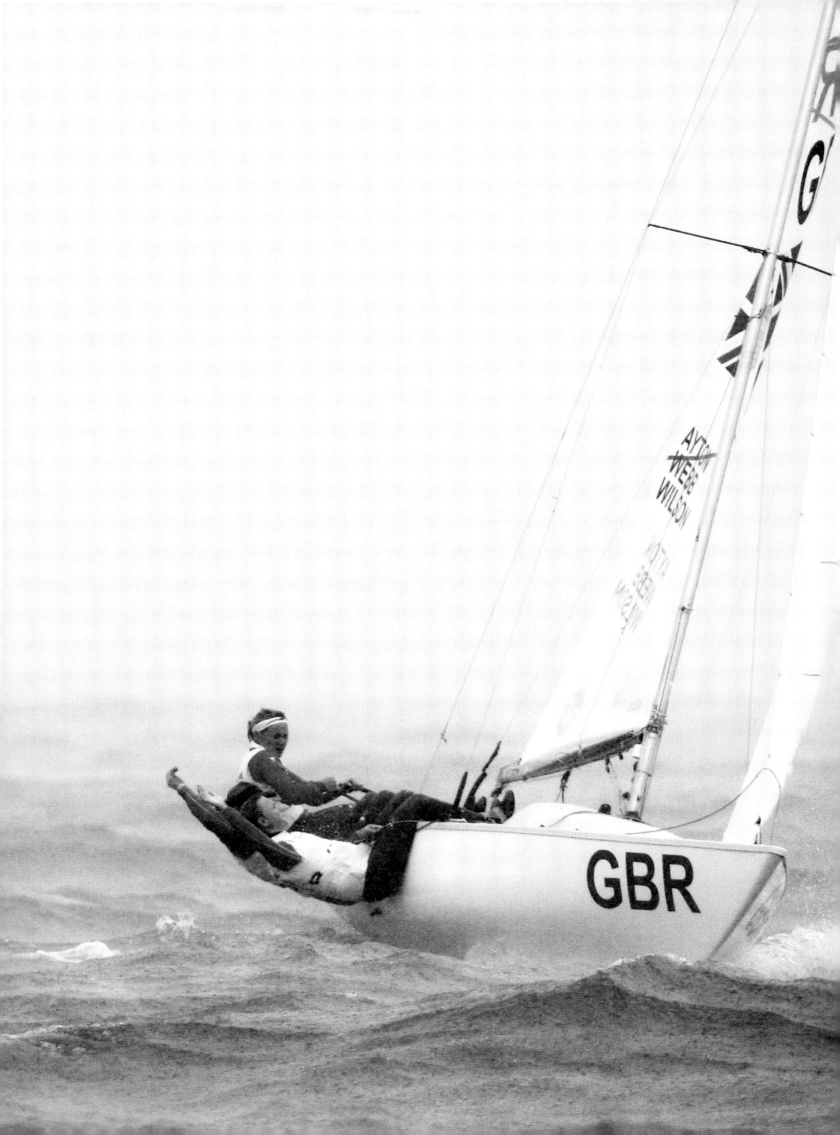

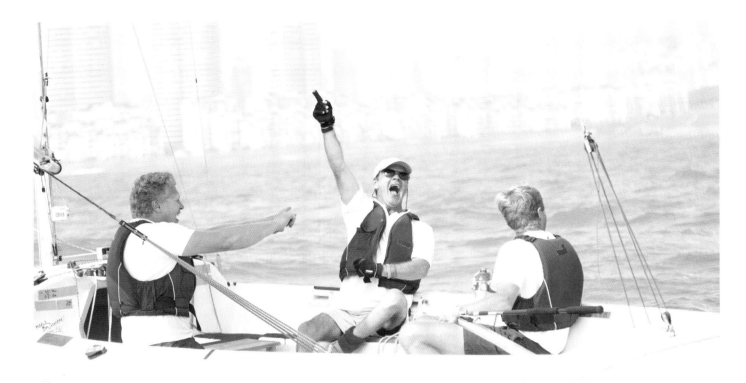

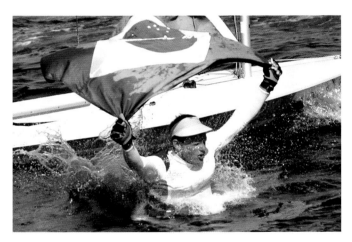

less opportunity; the sport only joined the Olympic movement in 2000. Despite that, two men have won both a gold and a silver medal. Damien Seguin of France won gold in the 2.4mR in 2004, and then silver in 2008. Jens Kroker of Germany won silver in the Sonar in 2000 before bettering it with a gold in 2008. Those tallies could be improved upon, since both men were still competing into the next quadrennial.

Another sailor still competing is the great Brazilian sailor Torben Grael, who's been quietly amassing his own medal haul for a while. Grael started with a silver medal in the Soling in 1984, before making a permanent

Top: Germany's Jens Kroker, Robert Prem and Siegmund Mainka celebrate after winning the Sonar gold medal in Qingdao in 2008. Kroker is one of two men to have won gold and silver at the Paralympics.

Above left: Damien Seguin of France is the other Paralympian to have won gold and silver – seen here celebrating his silver medal in the 2.4mR class in 2008.

Above right, opposite page left and overleaf: Brazil's Robert Scheidt is one of the most decorated of all Olympic sailors – here celebrating a second Laser gold medal, this one from Athens in 2004. He also has two silvers from 2000 and 2008, to go with his first gold from Atlanta in 1996.

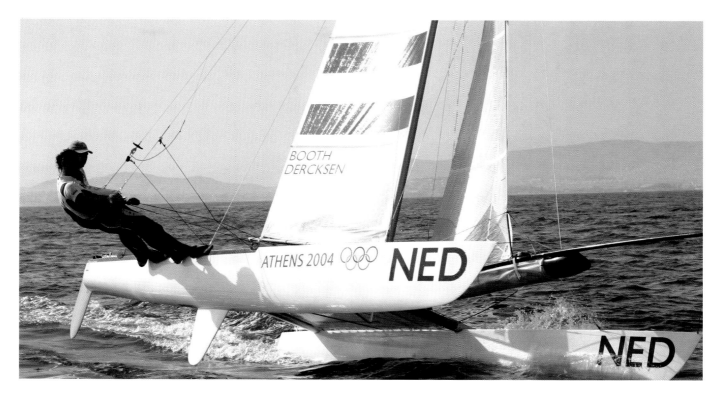

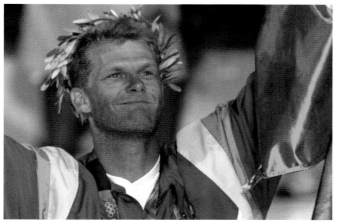

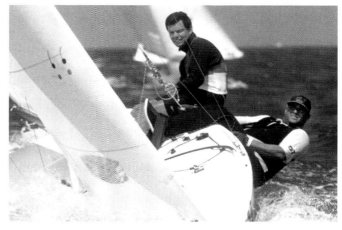

switch to the Star to win a bronze in Seoul in 1988. He missed out in Barcelona before winning gold, bronze and gold again at the next three Olympics. Grael holds the record for the greatest tally of medals (five) but didn't qualify for the 2008 Games. The man who beat Grael to represent Brazil in Qingdao in the Star boat is another of the great modern Olympians, his countryman Robert Scheidt. And they will once again face off in the Star for the single Brazilian place for London.

Robert Scheidt's name is inextricably linked with the other great Olympian of the modern era – Ben

Top: Mitch Booth and Herbert Dercksen race their Tornado to fifth place at the Athens Olympics in 2004. Booth has four Olympic appearances, but this is not one of the successful ones. He was fifth again in 2008, but has a bronze and silver medal gained while racing for Australia in 1992 and 1996.

Above right: The other great Brazilian Olympic legend – Torben Grael races the Star with Marcelo Ferreira at the Atlanta 1996 Games, where they won the gold medal.

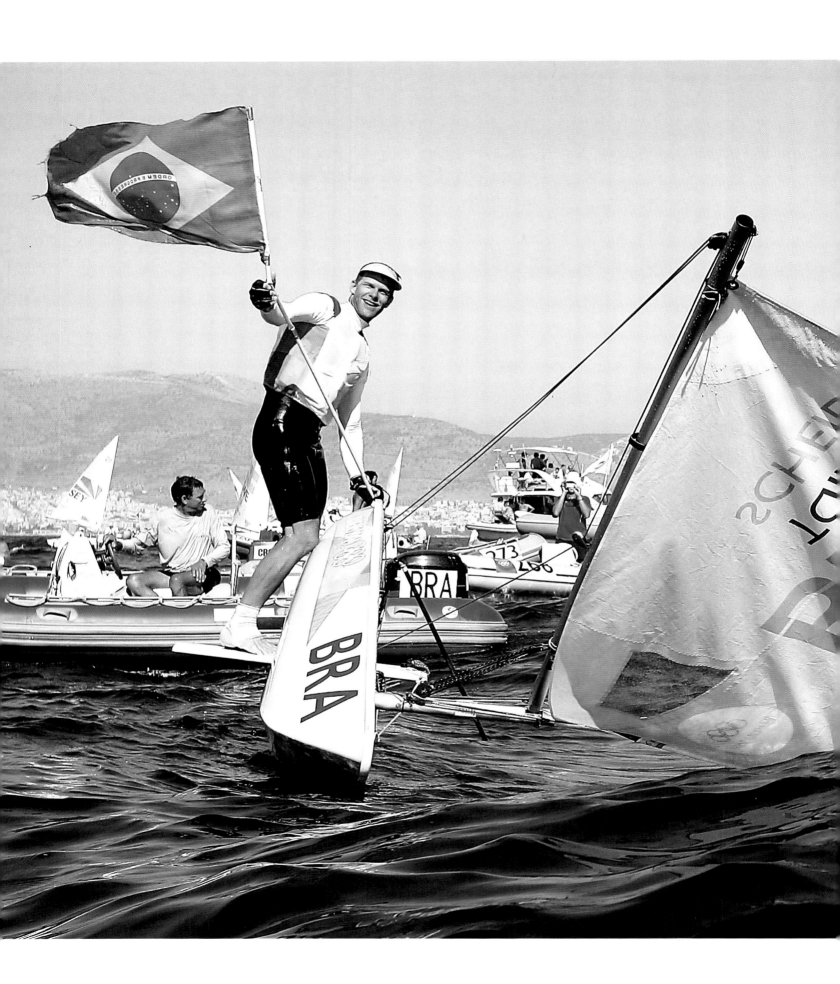

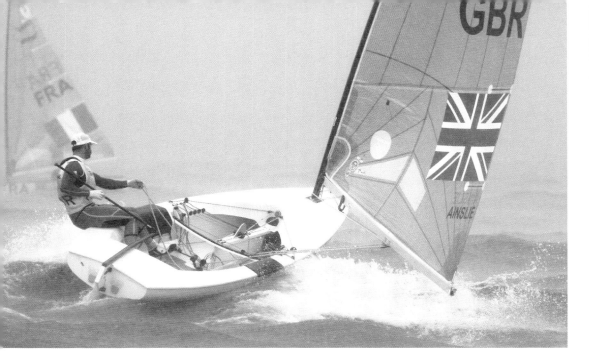

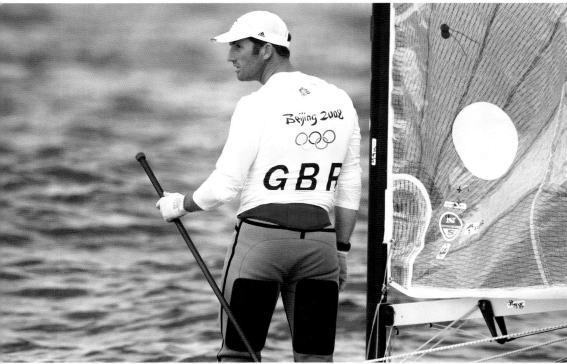

Clockwise from top left: in 2008 Qingdao provided some incredibly challenging conditions, not least this squall; but perhaps even more difficult to deal with in Qingdao was the lumpy left-over seaway and not much wind; winning gold in Athens in 2004; a pensive moment between races in Qingdao in 2008.

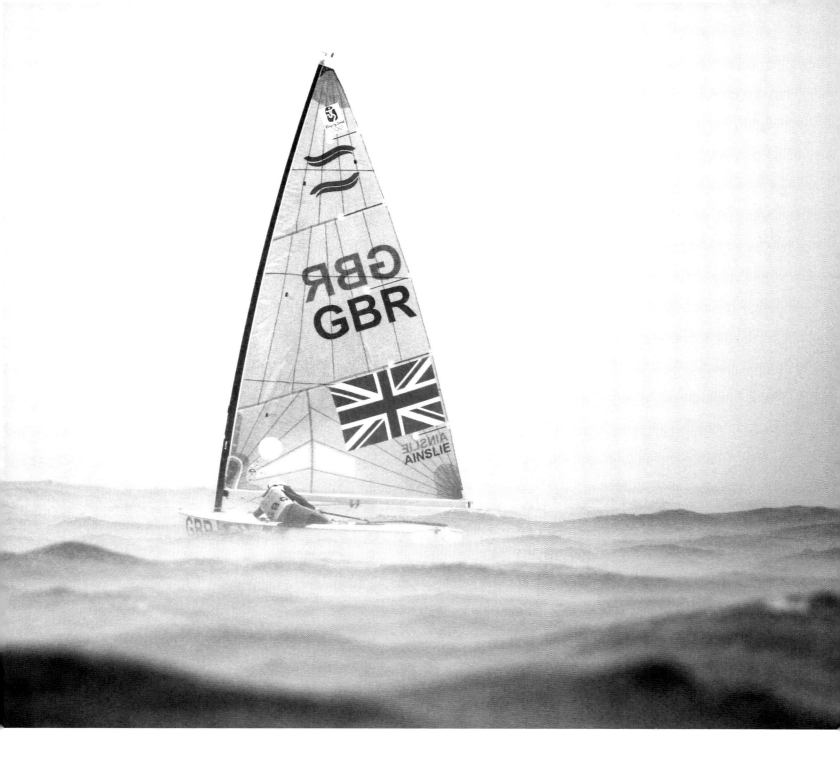

Ainslie. Both men first attended the Olympics in Atlanta in 1996, where they competed against each other in the Laser class. Scheidt came out on top on that occasion, winning gold and leaving Ainslie with silver. Four years later, Ainslie reversed the result, when he memorably sailed Scheidt off the course in the final race to go home with gold. Their paths then diverged – Scheidt stayed in the Laser for one more cycle and took gold again in Athens, before moving up to the Star. He may have beaten Torben Grael for the Brazilian place in Qingdao, but he then had to cede the gold medal to Britain's Iain Percy and Andrew Simpson and settle for silver.

Meanwhile, Ben Ainslie had moved into the Finn after Sydney, winning gold again in both Athens and Qingdao. Both he and Scheidt are in the frame for medals in London and the stakes are huge. Another gold for either would take them to the top of the heap with five medals each; in Ainslie's case it would be an undisputed four golds and a silver, finally surpassing the great Paul Elvstrøm. And for Scheidt it would mean three golds and two silvers, besting everyone except Ainslie and Elvstrøm. There's an awful lot to play for in 2012 – one way or another, London will be an historic and inspirational sailing Olympics. Bring it on.

Above: Thierry Peponnet and Luc Pillot of France sail to the bronze medal in the 470 class in Los Angeles in 1984 (top). They were beaten by Luis Doreste and Roberto Molina of Spain (bottom). Peponnet and Pillot went on to take the gold four years later in the same class in Seoul, while Doreste went on to win a second gold medal eight years later in the Flying Dutchman in Barcelona.

Right: Randy Smyth and Keith Notary won silver in the Tornado in Barcelona in 1992. It was the second silver for Smyth, who won the same medal in the same class eight years earlier at home in Los Angeles.

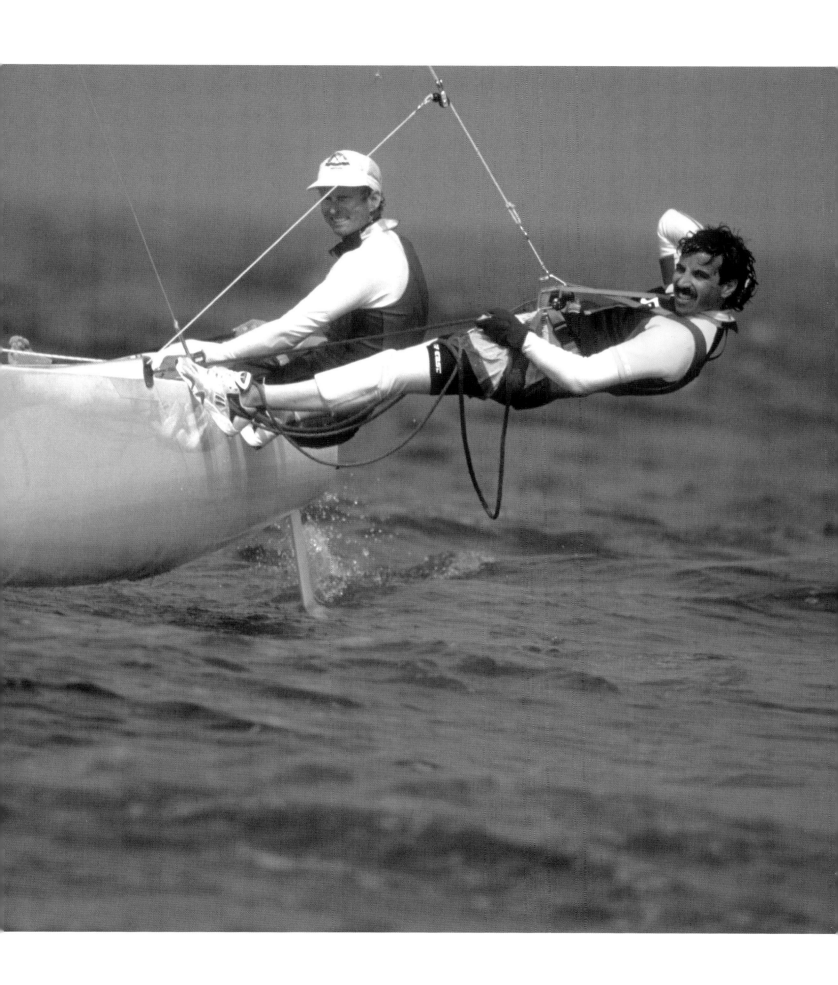

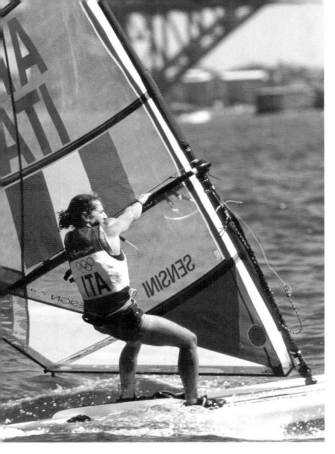

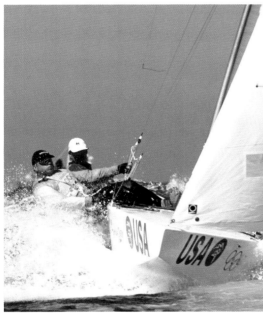

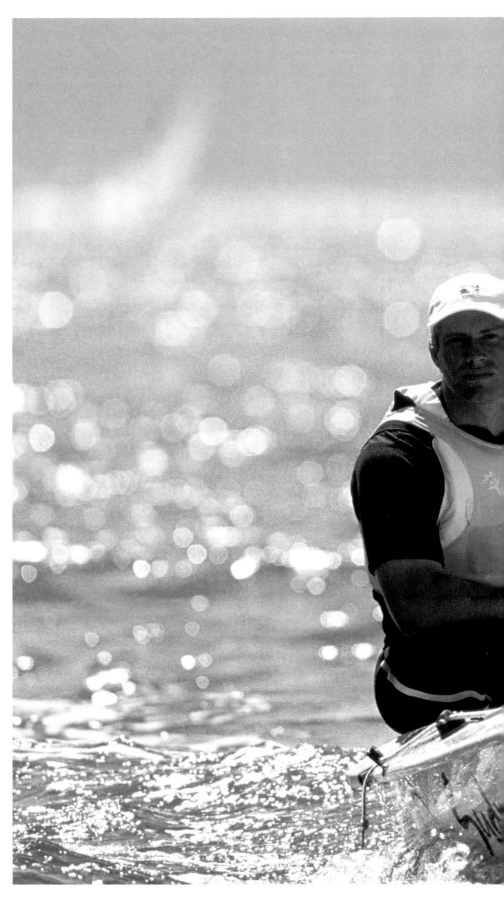

Top: Seen here in Sydney in 2000, Italy's Alessandra Sensini is the only woman to have won four medals, all in windsurfing: bronze in 1996, gold in 2000, bronze again in 2004 and then silver in 2008.

Above: America's Mark Reynolds is one of the great performers in the Star class, with two golds and a silver medal from four Games appearances spanning 1988 to 2000, seen here in Sydney (gold) sailing with Magnus Liljedahl.

Right: Britain's Iain Percy also has a Star gold medal, won at the Beijing Olympics in 2008, but here he is on his way to his first gold medal in the Finn, in Sydney in 2000.

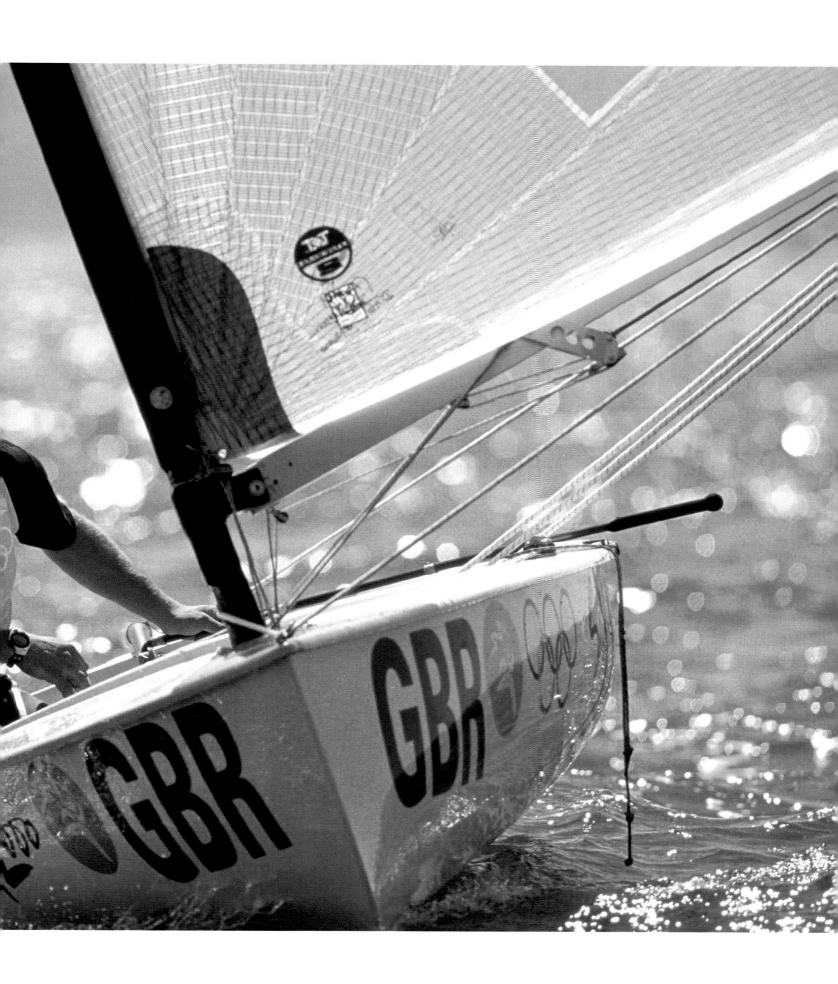

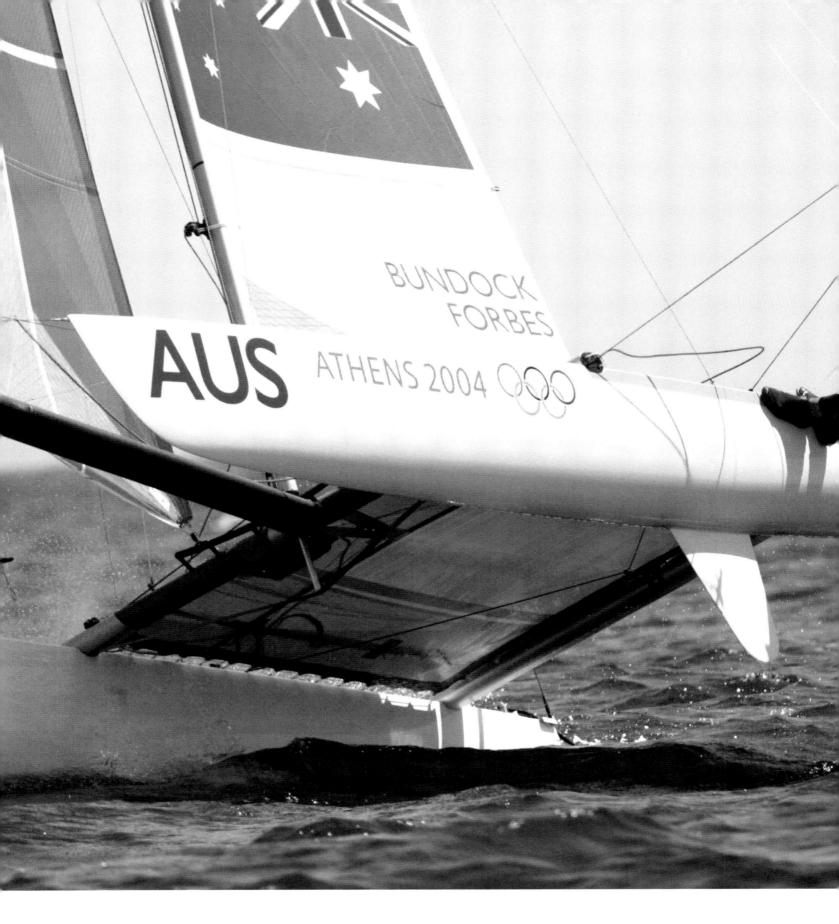

Darren Bundock and John Forbes race for Australia at the 2004
Athens Olympics – it was their worst Games appearance, with a sixth.
Together they won silver in Sydney in 2000, and Bundock went on to
win a second silver with Glenn Ashby in 2008, while Forbes has an
earlier bronze medal from 1992, racing with Mitch Booth.

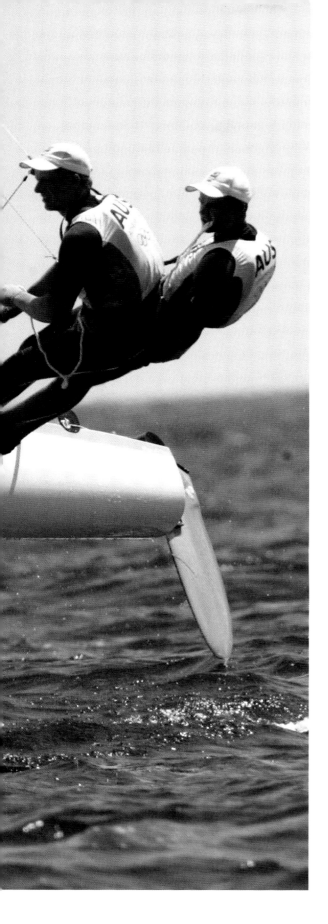

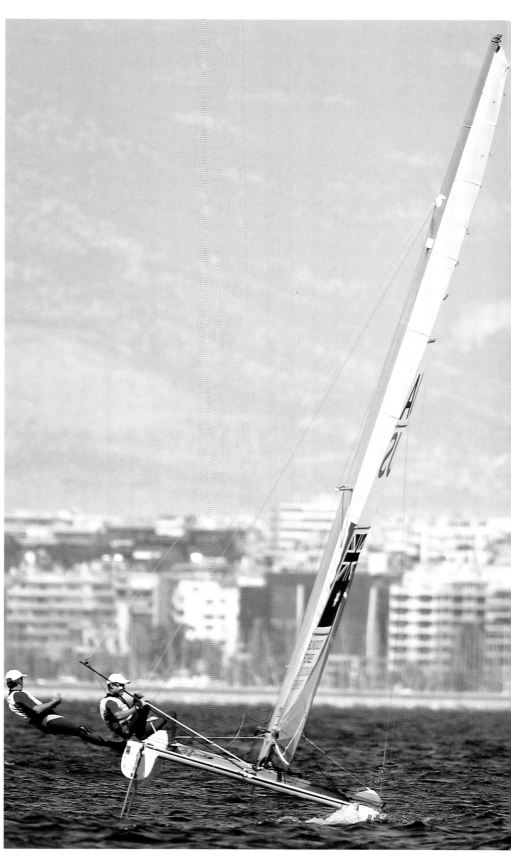

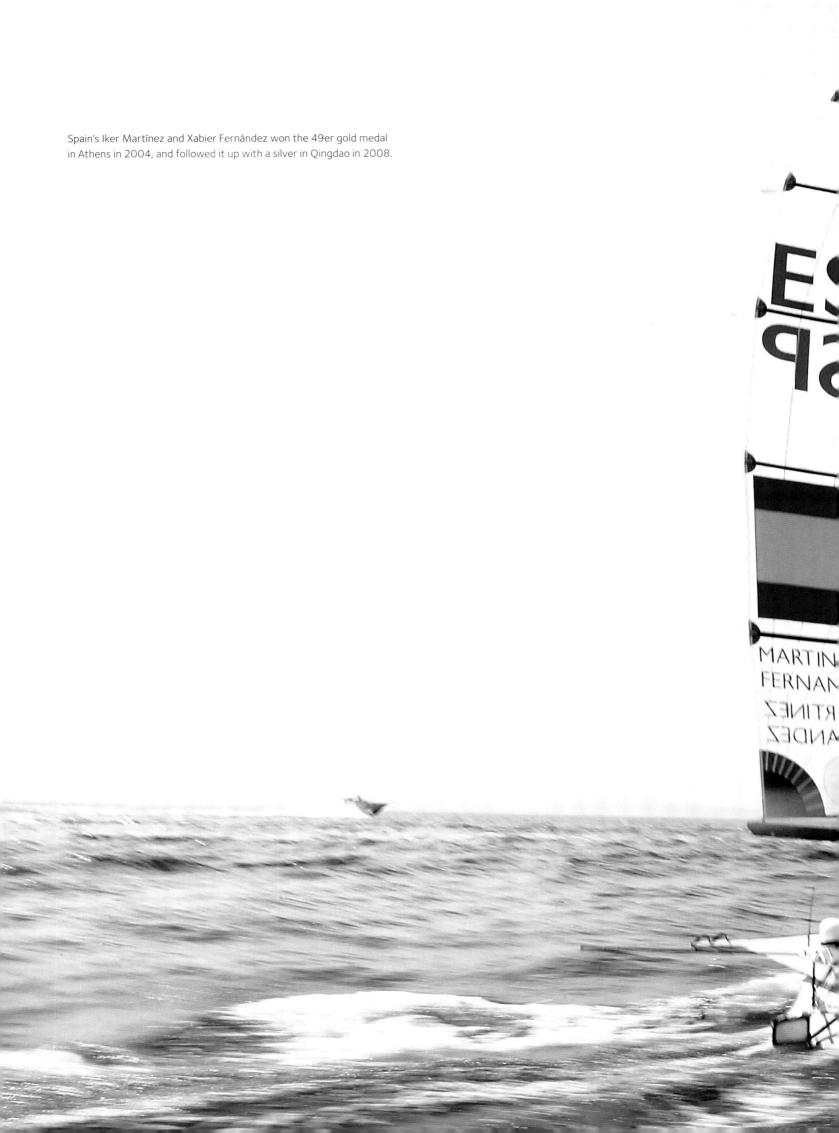

Spain's Iker Martínez and Xabier Fernández won the 49er gold medal in Athens in 2004, and followed it up with a silver in Qingdao in 2008.

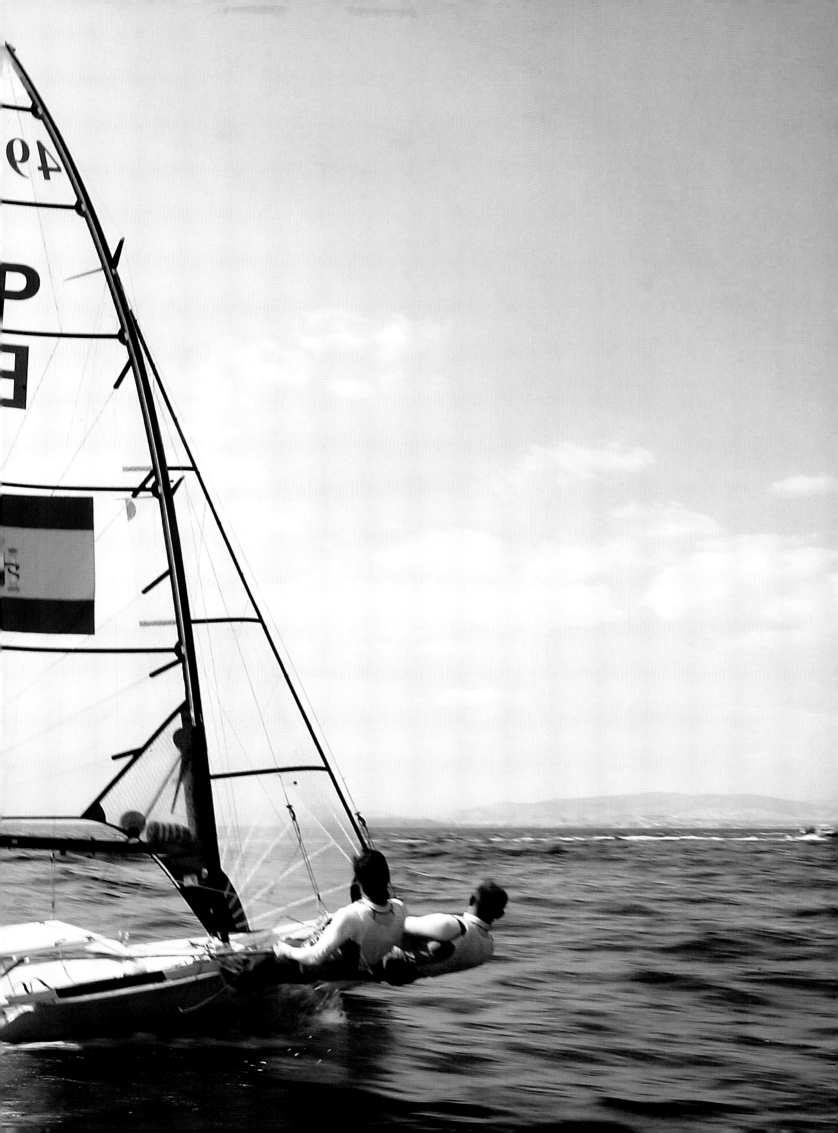

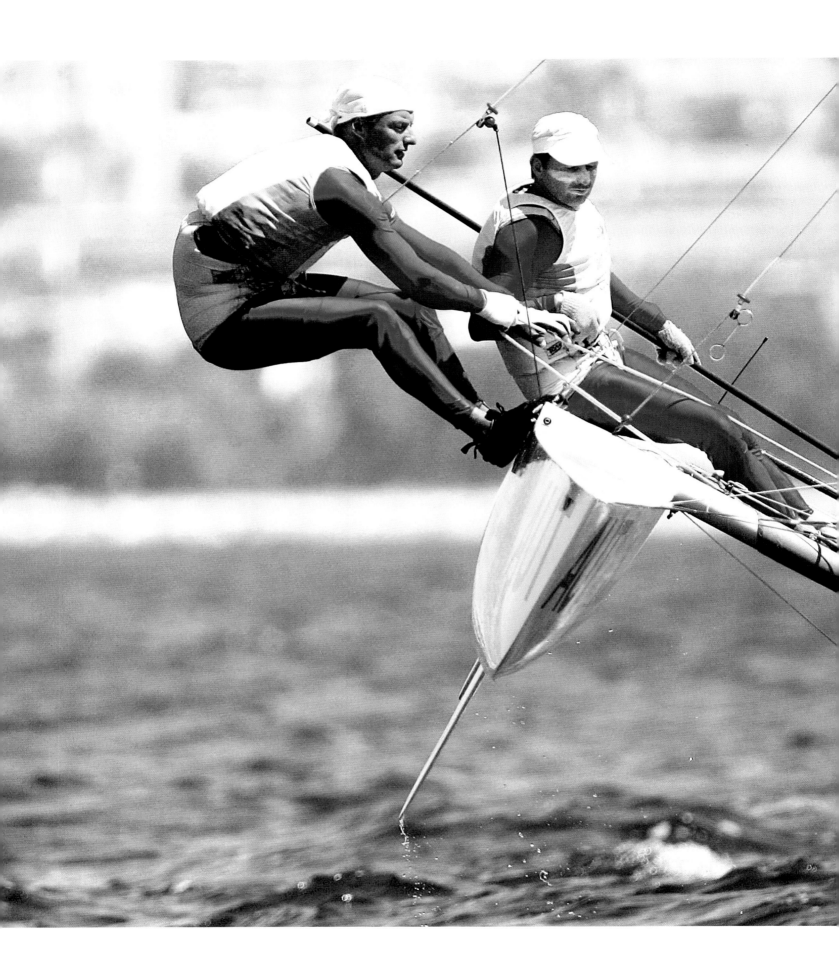

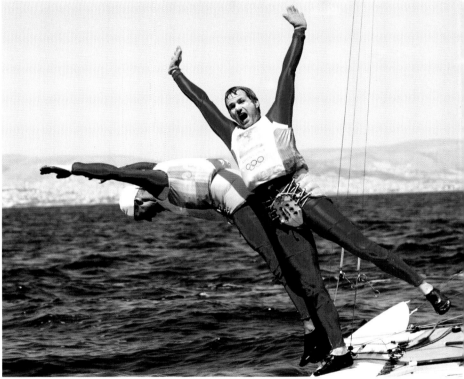

Roman Hagara and Hans-Peter Steinacher of Austria won gold in Athens in 2004. It was the pair's second Tornado gold medal, the first coming four years earlier in 2000 in Sydney.

Sweden's Fredrik Lööf is one of several Finn sailors to have moved up to the Star class very successfully. In his third Games appearance in the Finn in 2000, Lööf finally won a medal – bronze. He then teamed up with Anders Ekström in the Star. They were 12th in Athens but then won bronze together at the Beijing Games in 2008.

Above: Another of the icons of Women's windsurfing, Barbara Kendall of New Zealand. In the five consecutive Olympic Games between 1992 and 2008, Kendall placed first, second, third, fifth and sixth – in that order!

Right: Spain's Natalia Vía-Dufresne won a silver medal in the Europe in Barcelona at the age of 19, before moving on to helm the 470, sailing with Sandra Azón. They were sixth in Sydney, but then won silver in Athens. Vía-Dufresne changed crews for Beijing in 2008 and is seen here sailing with Laia Tutzo to tenth place in Qingdao.

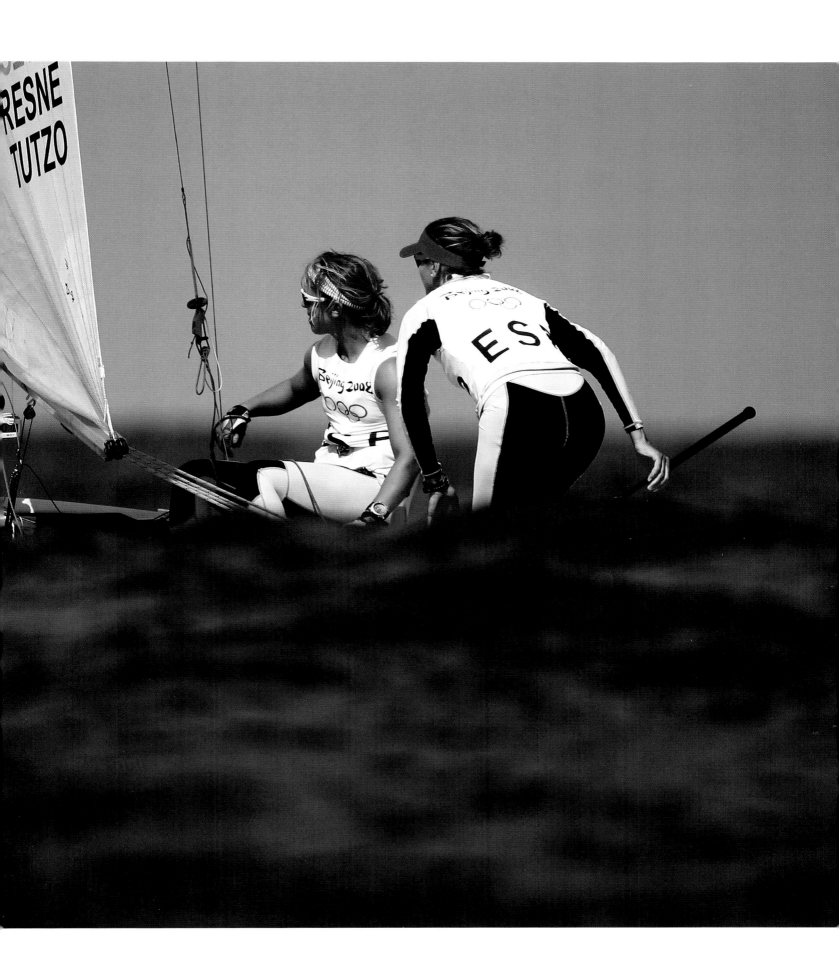

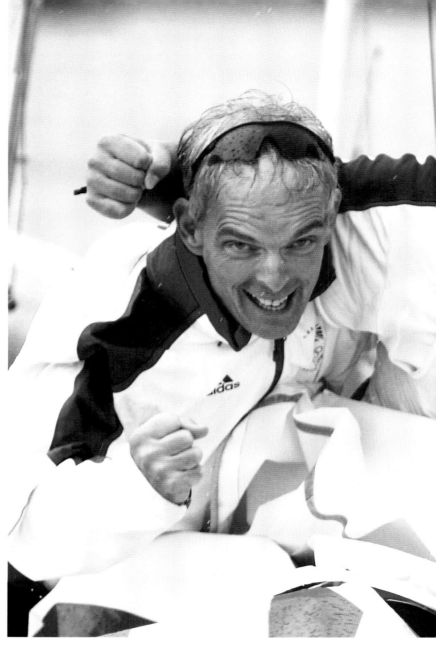

Team GBR has topped the sailing medal standings at the last three Games and has become an Olympic legend. In Beijing in 2008 they won an extraordinary four gold medals, a silver and bronze.

Top (left to right); Peter Bentley (technical support), Andrew Simpson (Star, gold), Bryony Shaw (RS:X Women, bronze), Iain Percy (Star, gold), Ben Ainslie (Finn, gold).

Bottom (left to right); Paul Goodison (Laser, gold), Sarah Webb (Yngling, gold), Pippa Wilson (Yngling, gold), Ben Ainslie (Finn, gold), Andrew Simpson (Star, gold), Sarah Ayton (Yngling, gold), Bryony Shaw (RS:X Women, bronze), Iain Percy (Star, gold), Joe Glanfield (470, silver), Nick Rogers (470, silver).

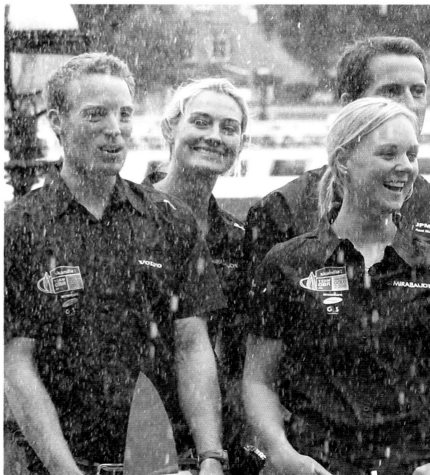

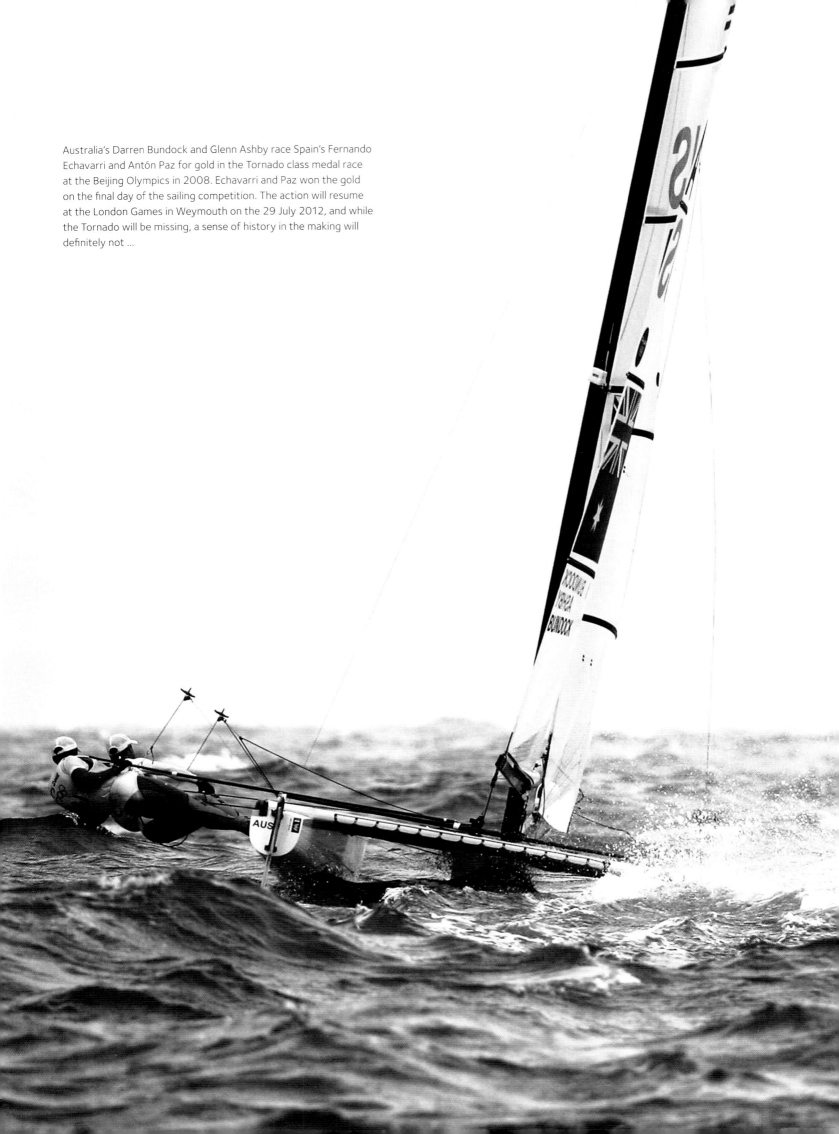

Australia's Darren Bundock and Glenn Ashby race Spain's Fernando Echavarri and Antón Paz for gold in the Tornado class medal race at the Beijing Olympics in 2008. Echavarri and Paz won the gold on the final day of the sailing competition. The action will resume at the London Games in Weymouth on the 29 July 2012, and while the Tornado will be missing, a sense of history in the making will definitely not …

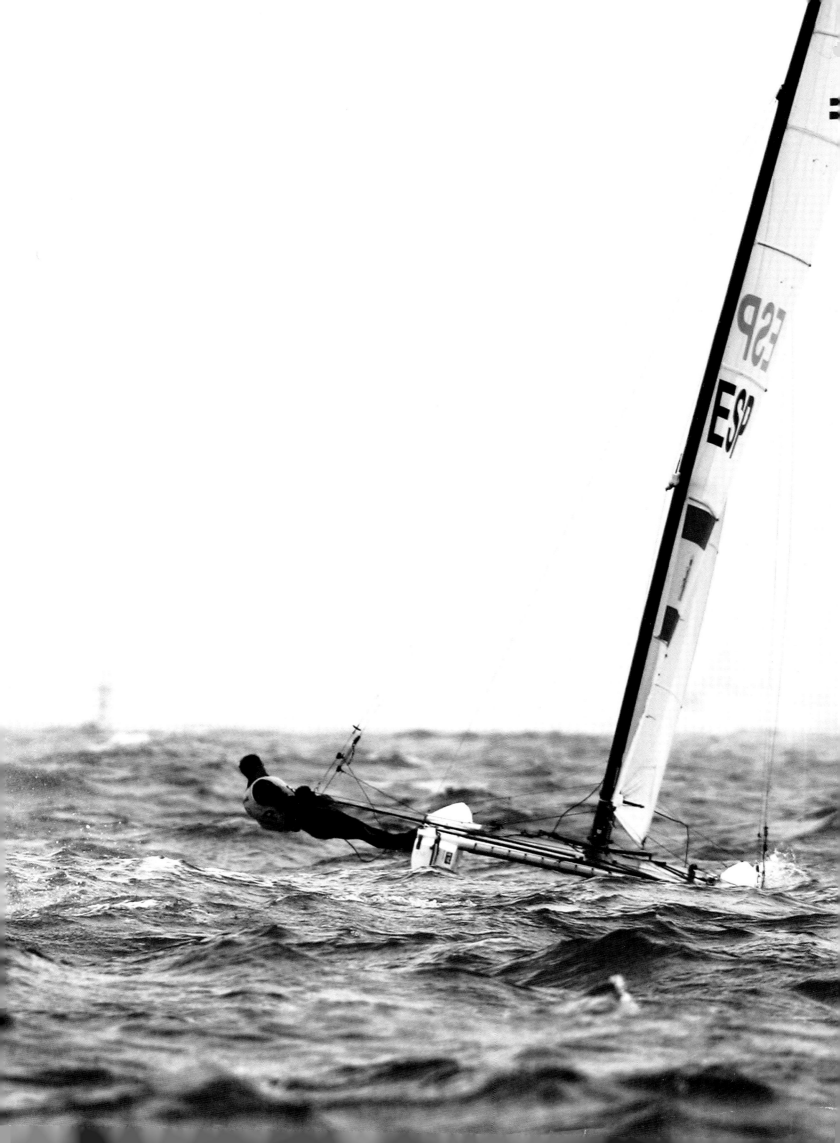

INDEX